SECRET CHATHAM

Philip MacDougall

AMBERLEY

First published 2016

Amberley Publishing
The Hill, Stroud
Gloucestershire, GL5 4EP

www.amberley-books.com

Copyright © Philip MacDougall, 2016

The right of Philip MacDougall to be identified as the
Author of this work has been asserted in accordance
with the Copyrights, Designs and Patents Act 1988.

ISBN 978 1 4456 5490 4 (print)
ISBN 978 1 4456 5491 1 (ebook)

British Library Cataloguing in Publication Data.
A catalogue record for this book is available from the
British Library.

Typesetting by Amberley Publishing.
Printed in Great Britain.

Preface

In this account of Chatham I have chosen to look at aspects of history rather than providing a more general survey. The latter is easily to be found elsewhere, allowing this book to take a glimpse at areas of Chatham's past that are less well known. In this respect I am using the word 'secret' in a less literal sense – something that is generally not so well known.

In researching this book I have drawn heavily on primary sources, including newspapers and original documents. A list of these will be found in the bibliography at the end of this book.

Contents

1. The Last Summer of Peace

Towards the end of July 1939, when schools in Chatham broke up for the long-awaited summer holiday, life was still running more or less as normal. Since the Munich Crisis of the previous year, and despite war still viewed as more or less inevitable, most families managed to push such gloomy thoughts to one side and contemplate light-hearted activities. But even so, the inevitable could not be avoided and by the end of that summer, on Sunday 3 September at 11.00 a.m., life was no longer the same.

The Munich Crisis was brought about by Hitler's desire to annex the Sudetenland with the agreement struck at Munich merely creating time in which Britain could fully prepare for a total war against Nazi Germany. A mere breathing space therefore, it at least permitted the country to continue developing a workable system of civil defence while bringing to the armed forces a rapid escalation in the supply of desperately needed modern weapons. As a town, Chatham certainly benefitted from this short period that became known as the 'phoney peace', having at the time of the Munich Crisis no civilian air-raid shelters, no effective civil defence organisation nor a plan for the evacuation of children and nursing mothers. Instead, at the time of the crisis in September 1938, the borough council had resorted to the digging of trenches in various public parks to provide emergency shelter should the town come under attack from the air. For this work, and to

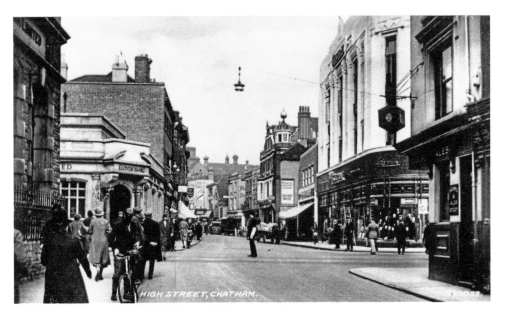

The Chatham High Street and Military Road junction shortly before the outbreak of war.

speed up its progress, some 700 unemployed helped the council's own employees, with the *Chatham News* reporting the following on 30 September 1938:

> The trenches are constructed in a zigzag plan, and vary in size according to the ground available. When completed they will be protected by some form of covering.

These slit trenches, which were gradually filled in after the crisis, were not the result of government advice but simply a borough initiative similar to that undertaken by numerous other councils in areas that were viewed as under threat from a surprise air raid. For its part, the government had been putting its faith in families protecting themselves through the creation of a safe zone or refuge within the home. In advocating this, and well before the crisis months of September and October, leaflets had been posted through the doors of every home in Chatham explaining how such a refuge might be created:

> Almost any room will serve as a refuge room if it is soundly constructed, and if it is easy to reach and get out of. Its windows should be as small as possible, preferably facing a building or blank wall, or a narrow street. If a ground floor room facing a wide street or a stretch of level open ground is chosen, the windows should if possible be specially protected. The stronger the walls, floor, and ceiling are, the better. Brick partition walls are better than lath and plaster; a concrete ceiling is better than a wooden one. An internal passage will form a very good refuge room if it can be closed at both ends.

Only after the Munich Crisis was attention really given to how civilians might more effectively be protected from the effects of an air raid. From that time onwards the government began to pursue a policy of encouraging local councils to construct public shelters in more congested areas while undertaking the distribution of easily assembled family shelters for those living in more spacious accommodation. These last could be erected either inside a house (the Morrison shelter) or garden (the Anderson shelter). A general fear of massive German air raids, seen as possible within the first few hours of a war being declared, was the big angst of the age, former Prime Minister Arthur Balfour having at one time stated that 'the bomber will always get through'. In other words, there was a widespread belief that no possibility existed of preventing a well-armed bomber reaching British towns, and attention directed instead to survival through the building of shelters and a good civil defence organisation. Helping to reinforce this view were a number of popular novels, many of them available at the local Boots lending library (No. 149 High Street), that graphically described the carnage and loss of life that would result from such raids. To this should be added the writings of so-called 'experts' in various journals and newspapers who also insisted that the bomber was the ultimate weapon of death.

Following the Munich Crisis, the government set about passing legislation that had required local borough councils to become more conscious of the need for civil defence. In Chatham an ARP (Air Raid Precaution) officer, Captain Douglas Cain, was appointed to take charge of all civil defence arrangements, his control room established in the basement of the town hall. Here Cain and his assistants were provided with a bank of telephones directly connected to various ARP, ambulance and fire brigade posts which would allow

him to direct and control all civilian operations during an air raid. At the same time, an increase in the borough rate (the local tax levied on businesses and householders) allowed for construction of forty-five surface shelters, while in February 1939 gas masks were distributed to all who lived in the borough. Into this was factored a further organisation, the part-time Auxiliary Fire Service (AFS), a self-contained organisation made up of volunteers working part-time who would, upon the outbreak of war, be called into full-time service and paid at the appropriate rate. In the meantime, and working alongside the regular fire fighters of the town, the AFS undertook special training in the fighting of fires caused by incendiary bombs, with the number of volunteers enlisting into the local AFS having exceeded the 100 mark by the end of March 1939.

The various military establishments in and around Chatham were also busily engaged during the post-Munich period with improving their own defences against aerial attack, with the dockyard and several barracks seeing rapid construction of underground air-raid shelters and a deep command bunker to the south of the dockyard. Yet, as shown by one practice military exercise, not all was as it should have been; a mock air raid in July 1939 on Chatham's Fort Darland, where the Army Technical School was based, resulted in thirty boys becoming trapped in a collapsed shelter. In a series of unacceptable delays, no rescue team was to arrive for thirty-five minutes. The *Chatham News* reported the following:

> It took eight minutes for the message to reach the Control Room by telephone, and after a long wait, a reserve and first aid party, numbering less than a dozen arrived to rescue the boys.

To this, the newspaper added,

> It would seem that the time taken for the squad to arrive on the scene was longer than was necessary, and moreover, the numbers sent were not sufficient to deal with a 'major' incident.

However, all this, for many, was temporarily forgotten as summer approached and attention was directed to dockyard holiday week, traditionally the first week of August. During that seven-day period the entire yard shut down, with only a minimal number of staff remaining on duty and the town of Chatham emptied of many of its residents who now escaped to various seaside resorts. For others too in Chatham this was an important week beginning, as it did, with the summer bank holiday Monday (now always at the end of the month) which also contributed to the carefree feel of the week. As in previous years, Southern Railway advertised additional trains that were designed to meet the travel needs of hundreds of dockyard families heading into the sun, with special excursion trains for Margate and Ramsgate leaving Chatham station a little after noon throughout the week. In addition other trains were laid on for London and Tunbridge Wells, these leaving earlier in the morning. For those who could afford it, the week's highlight excursion, as run by Southern Railway, was an all-inclusive day to Windsor, a train leaving Chatham at 11.50 a.m. that connected with coaches for Ascot and a river steamer trip departing from Maidenhead. This excursion also included afternoon tea and

might be considered a mere snip at 9s 11d per adult or 6s 10d for a child. However, given the average wage for a Chatham dockyard shipwright was around £3 per week, clearly such a day out would consume a fair amount of the August take-home pay.

Another easy way out of Chatham during dockyard holiday week – and slightly cheaper than the train – was that of booking a ticket at Sun Pier with Eagle and Queen Line Steamers for destinations that included not only the Thanet resorts but also Southend and Clacton. Leaving daily at 9.00 a.m., the return fare to Margate was 3s 6d while the excursion train was a slightly more expensive 3s 8d. Another advantage of the steamer, apart from the opportunity of walking around and taking in the sea air, was that they were fully licensed. Also available from Sun Pier were short weekend breaks to the Continent, coaches being laid on to Margate where they would connect with cross channel ferries operated by the New Medway Steam Packet Co.

For those remaining in Chatham for either part or the entire holiday week, the west end of Chatham High Street was the fashionable place to be. As with the whole length of the High Street, it had a large number of public houses and several cafés, including the Willow Café with its continental ambience created by its owner, Italian-born Luigi Panzeri. This end of the High Street was where higher sums of money changed hands, for here were several jewellery shops, upmarket gentlemen's outfitters and ladies' dress shops together with, at that time, the town's only department store, Featherstone's. In fact, the west end contrasted sharply with the east end of the High Street, for at that end, and the nearer it got to Luton Arches, the nature of the shops became more limited, directed mostly to everyday functional and domestic needs.

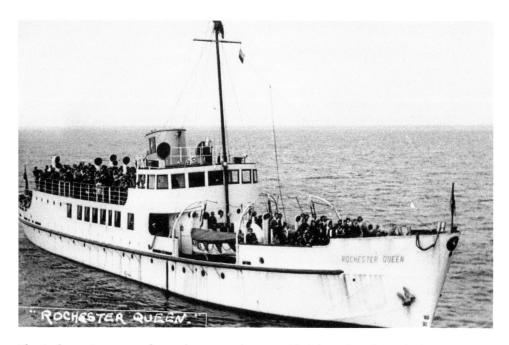

The *Rochester Queen*, one of several steamers that carried holidaymakers from Chatham to various seaside resorts during the 1930s.

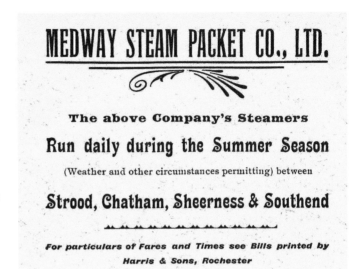

MEDWAY STEAM PACKET CO., LTD.

The above Company's Steamers

Run daily during the Summer Season

(Weather and other circumstances permitting) between

Strood, Chatham, Sheerness & Southend

For particulars of Fares and Times see Bills printed by Harris & Sons, Rochester

The Medway Steam Packet Co., the owners of the *Rochester Queen*, regularly advertised seaside trips that would depart from Sun Pier.

Another feature of the High Street's west end was that here was located the Royal Hippodrome, the town's one remaining theatre. In the 1940s it reverted back to its earlier name of Theatre Royal, and had a special matinee performance on that Bank Holiday Monday, which included a large number of acts and starred the then well-known comedian Ronald Frankau. A few weeks earlier, the Hippodrome had been offering something of a very different nature. Described as 'a play for adults only', it was entitled *Goodness, How Sad* by Robert Morley and was shown 'twice naughtily'. As well as the Hippodrome, the west end also had three cinemas: the Picture House, Empire and Regent Palace. The first two were owned by the same company and were situated in adjoining buildings; the Empire, having begun as a theatre specialising in variety had, due to falling audiences, gone over to the showing of films in 1929. For dockyard holiday week, Laurel and Hardy were starring in *Bonnie Scotland* at the Empire and a 'Bulldog Drummond' film was showing at the Regent.

The fact that 7–13 August was holiday week in Chatham impacted upon a planned civil defence exercise that involved most of south-east England. The exercise went ahead as planned everywhere else, but in Chatham, apart from the town being fully blacked-out, it was as good as cancelled because most of the senior volunteer ARP officers were employed in the dockyard and were out of town on holiday. Chatham, however, had played its full part in a civil defence exercise carried out in June with over 1,000 volunteers helping stage some 200 incidents across the borough. In an attempt to make the exercise more realistic, a number of small explosives and smoke bombs had been detonated with blue, red and yellow lights signalling whether the explosions represented high explosive, gas or incendiary bombs. In the Control Centre in the town hall messages were received and instructions sent out for actions to be taken by decontamination units, rescue parties and road and sewerage repair gangs. To help keep track of what was going on, a peg-board system had been introduced with pegs showing the various services at their posts and removed or replaced as units were sent out or had returned.

ROYAL HIPPODROME, CHATHAM

Phones 2211—2212 Box Office open as usual

6.20 Week Commencing MONDAY, JANUARY. 1st, 1940. **8.40**
TWICE NAUGHTILY
Two Matinees—on New Year's Day and Saturday—commencing at 2.30.

MAY WEST PRODUCTIONS offer LONDON'S LATEST SUCCESS
The Most Audacious Farce of the Age

"ROOM FOR TWO"

By Gilbert Wakefield

AFTER A NINE MONTHS' RUN AT THE COMEDY THEATRE, LONDON

SOME OF THE PRESS OPINIONS

"The audience loved every moment of it. Reception was enthusiastic."—Daily Mail.
"Naughty, but nice. Very, very funny."—News Chronicle.
"Outrageous, but funny."—Evening News.
"Riotous bedroom scene."—Daily Telegraph.
"Faster and faster grows the fun."—News of the World.

**The most amusing Farce of the present Era. A Play for the Broad-minded.
A PLAY TO SEE—but not with your Maiden Aunt.**

The NEWS CHRONICLE says:—

"NAUGHTY, BUT NICE"

"Speaking in the language of the racing stable, this piece might be described as out of Margaret of Navarre by Boccaccio. Speaking allegorically and metaphorically, it not only skates over thin ice, it skates over practically no ice at all.
"It's not only near the knuckle. It is the knuckle. With enough sauce for two or three joints. But it's very, very funny.
"Let me not detain you with the plot, except to say that the authors of the Heptameron and the Decameron would not have despised it. In fact, I'm not sure they didn't both use it."

While theatres and cinemas were temporarily closed at the beginning of the Second World War, they reopened a few months later. In January 1940, one of the coldest winters of the century, the Hippodrome was back to its more risqué entertainment; the theatre put on 'twice naughtily' an 'audacious farce' entitled *Room for Two*.

In August 1939 this former Chatham theatre was known as the Hippodrome, an entertainment venue which began to present live theatre of an increasingly risqué nature. It survived as a theatre until 1955 when it was closed and eventually converted into a shop before recent restoration to the front and foyer. For many years it was under threat of demolition but sense subsequently prevailed.

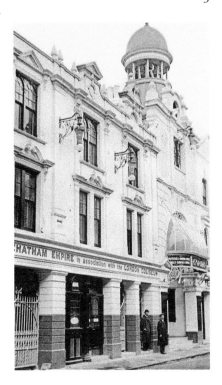

The Chatham Empire began as a theatre but by 1939 had been converted into a cinema. Next door, and also owned by the same company, was a second cinema named the Picture Palace.

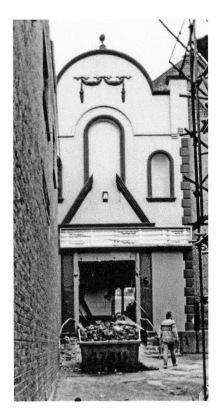

During the 1930s, Chatham was well endowed with cinemas. This is the entrance to the Invicta, just off the High Street in Fullager's Yard, a cinema that first opened in 1916.

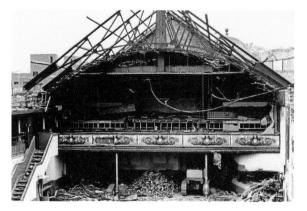

A glimpse, while under demolition, into the auditorium of the Chatham Invicta. It ceased as a cinema during the war; the building was taken over by the Church Army to provide additional facilities to support those engaged in the war effort. Many may remember it as a venue played by the Rolling Stones in 1964.

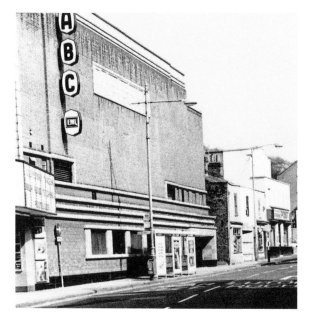

Opened as the Super Regent in July 1938, the cinema was due to show Jack Buchanan's *The Gang's All Here* on the day war was declared in September 1939. In later years, and as seen here, it finally became the ABC cinema. The building was demolished in 2003.

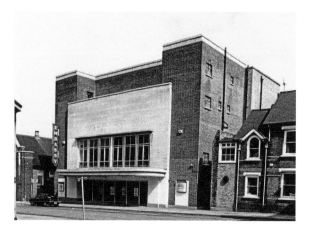

Another Chatham cinema in this period was the Ritz, which first opened in 1937 at the extreme east end of the High Street. On the day war broke out, it was advertising the film *Elephants Never Forget* with Oliver Hardy but not Stan Laurel.

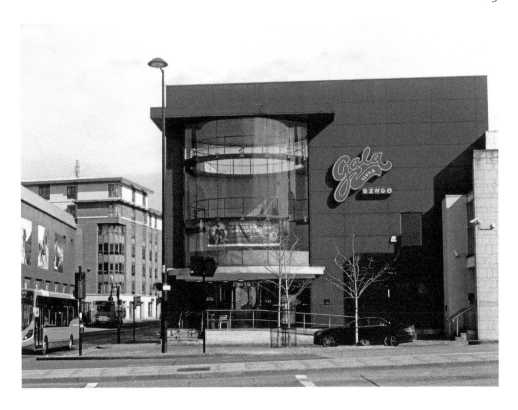

Above: A modern-day view of the Luton Arches end of the High Street, showing the site of the now demolished Super Regent/ABC cinema (middle building) and the now demolished Ritz (Gala Bingo building).

Right: Following the crisis of September to October 1938, considerable efforts were made to improve the civil defence arrangements in Chatham and the basement of the Town Hall was converted into a control room for the town's Air Raid Precaution officer and his staff. All information on bombs falling on Chatham was relayed to this control centre and appropriate instructions issued to emergency teams.

From that practice exercise, which was generally regarded by Chatham ARP officer Captain Douglas Cain to have proved invaluable, one thing became crystal clear: there was an insufficient number of volunteers. If the numbers available to the ARP, AFS and other emergency services was not increased, it would be impossible for the local defence network to be in a position to work continuously under wartime conditions. For this reason local newspapers, throughout the month of August, were continually reminding readers of the need to volunteer, it being emphasised that there was also a need for women to volunteer as telephonists and messengers in the control centre or for domestic duties in the various outlying posts. This, of course, was a time, when only men were placed on the front line and women had more of a service role.

As August wore on, and holiday week memories began to fade, the worsening situation in Europe once again took centre stage, becoming the town's major talking point. On 26 August Medway diarist Cyril Cate, employed in the dockyard as an electrician, made this terse entry into his pocket book: 'Great activity everywhere owing to European crises'. He then emphasised the point by adding, 'notices on schools for return of teachers and scholars for evacuation'.

Those notices being placed outside of schools were to prepare everyone for the inevitable, with plans for evacuation having been finalised earlier in the year. The problem was that the school term was not due to begin until 14 September, with it looking likely that evacuation might take place well before that date. It was for this reason that schools in Chatham were now opening early, with the children who came attending classes but receiving lessons that were described as lighter than those of the normal syllabus. Most

As a wartime emergency, some of the buildings in the dockyard, many of them made from timber and highly inflammable, were given an emergency covering of asbestos.

important though was a full practice evacuation at the end of the month with children in all Chatham schools marched to the station to catch imaginary trains. For this purpose a timetable was drawn up with trains supposedly leaving every fifteen minutes between 11.00 a.m. and 12.30 p.m. and each child issued with a label that identified the wearer's name, school and class. While an invaluable exercise that ran like clockwork, the authorities were aware that it had only involved around 1,300 children, whereas the total number of children attending schools in Chatham was four times that number.

Now things were looking really serious. The dockyard had gone from near idleness during the recent holiday week to maximum work output, with the entire workforce putting in a number of extra hours for the purpose of speeding up ongoing refits and getting ships moored in the Medway quickly and efficiently out to sea. Cate, by this time, was rarely leaving the yard before 7.00 p.m. and was signing on for work at 8.00 a.m. each morning. On 28 September he wrote in his diary, 'Crisis quite serious'. On that day he actually returned home at 4.00 p.m., but this was only because he had been rostered for overnight fire watch duty in the yard and had been sent home to collect his gas mask.

It was on Friday 1 September that children from Chatham schools were evacuated, with the *Chatham News* on that day announcing 'Local school children leave for unknown destination' and adding that the first train for evacuees would be leaving at 6.20 in the morning. As it happened, the first train did not leave until 8.30 a.m. The 'unknown destination' was just one of the glitches in the evacuation scheme that should have been resolved at a much earlier stage. Parents should have been cognisant of just where their children were being taken and the reception areas should have known who and how many they were expecting. In fact, parents in Chatham only learned where a son or daughter might have been when they received postcards from villages and towns on the east side of the county. Nevertheless, any problems with the entire evacuation procedure, such as school parties being broken up and the separation of siblings due to attending different schools, were generally glossed over. The *Chatham News* was confident in telling its readers that evacuation from Chatham was 'carried through with efficiency' and was characterised at the stations by 'the cheerfulness of the children'. Giving comfort to parents already missing their children and wondering if they had done the right thing in allowing them to be evacuated, it was added,

> On arrival at their destination the children were marched to centres where they were allocated to their billets. From reports already received from the reception areas, the evacuees show that they are settling down in their homes and are happy and comfortable.

This rosy view of what had taken place was reinforced by the local newspapers of the areas to which the children of Chatham were being evacuated. In Deal, one of the reception areas for Chatham, the *East Kent Mercury* reported,

> The reception and billeting of the 2,400 evacuated mothers, schoolteachers and children from the congested areas of London and the Medway Towns into the safer haven of Deal during the weekend was expeditiously and sympathetically carried out. On the whole the children were remarkably bright and cheerful.

But from beginning to end the evacuation programme had been only one step from total disaster and had only achieved what it did achieve through the number of children being evacuated falling far short of government expectations. From Chatham, less than 40 per cent of the planned number arrived at the station and boarded trains, which led to a complete upheaval in the number of trains required and accounts for why the transiting of evacuees was completed in such a short space of time. However, this did not prevent subsequent chaos, with school parties often split and sent to completely different destinations. Often it took days for these parties to be reunited, by which time the original accommodation that should have been available had been given over to others. On the other hand, two young girls from a Chatham school fell on their feet: evacuated to a mansion in east Kent they were reportedly waited upon hand and foot. As for the owner, she didn't think it 'quite the done thing for either of the girls to be seen in a sixpenny store' – by which she meant Woolworth's. As for two children from a temperance family, they were boarded in a public house.

Cyril Cate was among those whose family life was suddenly thrown into upheaval as a result of evacuation: his wife and ten-week-old son were evacuated to Sellindge near Folkestone. Eventually, and again bringing the whole Chatham evacuation scheme into question, those sent to various parts of east Kent had to be re-evacuated to Wales some eight months later. This was because nobody involved with the evacuation process at government level had given thought to east Kent, perhaps due to it being closer to the Continent and upon the outset of fighting, being an area of equal risk.

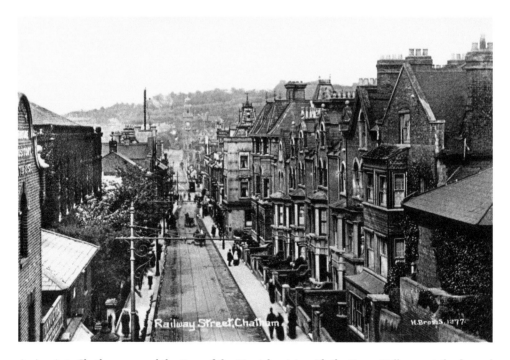

A view into Chatham around the time of the Munich crisis with the Town Hall seen at the far end of Military Road.

As for the remaining few days of summer 1939, which had begun in peace but was now ending as a time of war, Chatham began to adjust to the new situation. At night the town was blacked out, car headlights partially covered over and various public buildings given a shield of sandbags that would help offset blast damage from bombs. Other changes brought about by the declaration of war was that of the twice- or thrice-daily household milk deliveries being cut back to just one, allowing milkmen to deliver in daylight hours only. All cinemas closed, together with the Hippodrome theatre (but were allowed to reopen a few weeks later), and local police constables on patrol began wearing steel helmets. As an emergency measure also, a number of additional shelters were announced in existing buildings, which included a wine cellar in Manor Road, the basement of the Central Hall in the High Street and the basement of Ebenezer church in Clover Street. Other shelters were now also available, having been recently constructed into Coney Banks, Hills Terrace and the Great Lines. As for rationing, this had yet to be put in place, but shops in Chatham were preparing, with one store on the High Street taking out a large advertisement in the *Chatham News* which informed that 'when ration books are issued by the proper authority you are invited to register with Vye and Son, the Kentish grocers'.

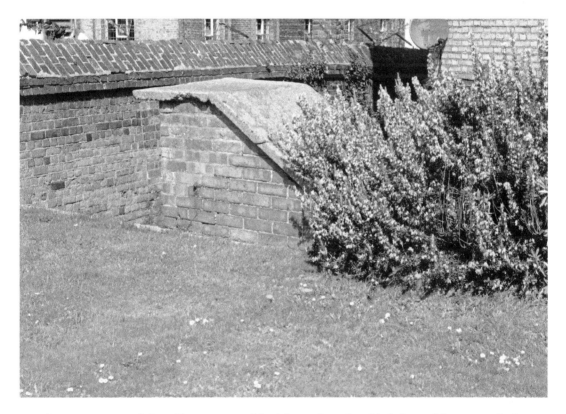

Entrance to one of the still extant, post-Munich wartime air raid shelters; this one was built alongside the dockyard wall and primarily used by the Royal Marine Police, a body then responsible for the security of the dockyard.

DID YOU KNOW THAT…?

The fear of air raids on Chatham would have been magnified by the experience of the First World War when one bomb dropped on the town in 1917 caused more fatalities than any other single bomb dropped from the air during the entire rest of war. Most of the casualties were naval ratings sleeping overnight in the gymnasium of the Chatham Naval Barracks.

On the first day of evacuation, 1 September 1939, a total of 1,827 schoolchildren were evacuated from Chatham mostly to the Sittingbourne, Swale and Faversham rural areas.

During the Second World War, while Chatham was bombed, it received nothing like the bombing suffered by two other naval dockyard towns, those of Portsmouth and Plymouth. One raid on the dockyard in December 1940, saw nine bombs falling on the dockyard factory, resulting in the deaths of several members of the Dockyard Home Guard.

During the Second World War, the dockyard workforce peaked at 13,000. During this period the yard launched fifteen ships and two floating docks and undertook 1,360 refits.

2. Gaol Fever

Could there be anywhere less healthy than the numerous prison ships of the French Revolutionary and Napoleonic Wars? At Chatham they were moored along the River Medway, close to the dockyard and stretching out towards Gillingham. Old and worn out battleships, known as hulks, were long past their usefulness for naval service and through rapid conversion were now crammed full of captured enemy soldiers and sailors. These unfortunates, mostly of French, American and Danish nationalities, would remain in the hulks for years on end, a few occasionally transferred to a land prison, but the majority otherwise incarcerated until a time of eventual peace. In the overcrowded conditions that prevailed, it was unlikely that they would avoid contracting one of the many diseases; tuberculosis, typhoid and kinds of respiratory illness were almost impossible to avoid.

When John Gale Jones, an English-born Republican and a member of the radical London Corresponding Society, visited the hulks at Chatham during an early stage of those wars, he commented on another facet of life in the hulks, that of despondency and despair which accompanied such long periods of incarceration. Rather foolishly, he had hoped that, in being the product of the new Jacobin state, they would have overcome such feelings:

> I expected at least to have seen them dancing the Carmagnole, or to hear them chant, in loud and vigorous strains, the patriotic tune of *Ca Ira*. But I had forgotten that long continued slavery debases the mind, and enfeebles the body, and that a man without hope is almost always destitute of exertion.

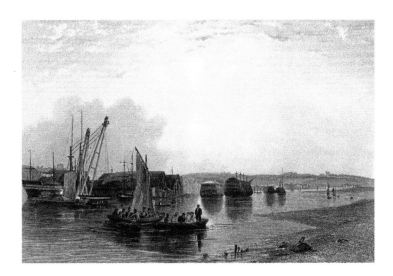

Hulked warships lying off Chatham dockyard.

Almost certainly, the worst period in the life of these prisoners came during the first few months of 1814 when hundreds of those imprisoned on the hulks were struck down by gaol fever, otherwise known as typhus; its chief warning signs were headaches, fever and flu-like symptoms accompanied by a rash that quickly spread across the entire body. Left untreated, and in an age prior to antibiotics, death was a common outcome. Adding to the suffering of those prisoners were the plunging winter temperatures, the country under the anguish of the worst winter of the entire century. In London it was even possible to hold a frost fair on the Thames and the Medway had also frozen over. January proved especially bitter, with heavy snowfall bringing the entire county of Kent to a standstill, with snowdrifts completely preventing the use of Chatham Hill.

Those on the prison hulks who showed signs of having contracted the disease were immediately transferred to one of the hulks that had been set aside as hospitals – which included *Crown Prince*, *Defiance* and *Trusty*. While this might outwardly appear to be a sign of humanity and care, the actual medical attention they received was of the absolute minimum. For the most seriously afflicted, it was simply a matter of ignoring them, and the poor unfortunates were left to lie in their own filth.

This dreadful situation might well have continued unabated had not the hero of this story, Dr William Burnett, been appointed to oversee the care arrangements given to all imprisoned on those hulks. As well as the thousands of French, Danish and American prisoners, Burnett was also charged with supervising medical arrangements for the officers and seamen of an allied Russian fleet that had recently entered the Medway. Stationed there throughout this bitter winter period, the workforce of the dockyard were busy refitting a number of Russian warships, with the crews also housed in hulks and other vessels moored in the River Medway.

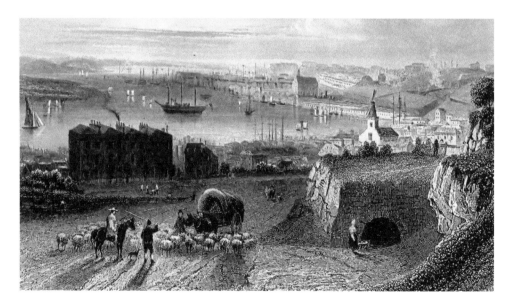

The River Medway as it appeared shortly after the French Wars. Many of the buildings would have been familiar to Dr Burnett.

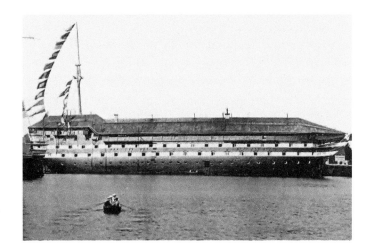

Although this is a view of HMS *Pembroke*, a hulked warship set aside to accommodate naval ratings in the Medway before construction of the barracks, it does give some idea of the appearance of the earlier convict hulks that housed prisoners during the Napoleonic War.

Upon first inspecting the hospital ships, Burnett found them to be in a most unsanitary state, reporting on the condition of the patients and indicating that he found 'fifteen with their lower extremities more or less in a state of gangrene and almost every patient covered with patches of vibicis'. This term 'vibicis' was a French medical expression that referred to some form of bruising and tenderness and may well have been bedsores from a lack of medical attention. This, of course, partly explains the low survival rate, with 28 per cent of those who contracted the disease failing to recover. Following Burnett's arrival and insistence upon proper nursing, this survival rate jumped to a seemingly miraculous 89 per cent.

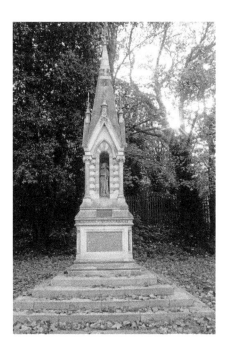

A memorial erected in the Naval Barracks (now Chatham Maritime) to the French prisoners of war held on hulks in the Medway who died during captivity and were buried on St Mary's Island.

Burnett himself explained how this miracle was achieved. In a report that he later submitted to the Admiralty, and which has lain unread in the British National Archives at Kew for well over 150 years, it is an amazing testimony to the bravery of one particular doctor. Written in the third person, it not only tells of many of his colleagues succumbing to the fever but of Burnett himself choosing to ignore all risk and entering the hulks on a daily basis to seek out those who needed his attention:

> ... he [Burnett] not only visited the infected ships daily but was obliged personally for hours to be in their crowded and unventilated decks, selecting such men as were attacked to send them to the hospital. And so hazardous was this part of his duty considered that the officers of the most sickly ship attempted to dissuade him from it alleging in addition to the probability of his being attacked with the prevailing fever with which, indeed, all of the Marines and every other person belonging to the ship's complement who had any intercourse with them had suffered, that the prisoners would murder him ...

Apart from typhus, there was also the additional problem of a number of prisoners having contracted smallpox. This, according to Burnett, 'prevailed extensively in one of the infected ships and so great was the alarm that the late Admiral Suridge [commander-in-chief at Chatham] had placed the whole in quarantine'. Again, this had to be treated, with Burnett insisting on full isolation, proper nursing and a more humane approach to those taken ill. In addition, he also pursued a policy of vaccinating all uninfected prisoners.

A detailed view of a hulked warship moored in front of the dockyard with this one possibly housing convicts rather than prisoners of war.

As for that terrible winter weather, Burnett, in a mastery of understatement, refers to it being 'a very inclement' season before going on to say,

> The ground being very deeply covered with snow and the execution of that part of [his duties] appertaining to the Russian Fleet he had often to walk through the snow to Gillingham before daylight in the morning to take advantage of the tide, to proceed down the Medway to visit the Russian Fleet.

Over the months both the fever and smallpox outbreak gradually dissipated with the mood on board those particular hulks full of French prisoners and their Danish allies changing to near elation in April when they learnt that a time of peace had come about. Nor was there any delay in getting them home, a task completed in less than a month with over 1,000 former prisoners transported to Calais by the end of April. Somewhat less fortunate were the American prisoners as the war between Great Britain and the United States that had broken out in April 1812 continued for a further year. However, with more room now available in prisons on land that had once been occupied by French prisoners of war, the Americans were shortly to leave the hulks at Chatham, bound for Stapleton. However, before that move had been completed, seventeen American prisoners had managed to escape, although the body of one of them was later discovered in the Medway. Because of

A further view of the Medway, showing the area of the river that was once occupied by the overcrowded prison hulks. The artist has made several errors in terms of the actual height and length of several dockyard buildings.

this sudden change in the course of history, Burnett became responsible only for the sailors of the remaining Russian fleet. Quite naturally, they too were not to remain in the Medway indefinitely, with the majority of their ships also sailing at the end of May. They had been given the task of conveying the Russian Imperial Guard out of France, collecting them at Cherbourg. Among those who sailed with them was Burnett himself, extending his duty to that of caring for the crew of those ships until they came to anchor in the harbour of Kronstadt.

In the years that followed, Burnett climbed the ladder of promotion. In 1822 he was invited to join the Navy's Victualling Board (then also responsible for naval medical matters), followed by a later appointment to the post of Physician-General. During these years he made frequent return visits to Chatham, regularly reporting on the state of medical care that was offered to those who either served in the Royal Navy or as artisans and labourers in the dockyard. One particular achievement was his insistence upon the need for a permanent naval hospital in the town. This came in the form of Melville Naval Hospital which was constructed during the 1820s and stood opposite the dockyard main gate in Dock Road. In 1851, Burnett eventually retired from service, settling down in Chichester where he died on 16 February 1861 at the age of eighty-two.

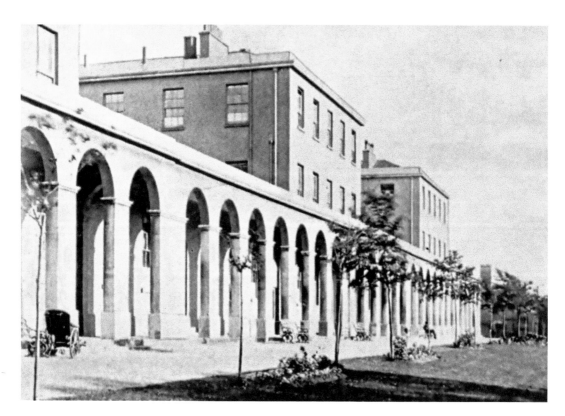

Melville Naval Hospital which was constructed during the 1820s, which had been built on the recommendation of Dr Burnett.

DID YOU KNOW THAT...?

Treatment of prisoners on board the hulks lying in the Medway was quite appalling, with those contracted to supply food and other items often providing underweight supplies in order to increase their own earnings. While each prisoner was allowed a 2-ounce block of soap each week, there was a period in 1796 where no soap was given to any prisoner for nine months.

Gambling on board the prison hulks was rife, with some who had wagered all their money resorting to the gambling of their clothes with continued losses leaving them completely naked.

To occupy their time and keeping them away from games of chance, a number of prisoners using wood and bone made detailed ship models that were sold to members of the public who visited the hulks.

3. The Chatham Chest

Established in the late sixteenth century, the Chatham Chest was a pension scheme intended for the perpetual relief of such mariners, shipwrights and seafaring men hurt or maimed while in government service. It was, in fact, one of the forerunners of the modern welfare state. Each seaman and shipwright paid in a small amount of money which, should he later sustain an injury, entitled him to a pension that was then paid out of the fund for the duration of his injury.

It was Sir John Hawkins, Treasurer of the Navy under Elizabeth I, who initiated the fund following the defeat of the Spanish Armada. Hawkins was shocked by the very poor treatment given to the seamen who had saved the nation from a Spanish invasion, as on their return to shore those who were sick or wounded were left to die in the streets. Lord Howard of Effingham, who commanded the Navy at that time, inspected the situation at Margate where matters were particularly bad:

> I am driven myself, of force, to come on land to see them bestowed in some lodging but the best I can get is only barns and outhouses and the relief is small that I can provide for them here [Margate]. It would grieve any man's heart so to see them that have served so valiantly to die so miserably.

Seamen and dockyard artisans supported by payments from the Chatham Chest collected their money by travelling to the dockyard at Chatham. This was for the purpose of proving their injury was still preventing them from working but, of course, was no easy task for many, especially in the case of a lost limb.

Hawkins hoped to eradicate such scenes by collecting the sum of 6*d* per month from each able seaman, from ordinary seamen 4*d* and from boys who were serving at sea 3*d*. All money, once collected, was then placed in a specially constructed timber chest that was held in the dockyard at Chatham – hence the name 'Chatham Chest'. At first the pension scheme seemed to work quite well. Supervised by Hawkins himself, money was regularly paid into the chest and a good number of men were subsequently given financial assistance.

However, on the death of Hawkins in 1595, matters changed dramatically, with the chest gaining an unenviable reputation for corruption and mismanagement, with those managing its affairs using it as a source of personal income.

Particularly corrupt in his handling of the affairs of the chest was Sir Robert Mansel who, on his appointment as Treasurer of the Navy by James I, freely took money out of the chest but failed to ensure that money was being paid in. An enquiry of 1608 concluded that money from the chest 'is lent by those who have no authority and borrowed by those who have no need'. Despite this uncompromising indictment, nothing was done to improve matters with a further enquiry in 1617 declaring,

> Great sums have been collected which should have been out into the chest . . . and not withstanding that a great part hath been charitably and orderly bestowed, yet many other sums of not small moment . . . have been lent out and still remain.

To help augment the money collected from seamen and shipwrights, a number of properties were also bestowed upon the chest, so that rent money could be collected. In all cases, these lands were situated in North Kent and in close proximity to Chatham and included Newlands Farm, St Mary's Hoo (given to the fund in 1632), Scocles Farm, Minister-in-Sheppey (1641), Macklands Farm Rainham (1647), Brook Marsh, Chatham (1636) and the Delce, Rochester (1660). However, embezzlement of chest funds continued,

At Chatham the chest was kept in the dockyard pay office and payments made from the money were held in the chest.

with Samuel Pepys in his diary referring to a further Treasurer of the Navy, Sir William Batten, also removing large sums of money.

A further problem associated with the fund was the method by which individuals were required to make claims. However badly injured, even if limbless, they had regularly to report to the commissioners of the chest, travelling to Chatham in order to prove their wounds were either uncured or incurable. This meant that seamen in an unusually poor state of health had to travel, some immense distances, to collect a pension that was theirs by right. Naturally, the most scandalous of frauds were attached to these journeys, many falling into the hands of unscrupulous innkeepers who kept a returning pensioner in a state of intoxication to gain the pension money for themselves. A further report on the Chatham Chest conducted in 1802 showed that of 5,205 pensions paid out, only 309 were paid to claimants in person – the others were seized by those who seamen referred to as 'land sharks'.

It was this enquiry of 1802 that finally brought much-needed change to the administration of the chest. Claimants, instead, of being forced to travel to Chatham were instead paid by the nearest customs and excise officers. Additionally, in an attempt to reduce mounting bureaucracy, the chest fund was moved to the naval hospital at Greenwich where it was administered as part of a more general fund. The chest itself, which had once been a permanent feature of Chatham, was also removed to Greenwich. Here, and for a short time, it continued to be used as a place for storing money until such an idea was completely abandoned, with the chest eventually falling into the hands of the National Maritime Museum, where it now rests but is no longer on permanent display.

As well as establishing the Chatham Chest to provide relief for sick and injured seamen, Sir John Hawkins set up a second charity for those employed in naval dockyards. This was the Hospice of Sir John Hawkins, which stands at the far west end of Chatham High Street. The present building dates from 1789.

4. The Gibraltar Riot and the Day the Clocks Stopped

A day once celebrated in Chatham by one section of society was 3 October. On that day in 1837, a demonstration organised by the leading radicals of the town hurled Chatham into the forefront of a major political campaign that had long been festering. Unusually, it had nothing to do with the dockyard or military, but was directed at the high-handed attitude of the Church of England which required all ratepayers, whether Anglicans or otherwise, to pay money for the upkeep of the parish church.

In Chatham this was an issue of great importance, for while there were two Anglican churches, the parish church of St Mary's and the additional church of St John's, there were no fewer than ten dissenting chapels with over 4,000 members. Almost certainly, this exceeded the numbers attending the two parish churches, with an even larger portion of the population only loosely connected (if at all) with either church or chapel.

It was the vestry, an administrative committee based around St Mary's parish church, and formed of parishioners who normally attended either this or St John's church, that

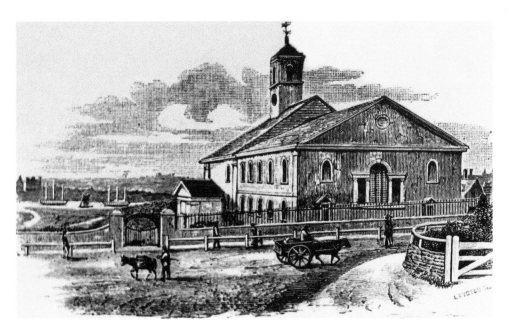

The parish church of St Mary's in Dock Road as it appeared at the time of the Gibraltar Riot. The building, no longer the parish church, now looks very different after being reconstructed in the mock-Gothic style. Supported at one time by a compulsory levee placed upon all rate payers irrespective of their religion, this sum was determined by a meeting of the vestry held in the meeting room of the church.

took the decision as to when and how much money should be raised to pay for the upkeep of the two buildings, with this money having to be provided by all ratepayers. Once the vestry had set the amount to be collected – known as the church rate – it was added to the general rate which was also used for the upkeep of the poor (as administered by the Board of Guardians) and the cleaning and lighting of the streets (Commissioners for Paving and Lighting). Levied in June (midsummer), October (Michaelmas) and January (Christmas), the set sum would be collected from the occupants of all chargeable properties, with only the poorest exempt.

It was not to the rates in general to which those with a grievance were addressing themselves, but only to the church rate, which was used by the elected wardens of the two churches for maintaining the fabric and paying the salaries of local church officials. The objection by those opposed to the church rate was partly based on principal but also on its unfairness in that it expected dissenters, namely Catholics and Jews, to support not only their own religious buildings but those of the established church of which they were not members. In 1836, at a public meeting in London, the Church Rate Abolition Society had been formed, with the dissenters in Chatham quickly establishing a local branch.

It would be interesting to know just who attended that demonstration on 3 October 1837 which some claimed to be a riot rather than a simple protest. While, of course, few if any would have been members of the local Anglican community, all would probably have been deeply religious. In addition, many would have had a strong dockyard connection, as it was among the artisans and labourers of the yard that religious nonconformity was particularly strong. However, those directly employed in the dockyard were unlikely to have been present in large numbers, the demonstration taking place in the morning when all but a few would have been at their workplace. Instead, it may well have included other family members of those employed in the yard. Of some though we do have a small amount of information, this relating to the ones, thirteen in number, who were summoned to appear before the local magistrates. Of those, one name stands out, that

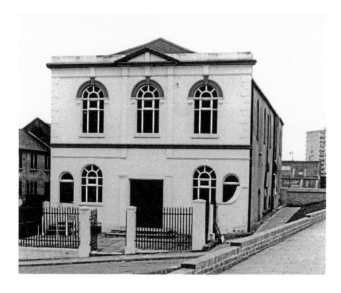

The Zionist Baptist chapel in Clover Street (now demolished) was one of many dissenting chapels in Chatham with over 1,000 people attending its Sunday services.

of Isaac John Dadd, a resident of Hamond Street and one of the leading abolitionists in the town. A messenger in the dockyard pay office, he was well connected in local radical circles, being related to Robert Dadd who, just a few years earlier, had spearheaded the local campaign to widen the franchise and which had resulted in the passing of the Great Reform Bill in 1832. Also summoned for their part in the demonstration was Samuel Dunstall, a dockyard shipwright living in Rhode Street, and Joseph Seaton, a cabinet-maker. In addition, two tailors, George Gray, who lived in the High Street, and Joseph Hopkins of Hamond Place, were also summoned. Finally, special mention should be made of John Tribe and Joseph Seaton, the licensees of the Mitre Hotel in the High Street, with John Tribe also holding the position of postmaster. The Mitre was the regular meeting place of all those who favoured the radical cause, including the abolitionists, with this establishment often referred to by those who were opposed to abolition as 'the Unitarian'. As well as those summoned, two others were mentioned in the *West Kent Guardian* as being present – a man named Semar, a fishmonger, and another unnamed but described as a butcher.

The presence at that demonstration of many who apparently came from Chatham's middle-rank society, as opposed to the wealthy, illustrates Chatham at that time being a deeply polarised society. The wealthy of the town, few of whom would have been chapel-goers, not only had this clear difference of religion but also lived in a distinct and separate part of town. Those who could afford it lived in those large and impressive houses that still line New Road, with Gibraltar Place the most sought after of those residences. In addition, this upper echelon of Chatham society voted differently, favouring the Tory party.

These houses in New Road were residences much sought after in the early nineteenth century by those of wealth and influence in the town.

As for Chatham's middle-rank society, they, in common with those who had been summoned, mostly inhabited houses along the High Street and the numerous roads running to the north and south. They were the ones who, as a result of the Great Reform Act of 1832, had recently gained the vote and used it to elect Chatham's Liberal Member of Parliament. However, there was also a third social group: those who were without employment or any form of regular income. Living on the breadline, or just above, their place of residence was chiefly in the area known as the Brook. This was a zone that all others would wish to avoid, the Brook at that time being nothing less than the town sewer. As to how they voted, this was quite simply a ridiculous question. Those at this end of society, along with women, didn't have the vote and therefore had little chance of changing the circumstances under which they were forced to live. For this reason, and the fact of the church rate not being levied upon them, it seems unlikely that they would have been present among those demonstrating.

Opposition to the church rate in Chatham had been festering for a number of years and it is this that had led so quickly to the formation of a local branch of the Church Rate Abolition Society. Rapidly energising the local population of dissenters, it encouraged as many as possible to refuse payment of the church rate. In doing so, however, the law laid down that property belonging to those who did not pay could be forcibly seized, or 'distrained', and auctioned to pay the required sum. It was around the auction of such property, including items distrained from the home of Isaac Dadd, that the October demonstration was organised.

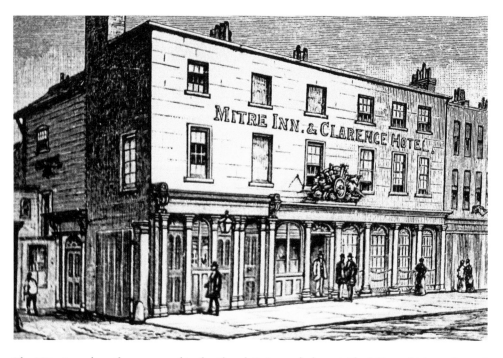

The Mitre Inn where those opposed to the Church Rate regularly met. The Mitre, which was located on the eastern section of the High Street, closed in 1935 and the building was soon demolished.

The auction itself was to take place outside the Gibraltar Tavern in New Road and was to encourage a large turnout of those opposed to the church rate to show their anger; the previous week had seen the town covered in posters. On the morning of the auction men were also engaged in carrying boards up and down the High Street, proclaiming 'Robbery, stolen goods will be sold at the Gibraltar at 11 o'clock.' Even the town crier was brought into the act, employed to read out a handbill that stated, in no uncertain terms, 'The State Church. Stolen property to be sold by auction, by H. Smith, on Tuesday October 3, 1837, at 11 o'clock, near the Gibraltar Tavern, Chatham, under the theft for church-rates.'

As for those who might be tempted to bid for the seized items of property, they had been warned in speeches previously made by some of the town's leading abolitionists that they would be 'marked men'. Even more threateningly, they were informed that the 'finger of scorn' would be pointing towards them and that their names would be 'posted on every pillar and post' throughout the town.

Not surprisingly, a large crowd had already assembled outside the Gibraltar Tavern sometime before the auction was due to begin, the number eventually amounting to around 500. They were there to prevent the auctioneer and others from entering the building and starting the sale. In this they were to prove successful, with Henry Smith (an auctioneer from Maidstone who had been engaged to undertake the sale), Mr Tipping (a Sheriff's officer, who had seized most of the property to be auctioned) and with two church wardens all failing to get through. In being violently jostled, Smith later stated in court that he thought he would be murdered if he had attempted to begin the auction. As for Tipping, he declared that he had never seen a more disgraceful riot and was apparently much bruised following several blows that included a violent one to the head. Not to be outdone, the two church wardens also claimed that they had feared for their lives, with one of them quickly hightailing it to Chatham Barracks where he hoped to get military support.

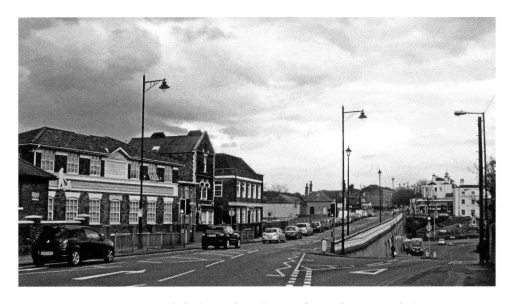

It was here, the Gibraltar area of Chatham, where the riot of 3 October 1837 took place.

With the auction abandoned, the thirteen considered to have organised and led the demonstration, which became known as the 'Gibraltar Riot', appeared before the local magistrate where they were ordered to appear at the county assize court at Maidstone to meet in August of the following year. Here a decidedly lenient attitude was taken, with all thirteen released on recognisance of £100 and a promise they would keep the peace. However, they were all warned that if they organised any similar action to prevent the law taking its due course, anyone so doing would be called up to receive judgement by the superior court of the Queen's Bench.

While the church rate abolitionists on that occasion in October 1837 had made their point, they had certainly not gained a victory. The situation in Chatham was unchanged, with the vestry still in a position to collect money from all ratepayers, irrespective of their religion, for the purpose of supporting the churches of St Mary and St John. Having failed therefore to bring an end to the local church rate through direct action, the abolitionists were now determined on a very different approach. As residents of Chatham, they had every right to join and influence decisions of the vestry when any vote was taken. Given, also, that the non-Anglicans in Chatham outnumbered those who regularly attended the two parish churches, then all they had to do was make an appearance at vestry meetings and vote against the imposition of a church rate.

Using this new tack, the abolitionists gained their first victory just seven months after the assize court had given its judgement, a proposal made during a vestry meeting at St Mary's for a church rate of 4d in the pound refused by the majority in attendance. Furthermore, this continued over the following years, with large numbers gathering in the meeting room of St Mary's church to oppose the setting of a church rate. In 1842, when voting numbers were handed to one of the local papers, the majority against was as high as 150. It was a situation that clearly did not please the owners of one local newspaper, the *Maidstone Journal and Kentish Advertiser*, printing this attack upon the abolitionists following the first of those victories within the meeting room of St Mary's:

> Unhappily the efforts of the agitators were but too successful and the rate defeated. In thus acting the radicals are, in our opinion, playing a most treacherous and disgraceful part, and are shamefully abusing the privilege given to the vestry – not to refuse the rate – but merely to determine its necessity and amount.

Referring to the abolitionists as nothing less than malevolent, it threw out one desperate plea:

> Thank God we have an established Church and we trust means will be found to compel the contumacious radicals at Chatham and everywhere else their trifling quota to its support.

As for the supporters of the Established church, following their failure to raise the church rate in the summer of 1842, the church wardens decided to take revenge through the stopping of the clocks on the two church towers. In so doing, they knew that it would be a decided inconvenience to the artificers of the dockyard, mostly chapel-goers, who relied

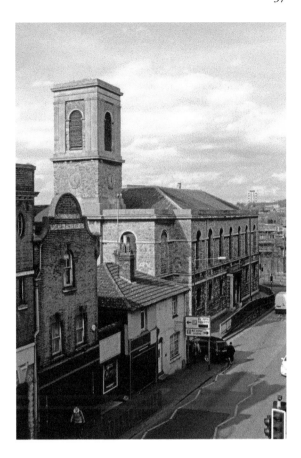

As well as supporting the parish church of St Mary's, the church rate in Chatham also provided finances for St John's church in Railway Street (formerly Rome Lane). The clock on the tower of both churches were deliberately stopped by the wardens as an act of revenge again the nonconformists of the parish.

upon the chimes to ensure they got to the yard gate before the muster was called. If they arrived late they were prevented from entry and lost their wage for at least half a day.

With attitudes nationally hardening against the church rate and many other town and city parishes also finding that, through the attendance of a large number of abolitionists, they too were unable to set a church rate, the government finally stepped in and took action. However, this was not until 1868 and the passing of the Compulsory Church Rates Abolition Act that allowed any person unwilling to pay the rate when levied by the vestry as exempt from payment. At the same time, any person so making themselves exempt would be excluded from inquiring into, objecting to, or voting in respect of the expenditure of the church rate.

As for those who had first campaigned in Chatham against a compulsory church rate they chose to celebrate the day their campaign really began to bite, the day of the Gibraltar Riot. On 3 October each year, and at the Mitre Hotel, a great fest was held and Jon Tribe led the proceedings through providing huge haunches of meat. Doubtless it was a very convivial occasion, but for how many years it continued is unknown. Given that the 180th anniversary of that same event is on the horizon, maybe just such a re-enactment of those original celebrations (but not the riot) might be added to one of the numerous special events already organised by Medway Council.

The gardens adjacent to the Town Hall were once the town cemetery. The old gravestones that now line the wall include, in this group pictured, the stones that stood at the head of those who were present at the Gibraltar riot, along with Isaac John Dadd and Samuel Dunstall.

On Hamond Hill, where an earlier nonconformist chapel was once located, the graveyard claims another of the organisers of the Gibraltar protest, John Tribe, one if the licensees of the Mitre Hotel in the High Street and who helped organise the commemorative feasts in the years that followed.

DID YOU KNOW THAT…?

Robert Dadd, a leading radical in Chatham at the time of the Great Reform Act of 1832 was murdered by Richard, his now world-famous artist son.

A leading Chartist, William Cuffay, was born in Chatham. He was the son of a former black slave, Chatham Cuffay, who had been brought to England by the Royal Navy and was employed on board the dockyard commissioner's yacht that also bore the name 'Chatham'.

Chatham was one of the first constituencies in the country to elect a Labour MP.

5. Possibly the Greatest Show on Earth

Chatham Lines, the extensive fortifications that were designed to defend the naval dockyard against a landward attack, was constructed during the eighteenth century. Originally consisting of a series of bastions and ditches, the Lines ran from just east of the gun wharf and out to enclose Brompton before returning to the river where the defences terminated at a point north-west of the dockyard. Towards the end of the century, the Lines were strengthened at both the north and south ends through construction of redoubts, with the one to the south, following further improvements and additions, taking on the name Fort Amherst.

 In never being called upon to fire a shot in anger, and entering into long periods of peace following the ending of the Napoleonic Wars in 1815, the line of defences took on an interesting if somewhat unintended role of providing the general public with a lavish form of entertainment. Found useful by the military as a training ground, practice sieges and other military operations were frequently conducted. In some years, these involved thousands of troops and an incredible amount of explosives and other warlike materials. The public were increasingly drawn to these, especially when such training exercises were carried out during the summer. While no special arrangements were necessarily made for the ordinary punter, and certainly there was never an entrance fee, those of a particular standing, the aristocracy and their friends, were provided with seating inside Fort Amherst or one of the protected bastions, depending on which offered the best view of the day's planned events.

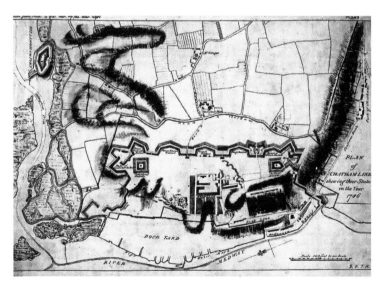

The Chatham defensive lines were completed by 1786 and by the early nineteenth century were regularly used as a military training ground. Large crowds were often in attendance to watch the various manoeuvres and accompanying explosions.

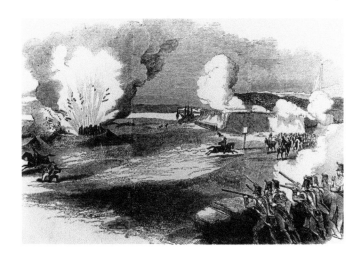

This is what brought the huge crowds to Chatham. What could be more exciting?

While this fantastic spectacle appears to have reached a peak during the middle years of Queen Victoria's reign, the attendance of the public goes back to at least the 1820s, a fact confirmed by George Calladine, a pay sergeant in the 19th Regiment of Foot, who kept a diary of his period in military service. It was in November of that year that this particular exercise took place and took the form of an attack on St Mary's Battery, which stood on the south side of the lines overlooking St Mary's Island. On that occasion, the battery was held by both veteran battalions and the East India Company while the Marines and the 19th Foot attempted to capture the battery by means of storming it. According to Calladine,

> Everything was managed in very good order, though I cannot say but many of our recruits thought it rather warm work when ascending the scaling ladders in front of the cannon's mouth . . . the Marines were close on our heels and in a short time we had possession of the works.

Among the dignitaries viewing the military exercise on this occasion was the future William IV, who at that time held the title Duke of Clarence. Earlier he had reviewed the Royal Marines at their barracks in Chatham before proceeding to a viewing stand erected within the grounds of Fort Amherst. As for the public in general, Calladine noted:

> There were also a good number of respectable people on the ground, who appeared much pleased with the afternoon's manoeuvres.

This however does not represent the first use of the Chatham Lines by the army for training soldiers in conducting siege operations; a report of an exercise carried out on 28 September 1759 appeared in a number of newspapers including the *Newcastle Courant*, and from which the following account is taken:

> Yesterday [28 September] the three regiments encamped at Brompton, viz. General Bockland's, Lord Robert Manner's, and Lord Loudon's were reviewed by Lord Ligonier

accompanied by Generals Campbell, Conway and Lord Effingham and many other officers &c. After the review a mock fight was acted when the works were assaulted and the besiegers made advances as far as the glacis but were at length (by terrible fire from the ramparts) obliged to retreat and the garrison by sallying out took their cannon and drove them into the woods and hedges but like generous English soldiers gave every man quarter so that there was no loss on either side.

While it is quite likely that, at the very least, a few members of the public and invited dignitaries were viewing this exercise, no mention of this is made in any of the contemporary newspaper accounts.

Acting as a very definite advert to the doings of the military on the Chatham Lines was the fact that Charles Dickens included a description of one such military exercise that was supposed to have taken place in 1826. This appears in *The Pickwick Papers*, first serialised between 1836 and 1837, in which Mr Pickwick and his party arrive in the Medway towns and decide to join the huge crowd that had walked onto the Lines to view one such military exercise. Although Mr Pickwick accidentally ends up in the firing line of soldiers, fortunately firing blank cartridges, there does appear to have been an area to which the general public were directed and soldiers ordered to keep them within a very definite crowd line. Dickens, who was of course a one-time resident of Chatham, provides this very comical account:

> Mr Pickwick and his three companions stationed themselves in the front rank of the crowd, and patiently awaited the commencement of the proceedings. The throng was increasing every moment; and the efforts they were compelled to make, to retain the position they had gained, sufficiently occupied their attention during the two hours that ensued. At one time there was a sudden pressure from behind; and then Mr Pickwick had jerked forward for several yards, with a degree of speed and elasticity highly inconsistent with the general gravity of his demeanour; at another moment there was a request to 'keep back' from the front, and then the butt end of a musket was either

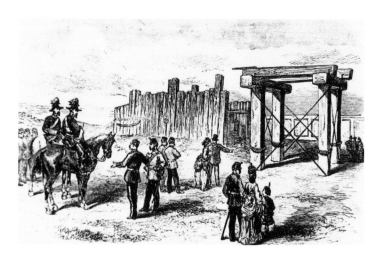

A temporary defence structure erected on the Chatham Lines being inspected by invited guests.

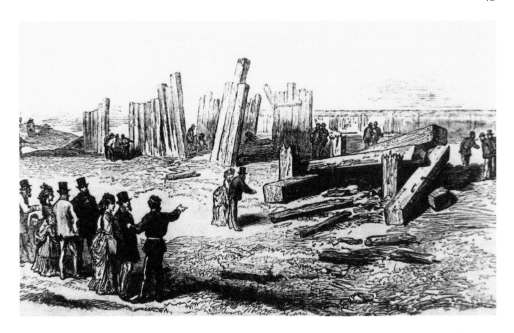

Above: The same structure after its demolition by a massive explosion.

Right: One of the explosions that thrilled hundreds of spectators.

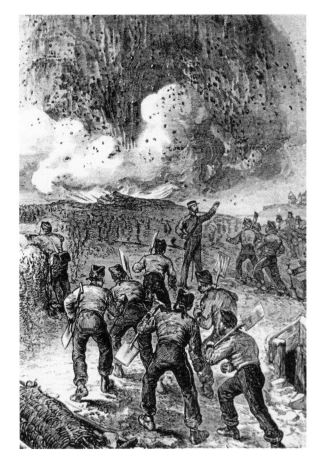

dropped upon Mr Pickwick's toe, to remind him of the demand, or thrust into his chest, to ensure it being complied with.

By 1849, and possibly as a result of the publication of *The Pickwick Papers*, the military manoeuvres at Chatham had become so popular that special trains were even put on by the South-Eastern Railway. These ran first to Tilbury, from where passengers were then brought directly to the edge of the Lines by paddle steamer along the Medway. In a report that appeared in the *Kentish Gazette* of 24 July 1849, the number of spectators coming to Chatham was estimated to be in excess of 60,000:

> The desire to see what a siege really was like acted as one of the most powerful means in drawing together the immense number of persons who, on Saturday, witnessed the operations at Chatham. Amongst them were many military men who appeared to take a lively interest in the details of the day's proceedings. The whole were scattered over the lines, occupying, as far as they might be permitted to do so, all the prominent positions whence a commanding view might be obtained, and presenting a singular appearance of confidence amidst a scene the sights and sounds of which were anything but reassuring on the point of personal safety. Thus diffused over a wide space the effect of numbers congregated on one particular spot was not produced; but they could not have amounted to less than from 60,000 to 70,000. Rochester and Chatham are considerable towns, and their population of course turned out to witness the spectacle. The inhabitants of the surrounding country were also present, and the resources of the railway and the river steamers proved quite unequal to the transit of the extraordinary numbers coming down from London. As might have been expected under such circumstances, the price of beds and fly hire rose to an unparalleled height.

For the siege operations of 1854, Prince Albert was among those who attended, brought to Chatham from London by special train. On disembarking at Chatham station, he received

A later re-enactment of a mock siege of the Chatham Lines, designed to entertain a much later audience.

a salute from the artillery while a large crowd waiting to see him loudly cheered. On this occasion, the *Illustrated London News*, fully reporting the events of the day, added a number of engravings that were guaranteed to provide an even greater attendance when the siege operations were undertaken in future years:

> The 35th Regiment, which had previously taken up a position with scaling ladders, advanced, on the word of command, and carried the right face of Prince Henry's Bastion by escalade, and established themselves within the lines. A column of Royal Marines advanced upon the 35th from Fort Amherst, and they resisted the attack, but were ultimately driven out of the fortress and, during the retreat, a smart fire was opened upon them from the King's Bastion by the large guns. The opponents continued firing for some time, the 35th lying on the ground after returning to their original position.

The finale, something never to be missed, was even more exciting on that occasion:

> The defence of ditches of a fortified place against an assault by rockets, forgasses, hand-grenades, live shells, musketry, and pierriers, was the last operation, followed by the mode of throwing a body of troops with artillery across a river, upon rafts of cylindrical and india-rubber pontoons. The proximity of the river Medway rendered this experiment, peculiarly interesting. The use of the helmet and diving dress was also exhibited.

In 1860, and according to a report that appeared in September of that year, the siege operations were no less exciting:

> Some highly interesting siege operations were carried out at this garrison during Tuesday and Wednesday, in order to make some further trials with the voltaic battery with which the charges of gunpowder used in blowing up the large cliff at Cuxton were fired, and which for long time failed to ignite the charges. The operations carried out consisted in

Military exercises were not restricted to the Chatham Lines. Here, Royal Engineers practise the art of river crossing through the construction of a pontoon bridge that stretches away from the dockyard.

blowing up a large two-gun battery, the powder being, as before, fired by one of Graves's voltaic batteries. The battery to be destroyed had been thrown up on the field-works at the rear of Brompton Barracks. The necessary mines having been excavated, upwards of 60 lbs. of gunpowder, contained in 10 charges, each of 6 lbs., was deposited in the chambers, and this having been accomplished, they were ignited by means of the voltaic battery. The effect of the explosions was exceedingly grand, the earth being thrown a great height into the air, and falling in a shapeless mass formed a mound where the two-gun battery formerly stood. The experiments were deemed highly successful.

Improvements in weaponry and the fact that fortifications in the grand style of the Chatham Lines had become obsolete eventually led to grand military exercises on the Lines being phased out. This did not mean that the military did not continue to use the Lines for training purposes, just that any military exercises being conducted were just somewhat less spectacular and would cease to draw public interest.

Temporary tented accommodation on the Lines for a military exercise conducted shortly before the First World War.

During the Second World War, the Home Guard also made use of the Chatham Lines for battle practice.

DID YOU KNOW THAT...?

Prior to being taken over by the military, the area of the Great Lines had seen a variety of uses, including the setting up of a cricket pitch and its use as a track for horse racing.

When the Great Lines were constructed during the eighteenth century, a number of intriguing discoveries were made including the remains of what was probably a mammoth that had walked the future area of Chatham over 10,000 years ago. Under Fort Amherst are still the partial remains of a Roman villa.

Land for construction of the Great Lines was first acquired through Acts of Parliament dating to 1708 and 1709, but construction work did not begin until the 1750s. In the interim, much of the land continued to be used for sheep grazing.

During the Second World War, the Great Lines were again used for military training, with the Home Guard making use of the area at that time.

The tradition of the military putting on huge spectacular events that drew the public in large numbers to Chatham continued into the twentieth century, but not through siege operations on the Lines. Instead, both the Royal Marines and Royal Navy stepped in with a series of spectacular events held at their respective barracks. Most impressive of all, however, was Navy Week at the dockyard and which, after the Second World War, became Navy Days.

During the early twentieth century, the many soldiers and sailors barracked at Chatham still made efforts to entertain the public. Here, Royal Marines, photographed in the 1920s, are seen performing a historic pageant that showed different military dress over time.

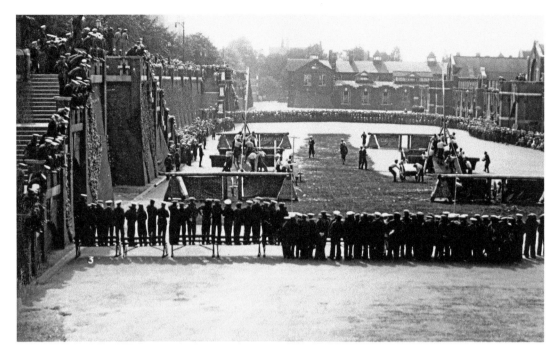

A popular crowd-puller to the Royal Naval barracks was the field gun display. Here, two teams are in competition to see which group would be the fastest to carry a field gun and its equipment over a series of obstacles. On this occasion, the audience are sailors from the barracks.

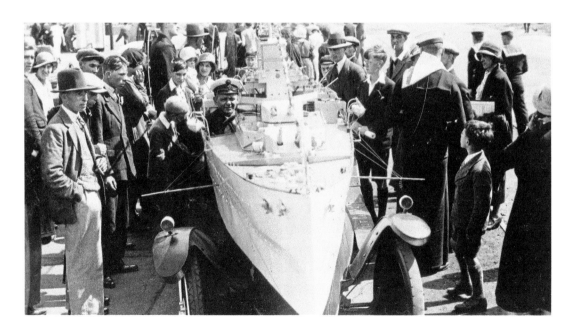

The Navy also showed what it could do during the interwar years. Navy Week was a spectacular event that drew thousands into Chatham dockyard. One way of advertising the event was the driving of this motorised model of HMS *Kent* around the Medway area and beyond.

NAVY DAYS
CHATHAM

2nd, 3rd & 4th
AUGUST 1952

PROGRAMME · ONE SHILLING & SIXPENCE
PLAN AND THE TIME-TABLE OF EVENTS ON CENTRE PAGES

6. The Chatham Disaster

On Sunday 26 July 1885 Chatham witnessed a potential tragedy that could have ended in the loss of a great many lives. From Sun Pier, just off Medway Street, a large number of festive holidaymakers were plunged into the Medway when an extension to the pier, which was being used to allow boarding of a pleasure steamer, gave way under the weight of the larger than usual numbers that had been brought out by the fine sunny weather. At the time, it was feared that several had been drowned, but miraculously all survived, although some sustained considerable injuries.

It was not so much the pier that was at fault, but a temporary structure that had been added to the end of the pier to allow its continued use during a period of general improvement. The Board of Health, which operated the pier, had decided to replace the older pier and had to put up what was, in effect, a temporary walkway. This extended some 80 feet into the river where a barge was moored to provide both further support and an easy means of boarding the regular river steamers that called into Chatham. Eventually the temporary walkway was going to be replaced by a proper landing stage but this part of the work had not been started.

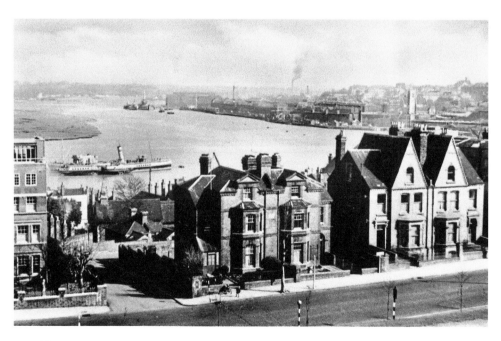

A paddle steamer moored in the Medway, not far from Sun Pier, in this mid-twentieth-century view of the river seen from above New Road.

These pleasure boats mainly traded between Southend, Upnor and Sheerness, and on that Sunday afternoon some 100 or more had assembled on the pier, with many of them forming a queue on the walkway itself. Jollity prevailed, with the cares of work forgotten as husbands, wives and children looked forward to a few hours away from the hot and sticky crowded streets of Chatham, where temperatures on that day had hit the 80°F (27°C) mark. Those bound for Upnor had been requested to wait while the steamers for Sheerness and Southend took on their passengers and it was this that probably caused the accident. Many more people were standing on the temporary walkway than it could possibly support, but at the time nobody realised the potential danger. The walkway began to rock from side to side in protest, a warning that was simply ignored. Instead, and in keeping with it being a festive occasion, those on the walkway and nearby simply laughed, even calling out the playground chant of 'See Saw Margery Daw', not caring that the rocking motion was becoming more violent.

As the side-to-side lurches became more extreme, those nearest to the head of the old pier, which remained steady, began to struggle back. But such attempts proved futile as it was almost at this same moment that the walkway collapsed, its iron supports twisting and crumpling, throwing all who were standing on it into the Medway some 15 feet below. Included were babies in arms and women in heavy clinging skirts. All were in great danger as the depth of the river was in excess of 8 feet.

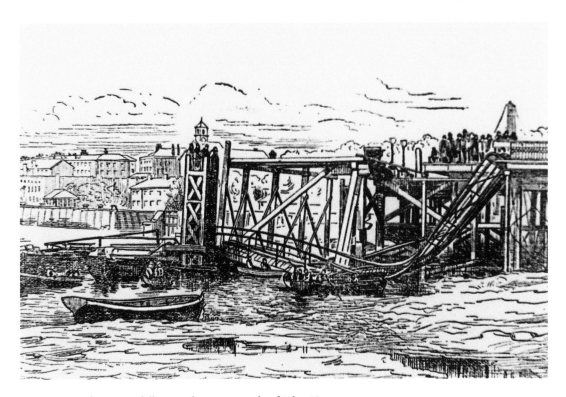

A view of Sun Pier following the near tragedy of July 1885.

Some, in being tossed from the walkway, fell onto the wooden piles and sustained fractures and considerable bruising. As to those who fell into the Medway, they were helped by it being exceptionally calm and most were able to remain afloat, and grabbed on to passing debris or the sides of the collapsed gangway. Others who could swim moved further out and were rescued by small boats. Remarked upon by a number of newspapers were the special efforts of the piermaster, named as Whitfield, and two local boatmen, Adams and Moore, who were among the first to set out to rescue the most precariously positioned, carefully threading their boats in between the jagged and twisted wooden supports that had once held the walkway in position.

Only on the following day was it realised that not a single life had been lost; the river had been dragged for a number of hours by boatmen with grappling irons and assisted by divers, the expectation being that a number of bodies would be found.

The accident had been a direct result of the temporary gangway; the pier itself was not at fault and rebuilding work was allowed to continue the next day. Eventually the work was completed in 1886, and a permanently fixed landing stage was brought into operation. Both this and the rest of Sun Pier still remain near Medway Street and provide some of the best possible views of Chatham and the more distant dockyard. To one side of the pier can also be seen the much safer gangway, which was erected after the accident.

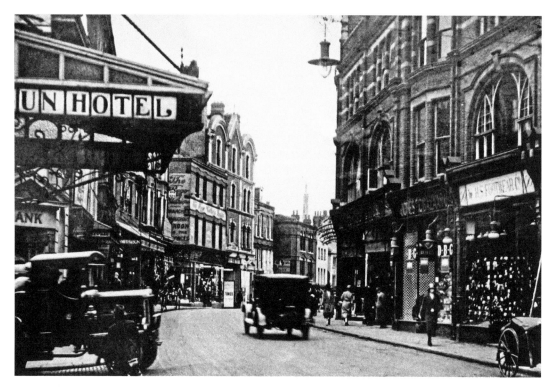

The Sun Hotel, which for many years stood on the corner of the High Street and Medway Street. It was here that those thrown into the Medway, as a result of the collapsed pier, were first brought with the severely injured later taken to St Bartholomew's Hospital.

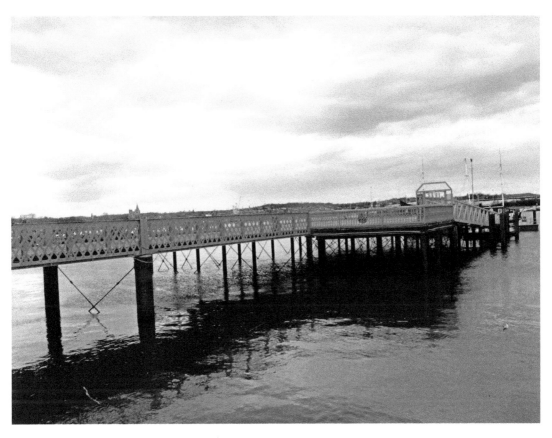

A more recent view of Sun Pier.

It is an interesting device that rises and falls with the tide. If this had been completed by the summer of 1885, the accident would never have occurred.

DID YOU KNOW THAT...?

Before the arrival of the railways, boats on the River Medway were, for the less affluent, a favoured means of transport. To meet this demand, the Medway Steam Packet Co. had been formed in 1837, linking Chatham with Sheerness.

River trips to Southend were also once very popular, with several paddle steamers at one time or another plying the River Medway.

The last regular paddle steamer service on the Medway was offered by the *Medway Queen* until taken out of service in September 1963. She is now under restoration by an enthusiastic group of volunteers who are currently fitting her out at a berth alongside Gillingham Pier.

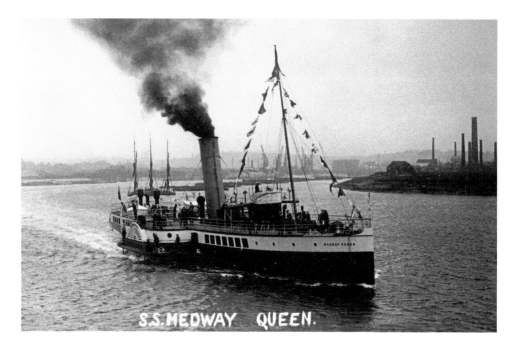

Above: The *Medway Queen* regularly collected passengers from Sun Pier during her time as a pleasure steamer on the Medway that began in the 1920s and ended in 1963.

Left: Progress on restoring the *Medway Queen* began many years ago and currently she is seaworthy but lacks any form of motive power; the Preservation Society hope that one day it might be possible to fit a boiler and other machinery. The efforts made by the Medway Queen Preservation Society can be well appreciated when the former state of the *Medway Queen* is seen from this photograph, taken when she was once berthed alongside the dockyard.

7. Drunken Revelry

Chatham, throughout much of the its existence, was at the heart of a huge military-industrial complex that heavily influenced its development. The extensive surrounding fortifications, the naval dockyard and adjoining ordnance wharf, together with numerous barracks, were all part of this complex, impacting not only on the layout and architecture of the town but upon everyday life. Even for civilians and those not otherwise employed by the government, the military brought huge advantages, especially during periods of war. Employment at such times was abnormally high, with merchants also finding an abundance of work, be it tailors who made officers' uniforms, slop sellers who sold rough working clothes or moneylenders of the payday loan variety.

With its many military establishments, including the Royal Marine barracks that once stood in Dock Road, as depicted here in the early twentieth century, Chatham often saw bouts of street violence when the many young recruits visited the numerous pubs in the High Street area, and had a little too much drink.

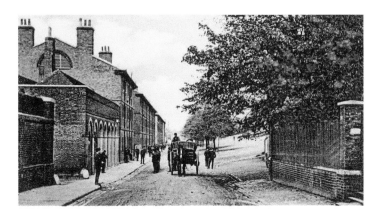

A nineteenth-century view of the Marine Barracks at Chatham.

DID YOU KNOW THAT...?

The most popular names for public houses in Chatham during the early nineteenth century was Red Lion, of which there were three, while the King's Head and the Ship came in a close second.

A pub with an unsavoury reputation during the early twentieth century was the United Services in the High Street. Given that fights often erupted here between different branches of the armed services, 'United Services' may not have been a fitting name.

But there was a downside to all this. Chatham was a hard and mean place to live, with violence a not infrequent occurrence. The cause, as much as anything, was the large number of taverns and public houses that were to be found on every street corner, with a local directory of 1839 listing more than seventy that were either close by the dockyard of located in the centre of town. To this should also be added various unnamed drinking dens and gin shops for which the town was renowned. Not surprisingly, drunkenness was rife, especially among the young recruits billeted in the barracks and who had little else to entertain them once they were off-duty. A letter published in the *Chatham News* in August 1866, gives this view of life in Chatham at that time:

In the streets filthy vile language is constantly heard from the lips of prostitutes who teem at every corner of our streets so that decent people cannot walk therein without insult to eyes and ears; and why the military authorities allow drunken worthless soldiers out all night, to the annoyance of the inhabitants; and why our police permit such drunken rioting with men and women during the night and far into the morning.

Admittedly there were attempts to police the town, but they lacked strength, efficiency and regularity. A small county force undertook most of Chatham's policing duties but could be easily overwhelmed when large numbers of soldiers or seamen were on a drunken rampage. In theory, however, the county force were also supported by military and naval pickets who were supposed to patrol the town, but their numbers varied and depended very much on the mood of a local garrison commander or the naval commander-in-chief. In addition, the dockyard also had its own police force and in dire emergencies might also be sent into the town to apprehend serious offenders.

It was when a new regiment or naval warship had either returned from overseas service or was about to depart on extended service abroad that trouble was most likely. On such occasions, entire groups would descend on the town intent upon enjoying themselves irrespective of the pain it might cause to others. One especially serious incident was reported by the *Chatham Observer* in October 1882, when a number of seamen serving on *Constance* and *Linnet* marched into the town the evening before these two ships were to sail for the Far East. Being a Sunday, and around 8.00 p.m., the streets were already fairly

busy as large numbers were making their way home from church or chapel where they had been attending services. One might, perhaps, have thought that the seamen out on the town might have accorded them a little respect, but as forty of them marched from Military Road and along the High Street they simply pushed the homeward bound church attenders out of the way. The newspaper report further adds that in marching in haste to the first of the taverns at which the seamen were intending to stop they were followed by 'a crowd of roughs who seemed highly delighted with the proceedings'.

Several public houses were visited and in some of these the men, on being served, refused to pay. Upon reaching their last watering hole, the Cross Keys at the eastern end of the High Street, they 'liquored-up' before returning down the street, their number now having greatly increased. Generally behaving in an offensive manner, they were met by a large crowd as they reached Military Road. Men of the county police intended to take action but were hopelessly outnumbered, even with the support of a small number of military pickets from one of the barracks. Normally, military pickets could not touch seamen, even when misbehaving, but the Navy had made no attempt to send their own pickets into the town that evening. With fists flying, and 'the crowd of roughs' supporting the sailors, it was the men of *Constance* and *Linnet* who got the best of the encounter.

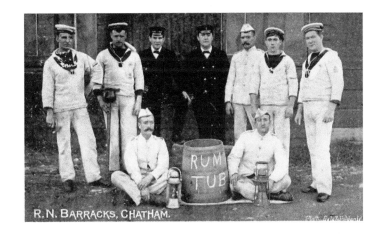

The Navy had a strong tradition of providing alcohol to those who served.

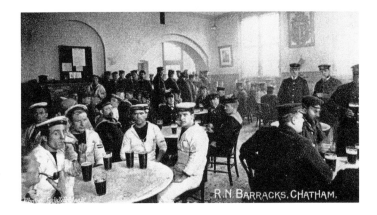

The petty officers' mess, Chatham barracks, c. 1906.

The police house by the dockyard gate. First occupied during the 1860s, it was from here that off-duty officers were occasionally brought into Chatham to deal with the occasional drink-fuelled riot.

Fearing that the situation, which was already out of hand, could get appreciably worse, a messenger was sent to the dockyard urging that a detachment of the dockyard police (at that time a division of the Metropolitan Police) be sent into the town while a second messenger was sent to Chatham barracks for more pickets to be sent out.

In all, the dockyard police were able to assemble their reserve force of thirty-five constables, with additional pickets soon joining them, and they all arrived in the town within forty minutes. By then the sailors were over 100 strong and at the Brook end of Military Road where they were in the process of taking possession of a public house. However, with the forces of law and order suitably reinforced, an onslaught was made on the rioters, with blows 'freely exchanged'. Some ten were arrested and returned to their ships for punishment while the others were forced to scatter in all directions, with the dockyard police remaining on duty until nearly midnight.

To be fair, such drunken riots, and they were fairly frequent, were not always generated by those serving in the Army or Navy. Only a year earlier, in November 1881, a riot that started in the High Street close by Holborn Lane was very much a civilian affair. On that occasion, a crowd attempted to release one of those who had been arrested by two police officers. The man arrested, Robert Merritt, a coal whipper employed at the dockside to raise coal from the hold of ships, had been accused of assaulting 'a respectable looking woman', with the mob shouting for a 'rescue'. Despite a brief scuffle, in which one of the two police officers was pushed to the ground and hit several times, they still managed to get Merritt to the police station which was then in New Road. However, the would-be rescuers had followed on behind and on reaching the police station placed it under siege, hurling a number of stones at the building.

A glimpse of Chatham during the early nineteenth century is given by George Calladine, a private in the 19th Foot, who was ordered to the barracks in the early part of 1820. This occurred upon the return of his regiment from Ceylon (now Sri Lanka), the troopship having disembarked at Gravesend. Following a nine-mile march, Calladine and his fellow

The White Lion, on the corner of the High Street and the Brook, was a traditionally styled Chatham pub that was once a favourite of the soldiers in Chatham wishing to get away from military regimentation.

Midway along the High Street was a venue named the United Services pub, popular with servicemen, especially those serving in the Royal Marines. The notice, proclaiming the 'Long Bar' of the United Services, can be seen just by the lamp post and the patrolling policeman. Residents during the early twentieth century might be forgiven for giving this particular pub a wide berth; it was often the scene of inter-service rivalry fights.

60

Exterior of Long Bar, High Street, Chatham.

A closer view of the United Services pub in the High Street, as depicted in a postcard from the late Victorian era.

No longer a pub, the Prince of Orange was once popular with servicemen and theatregoers. Nowadays, despite the easy visibility of its name, the building serves as a restaurant located in the west end of the High Street.

The Little Crown in the High Street's east end is another public house from the Victorian era, this one having survived the extensive pruning of Chatham's one-time abundance of taverns and inns.

soldiers were told when they arrived at Chatham barracks that it was too late for them to be found bedding, and that they were to find billets in town. Calladine relates:

> The men who were billeted with me were soon paired with female companions, as for myself I took the safest way, for, after getting some refreshment, I gave the landlady all my money and what other articles I had about me of any value, and then returned to rest.

Remaining at Chatham until June of that same year, Calladine gained a very poor impression of the place and was much relieved when his regiment was ordered to Winchester. Again, in his own words:

> I soon found Chatham was a bad place for a young single man. Too many temptations and enticements, that if you were inclined to keep yourself out of bad company it was a difficult matter to get into good company in such a place as Chatham.

To help ease some of the problems, attempts were made during the nineteenth century to provide young new recruits with pastimes other than drink and fornication, to which many of them were driven during their off-duty hours. In 1861 the 'Soldiers Institute and Garrison Club' had been erected on the boundary of Chatham barracks, with other military clubs and institutions following later in the century. Among these were the Welcome Sailors' and Soldier's Home in Military Road, the Navy House in Clover Street, the Army and Navy Home in the Brook, and the Royal Sailor's Home in Upper Barrier Road. These were usually run by various religious groups such as the Church of England and the Salvation Army, although some of the institutions established in Chatham were non-denominational or free of religion altogether.

Although the growth in the number of these institutions did help reduce the problem, it was far from a solution, with street rowdiness generated by too much alcohol remaining a difficulty that continued well into the following century. In 1904 the Chatham magistrates entered into discussion with some of the local breweries in an attempt to reduce the

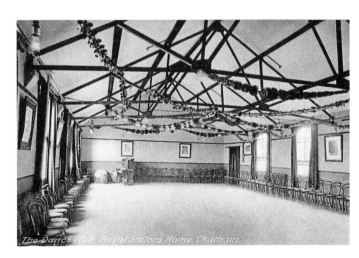

To provide young new military recruits with alternative entertainment to drink and fornication, several charities and religious institutions established places of entertainment that did not feature alcohol. Among them was the Royal Sailors' Home in Upper Barrier Road.

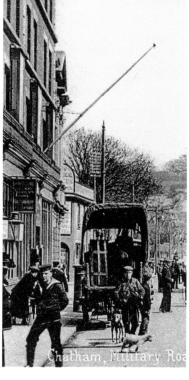

The Welcome Sailors' and Soldiers' Home in Military Road also offered alternative places for those serving in Chatham within the same building, now part of a fashion outlet.

In this photograph, a sailor stands immediately outside the Welcome Sailors' and Soldiers' Home.

number of public houses in the town, but nothing came of this. Indeed, the magistrates appear to have got very little help from those actually selling alcohol. Some publicans went out of their way to flaunt the licensing laws that since 1872 required all pubs to cease selling alcohol from 11.00 p.m. onwards, with selling hours even more restricted on Sundays. In one spectacular case brought before the Chatham magistrates in 1901, a publican was found to be circumventing the law by placing out of the back window of his pub on Sunday mornings, well before the permitted opening time, a long-stemmed funnel that allowed beer to flow into the jugs and bottles of his customers without them being on the actual premises. Although the licensee claimed it as legal, he was nevertheless fined £3 12s 6d.

The outbreak of war in 1914, which brought large numbers of new recruits into the town, once again highlighted the problem, and an even greater number of servicemen beginning to appear before the local magistrates on various charges arising out of excessive alcohol consumption. One magistrate in September went so far as to make clear his belief that Chatham was 'seething with drunkenness', placing the blame on publicans who had not agreed to requests made by the military authorities that navy and army

personnel should not be served after 9.00 p.m. It seems that a civilian desire to reward those who had enlisted was also partly to blame: those in uniform, when present at a public house in Chatham, were frequently offered free drinks even though they may well have been under the influence already. Another Chatham magistrate commented on this, accepting 'it was done out of kindness', but indicating that it must be stopped as it was doing 'an enormous amount of harm'.

The solution in 1914 was a decision by the military authorities to take matters into their own hands; using new temporary wartime legislation, they enforced an 8.00 p.m. closure of all public houses throughout the Medway towns. To help ensure that the soldiers and sailors from the local barracks had the opportunity of alternative entertainment, given that the various clubs and institutions established prior to the war could not cope with the rapid expansion of those being ordered to Chatham, a large number of church and school halls began to be fitted out by churches and other charities with books, games and magazines, as well as quiet areas that allowed a soldier or sailor to write home. Instead of alcoholic drinks, most of these temporary quarters offered non-alcoholic beverages either free or at a very low price.

While excessive drinking on the scale witnessed in the nineteenth and early twentieth centuries was never to be totally eliminated, the combination of providing alternative recreational activities and much-improved policing certainly brought about a general overall improvement. During the 1940s and 1950s in particular, and despite the high continued military presence, most local residents who can remember those years would claim that the town had embraced a period of general calm. In those years, the local 'bobbies' on the beat, who constantly patrolled the High Street and Brook area at night, would be accompanied by military police, the one to deal with civilian ne'er-do-wells and the other with offending soldiers and sailors. Some residents from that time would go so far as to say that Chatham, in those years, was a much safer place to live that at any other time in its history.

DID YOU KNOW THAT...?

Chatham Barracks (later renamed Kitchener Barracks), which stood alongside Dock Road, was built during the mid-eighteenth century and eventually had accommodation for over 2,000 soldiers.

Also in Dock Road once stood the Royal Marine Barracks, constructed during the 1770s with the buildings being demolished in 1960. The same site is now occupied by the Medway Council Offices.

Chatham Naval Barracks, HMS *Pembroke*, which was technically in Gillingham, was opened in 1903, but prior to that naval seaman were housed in hulks moored along the banks of the Medway.

8. The Outlet Centre with an Obscure History

Ever wondered about the original site of the outlet centre over by the dockyard with its waterside backdrop? Oh yes! It was certainly once part of the dockyard – an extension built during the reign of Queen Victoria. But connected with that same area is a nasty little secret that isn't much talked about. Many of those who built the basin and docks that lie alongside that shopping centre were harshly treated convicts who were really little more than slaves. Worse still, some of them were subjected to forms of torture that would be familiar to Gestapo suspects.

In time we are going back to the mid- to late nineteenth century when Chatham had its own prison, located on the site of the later naval barracks and where Chatham Maritime is now located. It was also the convicts who built the prison, for they at the time were housed in former timber-built warships that were moored in the river. Every morning they would be brought ashore, manacled together to prevent their escape, and marched across the marshes to where they would continue a daily grind of breaking stones, digging new foundations and laying bricks. Once the prison was completed the prisoners were moved to their new accommodation and the hulks destroyed.

It was then the convicts began their work on the dockyard extension that is now overlooked by the Outlet Centre. Forced to work long hours, subjected to severe punishment and expected to survive on a diet of bread, beef, cocoa and gruel, it is hardly surprising that discontent was a massive problem. On several occasions riots broke out, these brutally put down by the warders who, in truth, were thugs themselves.

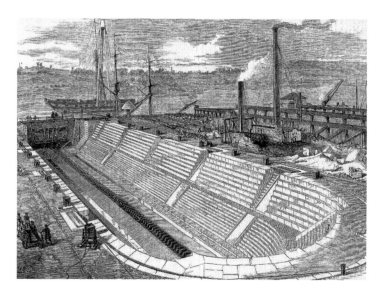

Following the construction of the prison, which was completed in 1854, one of the first tasks given to the convict was that of labouring work, associated with the extension of the No. 2 Dock located in the Georgian end (now the Chatham Historic Dockyard) of the yard.

An enlarged view of the earlier engraving which first appeared in an October 1858 edition of *Illustrated London News*, showing a small group of convicts hauling timber towards the dockside. Accompanying them is a prison warden shouldering a musket.

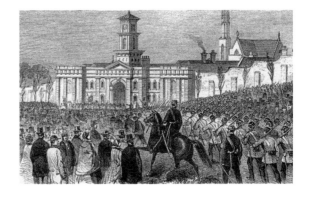

The convict prison, seen here in 1861, following a series of riots within the prison building which required military reinforcements to help restore order.

A rare view of the interior of the prison that had been built to house 1,200 convicts.

This probably explains why one warder, James Boyle, had his head smashed in by sledgehammer-wielding James Fletcher, a convict undergoing a seven-year sentence who could take no more. It seems that Boyle had a reputation for continually picking on some of the men, forcing them to eat candles and soap. At Maidstone Assizes, in December 1866, James Fletcher was sentenced to death, accepting the verdict without demur, having previously admitted that it was a merciful release.

Although ill treatment was rife throughout the prison, with the weak and friendless often those most picked upon by insensitive wardens, it was one particular group of prisoners that brought all this to public attention. They were a number of Irish prisoners, members of either *Clan na Gael* or the Irish Republican Brotherhood (IRB) who had been sentenced for acts of violence, or attempted violence, against the British state. Both *Clan na Gael* and the IRB had the same objective – that of achieving Ireland's independence through any means necessary, with the former an Irish-American organisation based in New York and the latter based in Dublin. In drawing attention to prison conditions in England, a useful propaganda ploy that gained them much sympathy in Ireland and the USA, Chatham particularly featured as it was here that an increasing number of political prisoners were sent. As for the choice of Chatham as the home for so many Irish Republican prisoners, this was because the prison was considered secure from escape, located as it was in the midst of marshlands and well away from any urban centre or village. Admittedly, the prisoners were taken out during the day for construction work on the dockyard extension, but as this was on St Mary's Island, surrounded by water, escape during the working day was also viewed as virtually impossible.

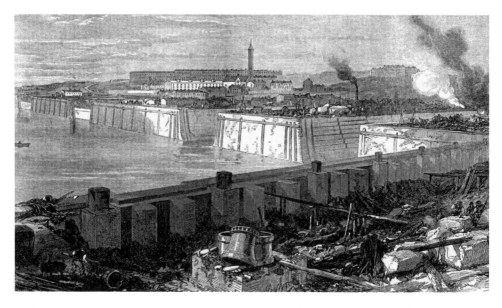

Looking across the part-completed No. 1 basin with Chatham prison in the background. To the immediate right, dry dock Nos 5 (the future Invincible Dock), 6, 7 and 8 can be seen. All were built by convict labour. The outlet centre of today (previously the No. 1 Boiler Shop) can also be seen just a little beyond Docks 7 and 8.

This photo dates from around 1875, when one of the docks into the No. 1 Basin is being inspected by a group that includes a senior prison warden.

Work underway on a dry dock located close to the future outlet centre.

Convicts seen here at Chatham hauling a load of timber, work that would otherwise have been undertaken by horses.

One of the earliest groups of Irish 'politicals' to arrive at Chatham was received in 1868. Among them was Jeremiah O'Donovan Rossa, who was to prove a particular embarrassment as, while being held at Chatham, he was elected to the House of Commons as member for Tipperary. Unable to take his seat, the election was declared void as he was a convicted felon, O'Donovan Rossa, who had been convicted for life, was released after serving twelve years on condition that he leave the country and never return. This he did, travelling to New York where, through association with *Clan na Gael*, began organising a campaign of dynamiting that was aimed at some of London's best-known landmarks.

On his first arrival at Chatham, O'Donovan Rossa was already recognised as a man who might prove difficult and was immediately placed in one of the isolated punishment cells. In his later writings, he provided a description of this cell:

> It was ten feet by seven. I saw my bedstead nailed to the ground and the pillow of it raised four inches high; the bed clothes were folded, and lay on a thin straw mattress which was also folded. My table was a small board imbedded in an angle of the wall, and my stool was two feet high, the trunk of a tree, fastened to the floor alongside of the table.

On his second day he was given a pen and paper to write to his wife, but on completing the letter he was told it would not be sent as he had written of his treatment at the prison. One particular annoyance directed towards him resulted from O'Donovan Rossa being left-handed, with him being forced by the wardens, when sent out to break stone on St Mary's Island, to use his right hand to wield the sledgehammer rather than his left. That others were allowed to use their left hand was proof to O'Donovan Rossa that he, and the other Irish prisoners held at Chatham, were especially picked on. Further evidence of this came sometime later when O'Donovan Rossa was given a scrap of newspaper by a fellow prisoner that carried a report of Irish activists in England freeing other Irish convicts from Clerkenwell Prison. Possession of a newspaper was forbidden, and within moments of returning to his cell two wardens entered and demanded that O'Donovan Rossa strip off his clothes. In doing so, the scrap of newspaper was discovered. It later transpired that the prisoner who had given him the newspaper was a prison informer and had been given the scrap of newspaper by one of the wardens to pass to O'Donovan Rossa. Once the wardens were sure that O'Donovan Rossa had the illicit item they sprang their trap. For this offence O'Donovan Rossa was punished with ten days of solitary confinement and a bread and water diet.

O'Donovan Rossa's treatment eventually improved when he was nominated for Tipperary in the upcoming by-election. At the same time he was also smuggling letters out of the prison that told of the conditions under which he was held and these began to appear in the Irish press. One of these tells of the long string of punishments he was undergoing and was possibly written at the beginning of 1869:

> My last punishment was ten days on a false charge in December. The one before that was the one decreed in July, of 28 days bread and water and penal class diet, till the 1st October. A special privy was built in my cell; it had a flag for a seat, and no cover. The stench from it was not pleasant.

Jeremiah O'Donovan Rossa, an Irish Republican who, while imprisoned at Chatham, was elected to the House of Commons as Member of Parliament for Tipperary.

Before that round of punishments, O'Donovan Rossa told of:

Thirty-five days with my hands tied behind my back, on short rations; and before this I had fifteen days on bread and water.

DID YOU KNOW THAT...?

Although the prison for convicts was completed in 1854, there had already been a tradition of using convicted felons to undertake work in the dockyard, which goes back to the 1820s when they were employed on various unskilled heavy labouring duties.

Before the prison was built, convicts were housed in hulks on the River Medway in the same fashion as that of the earlier French, Danish and American prisoners of war.

The entire area that now composes Chatham Maritime – including the shopping centre and various other developments – was all originally land prepared and laid out by convict labour.

When brought before the governor, as it seems he frequently was, O'Donovan Rossa had to stand rigidly to attention. To ensure that he did so, one of the wardens would stand 'behind my back clutching me by the neck to keep straight, and another officer at each side of me holding my hands down by my thighs in this position of attention'.

Although O'Donovan Rossa was released from Chatham in 1870, other Irish 'politicals' were still held there, and this led to a fear that an armed attempt would be made to free these prisoners. The Admiral Superintendent of the dockyard was even told that such an attempt was planned for the night of 2 September 1876. The yard police force, a division of the London Metropolitan Police, were put on full alert in case the dockyard should also be attacked. Armed with cutlasses, a relief force of twenty sergeants and constables remained on duty the whole night and well into the following morning, with nothing out of the ordinary occurring throughout that entire period.

A further batch of high-profile Irish 'politicals' began to arrive at Chatham from the end of 1883 onwards, many of them members of *Clan na Gael* and part of the dynamiting campaign that O'Donovan had organised from New York. Caught with large quantities of nitroglycerine explosives, many of them had been sentenced to penal servitude for life. Among them was John Daly, a future Lord Mayor of Limerick and for whom there is a fair amount of evidence to suggest that he had been convicted on perjured evidence. While at Chatham he also became a cause célèbre due to him being given poisonous concoctions of belladonna by the prison infirmary's compounder. A subsequent commission of inquiry simply brushed it aside as a simple error while ignoring the treatment that Daly had received while vomiting and suffering diarrhoea as a result of the toxins he was being given. Forced to attend chapel, he soiled his clothing and was instructed to bathe himself in cold water and wash his clothes in the same water.

One of the Chatham prison wardens, seen here posed in front of a brick-making machine. Manufacturing of bricks for use in the yard was one of the tasks undertaken by convicts.

The completed No. 8 Dock. At the head of this dock was to be erected the No. 1 Boiler Shop (the future outlet centre) and, to the side, Machinery Shop No. 8. Both buildings were brought to Chatham from Woolwich in the mid-1870s for rebuilding following the closure of Woolwich dockyard in 1869.

The No. 1 Boiler Shop (aka Chatham Outlet) under erection sometime around 1875 and following its arrival from Woolwich.

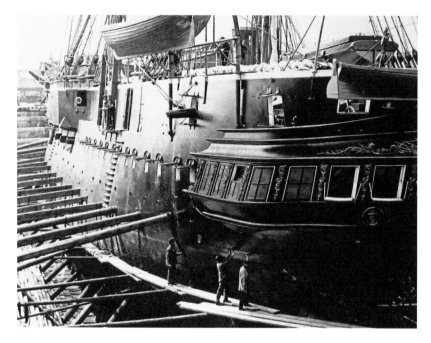

No. 5 Dock, located to the immediate north-west of the outlet centre, actually has a more impressive name, the 'Invincible Dock', having been given this name in June 1871 when the ironclad battleship of that name became the first ship to enter that particular dock. This is an early photograph of *Invincible* in the No. 5 Dock.

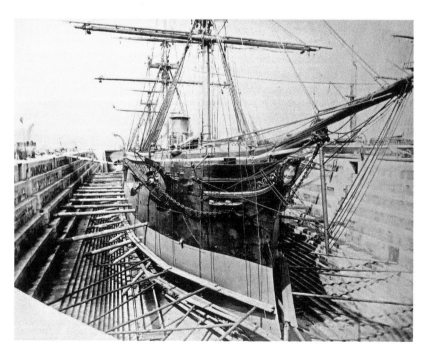

A further view of *Invincible* in the Invincible Dock.

A distinctive and still-remaining feature of the part convict-built dockyard is the Dockyard Pumping Station, seen here shortly after completion.

Another of those brought to Chatham in 1883 was Thomas J. Clarke, a future leader of the 1916 Dublin uprising and who wrote of his time at Chatham,

> At night, jaded in body and mind with heavy labour of the day and the incessant nagging of the officers, I would return to my cell, and when once inside the door would fling myself on the floor and not move until supper time. If I went to bed before the bell rang it meant a bread and water punishment, and I was already getting enough of the systematic starvation. When the bell rang I would turn into bed, sometimes to sleep, sometimes to lay awake for hours, with body too weary and nerves too shattered for any refreshing sleep to come. If sleep came I was wakened within an hour by a noise something like the report of a small cannon being fired close beside me. The officer inspecting us had merely banged the heavy iron trap door after him.

The last was a deliberate attempt on the part of many warders to deny such political prisoners their sleep. It was this which caused madness among many, with Thomas Gallagher, who had led the *Clan na Gael* mission, being allowed an early release for this very reason. On arrival in New York, a specialist who attended upon Gallagher felt able to write,

> The prison officials must have treated these men cruelly. Gallagher's condition is worse than death. The torture he received in the first five years – now that we know he is

insane for eight years – must have been very severe. The punishing of this man for shamming was cruel in the extreme.

As with O'Donovan Rossa, none of the *Clan na Gael* prisoners served out their full sentences; most of them (or at least the ones who did not die in prison) were released after around twelve years on the condition that they also leave the country. Possibly one further reason was that, with the Chatham dockyard extension works having been completed in 1885, the prison began to be run down. Quite simply, apart from stone breaking and oakum picking, there was nothing else that the government could order the convicts to undertake, with the prison itself eventually closed in February 1893. From then on, the history of the prison site is much better known as the land on which it stood being granted to the Admiralty. Once in their hands, it was seen as the ideal location for a much-needed naval barracks – the future HMS *Pembroke*. Previous to that, all naval seamen attached to Chatham, when not on board a serving naval warship, had been housed on hulks not unlike the same ones that had once accommodated convicts prior to the erection of the prison. As for HMS *Pembroke*, the naval barracks, work on this project began in 1897, with building work completed some six years later at a cost of £425,000 (£46.2 million in today's money). Today, of course, the former barracks and the site upon which the prison once stood is part of Chatham Maritime. As for the Irish 'politicals' who were once imprisoned here, they are names now celebrated in Ireland's national history as part of the struggle for independence. Indeed, in the summer of 2015, the Irish state held a state centenary commemoration of the death of O'Donovan Rossa, the first state memorial in the Republic's programme of events to commemorate the Easter Rising of 1916.

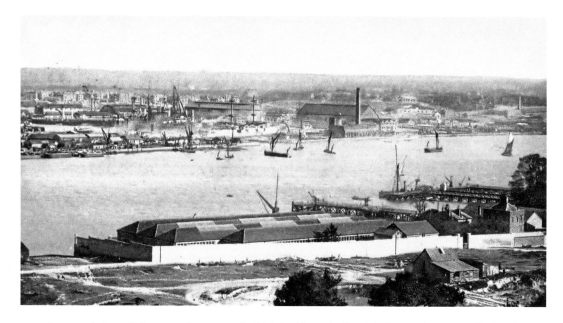

A general view of the extension, part of which had been built with the involuntary aid of Irish Republican prisoners such as O'Donovan Rossa.

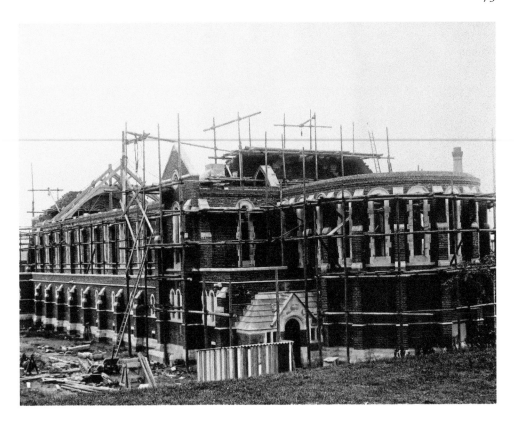

Above: Following the demolition of the convict prison construction, work began on the naval barracks (HMS *Pembroke*) with St George's Chapel, the building seen in this picture.

Right: The clock that stands guardian over the outlet centre also came from Woolwich.

Left: Interior view of the outlet centre that was originally constructed to cover a slipway at Woolwich.

Below: A modern-day view of the No. 1 Basin with the Invincible Dock visible at the far end of the basin and the outlet centre to the right.

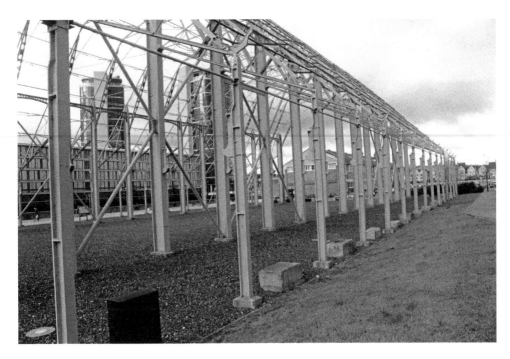

The No. 8 Machinery Shop that stands in frame was also brought from Woolwich and was re-erected at Chatham. It is also a Grade II-listed building.

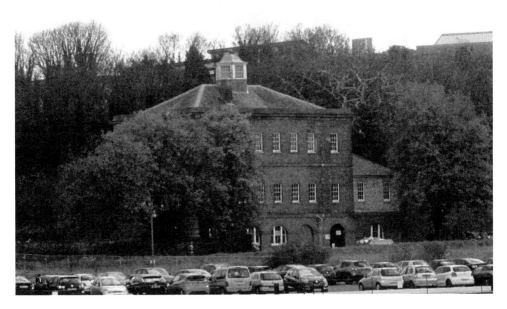

To ensure that convicts employed in the older part of the yard were carefully supervised, this dockyard building has a viewing room set in the roof, used by senior officers to make sure all was running smoothly.

DID YOU KNOW THAT...?

Convicts, including most probably those of an Irish Republican background, would have helped in the erection of No. 1 Boiler Shed that now serves as the outlet centre within Chatham Maritime.

No. 1 Boiler shed, now a Grade II listed building, originally stood in the dockyard at Woolwich and was really a slipway covering.

Chatham convict prison remained in use until 1893 and, following its demolition, the site became HMS *Pembroke*, the naval barracks that today is Chatham Maritime.

9. The Hidden War

Chatham, up until more recent years, has always been a government town and the centrepiece of a huge military-industrial complex. Surrounded by fortifications and the location for one of the nation's largest naval dockyards and ordnance stores, it was also a base for housing hundreds of soldiers. In wartime especially, the town was always a hive of activity, with newly built or repaired battleships a common sight and arriving military battalions, be they composed of soldiers or marines, so frequent as not to be worth commenting upon. It was a town where men throughout much of its history played the starring role, for they were the ones who wore the uniforms, polished the guns and built the ships.

During much of the town's early history, women were simply written out of the everyday story, present most certainly but only in the distant background. With only a limited number employed in the dockyard – and this not until the nineteenth century – and totally restricted from the fighting services until the twentieth century, women were invariably the ones who carried out the domestic chores of maintaining the home and keeping the family together. In wartime this was a particularly difficult task, for in preparing family meals and nursing the young, essential items that might at other times be plentiful were often difficult to obtain. A major cause of this difficulty was that of the town's population doubling in such years, while the merchants who supplied the town were rarely able to provide a similar increase in such basic necessities as flour, milk, meat, vegetables and butter. The arrival of a new regiment into the town was often seen as bad news, for the market traders would simply put up their prices, knowing that the demand for their goods would suddenly increase.

This was the hidden war: war fought by housewives to keep their families from starving. It was they who were on the front line of this battle while their menfolk toiled a lengthy day at the dockyard or gun wharf. However, at lunchtimes, especially during the eighteenth century, a break was allowed, and women permitted to enter the yards with prepared food that they would share on site with their fathers, husbands or brothers. Their morning would have been spent haggling with the market traders, trying to get them to accept the few coins that had been adequate in the past.

Clear evidence of this struggle occurs during the early years of the war with Revolutionary France that broke out in 1793. Throughout the country this was a time of rocketing prices, not helped by two meagre harvests in succession. In Chatham, where the dockyard wage had remained static for over 100 years, women had not the wherewithal to meet those new prices. In earlier times this had not been a problem, inflation running at zero and prices rarely altering from one year to the next. Now however, things were out of hand and something had to be done.

In past conflicts the town of Chatham has been on the front line, but there is one war that is often forgotten, this being the war to ensure there was sufficient food to prevent the starvation of ordinary men and women of the town.

And this is where the womenfolk of Chatham enter into the history books. On Saturday 28 March 1795, with prices in the market reaching unprecedented levels, they began a demand that the price of meat and bread be lowered to a more reasonable level and, although laughed at by the marketers at first, they soon gained a wide degree of support. Within hours the town was in uproar. With the marketers still refusing to lower their prices, a degree of rough justice was called for. The women, now supported by some of the men from the dockyard, mainly ropemakers, began to seize items of food and paid only what they considered to be a fair price – that which they would have paid only a few weeks earlier. For the local magistrates of the town and who those were responsible for maintaining law and order, this was a nightmare situation. Worse still, many of the soldiers quartered in the town began giving their support to this demand for lower prices on the market.

Normally in such a situation, magistrates, could quickly regain order by calling upon the militia. But it was the militia – in this case the West Middlesex Militia who were quartered in the town – that was supporting the rioters. A letter written by a local Medway resident and reproduced in a number of contemporary newspapers provided a description of the events:

The circumstance was immediately conveyed to the War Office and an instruction came accordingly to order them [the West Middlesex Militia] away as soon as possible; but

before they departed the East Norfolk Regiment had arrived from Dartford, completely equipped, and furnished with ball cartridges, not only for the purpose of replacing them [the West Middlesex Militia], but of guarding against any riotous behaviour they might observe in their march from the town.

The departure of the West Middlesex Militia was at the very least, somewhat ignominious:

> For the purpose the East Norfolk militia were ordered to line the streets, while the others marched between them, as they stood under arms, like soldiers guarding a conquered enemy.

Improved harvests, putting more land under the plough, a government-led campaign against food squandering and large imports of wheat from Canada and the Baltic eventually forced a general lowering of prices, thus ensuring that there were no further food riots in Chatham during that period. However, the lesson of ensuring adequate supplies of essential foods was forgotten by the time a further major war broke out just over 100 years later.

It was during the bleakest years of the First World War that a very similar shortage of many basic food items led, once again, to a massive increase in prices and pressure placed on those responsible, mainly women, for replenishing the kitchen larder once again. Although supported by a good many other strategies, the inducement to economise was again implemented, George V issuing an almost identical proclamation to one that had actually been issued by George III over 100 years earlier:

> Our Royal Proclamation most earnestly exhorting and charging all those of our loving subjects the men and women of our realm who have the means of procuring other articles of food other than wheaten corn, as they tender their own immediate interests and feel for the wants of others, especially to practice the greatest economy and frugality in the use of every species of grain.

On this occasion, the food shortage had been brought about by the intensity of the German U-boat campaign and the destruction of large amounts of European farmland. Lord Milner, a leading member of a five-man War Cabinet sitting in London, estimated that the price of foods had approximately doubled by early 1917. Increasingly the government became involved in the distribution chain, introducing the office of Food Controller in December 1916 and establishing localised Food Control Committees. The latter had the authority to monitor and restrain prices, introduce localised rationing and seize food stocks. The value of the Food Control Committees came to the fore during the winter of 1917/18, when supplies of dairy products and meat were especially difficult to secure. In Chatham, the local Food Control Committee was proactive in seizing four tons of margarine in February 1918 and sharing it around various shops in the area where 'people had been waiting for hours'. However, meat was also in short supply with none available for butchers throughout the whole town. As a result, the Chatham Food Control Committee was given government priority to secure cattle from markets in East Anglia.

For Chatham's Food Control Committee, one particular problem had to be met – that of overseeing an area with a population subject to a constant increase because of the movement of so many men in and out of the town throughout the period of the war. The government had also calculated a food supply level based on an estimate made in 1915 that was not subsequently revised until the war had ended, which only added to the difficulty. Under this arrangement, every person living in Chatham was allowed 1 lb of meat per person per week with the correct quantity for the estimated population always available. However, the population of Chatham rose well above its 1915 level, with the amount of meat available in Chatham soon falling far short of what each person was actually permitted. In addition, as the chairman of the Chatham Food Control Committee bemoaned, there were additional problems inherent in being both a port and a military town: 'a man could come ashore with a Board of Trade certificate entitling him to purchase 35 lbs of meat but there was not 35 lbs to purchase'. To this, he added, 'the difficulty of patients in hospital who were authorised to receive 4¾ lbs of meat' with the diet available to local inhabitants being considerably less.

To further help ease the food crisis, the government fostered the idea of National Kitchens. Established from May 1917 onwards, they provided cheap basic meals outside of the ration system. Several kitchens were established in Chatham, these open throughout the lunchtime period and providing a three-course healthy cooked meal for as little as 8d (approximately £1.65 in today's money).

The frontline of this war against starvation was, during the wars of the eighteenth century, the weekly market. In later years the war centred on the High Street; during the First World War the town of Chatham came close to losing supplies of many essential foods.

However, none of this eased the need to queue, with any shop known to have a supply of sugar, margarine or meat soon descended upon by hundreds of local housewives. Here they would stand waiting for hours on end only to find they were permitted only the tiniest amount of whatever they were hoping to purchase. Unfortunately, one such queue in Luton Road led to tragedy. This was in February 1918 when a young child, having just secured half a pound of margarine for a family that had gone without for two weeks, stepped into the path of a butcher's van and was killed. The vastness of the queuing crowd had prevented the driver from seeing the boy in sufficient time to stop.

It was the introduction of a nationwide scheme of rationing that helped reduce the time many spent in shop queues while ensuring a more equitable distribution of those essentials in short supply. Initially, it was only sugar that was subjected to rationing – a nationwide restriction on the purchase of sugar was introduced in December 1917. As for the Second World War, the government introduced rationing at the very outset of the war. Furthermore, it had been preparing for war over a long period of time, with warehouses in secret locations being used to store substantial quantities of basic essential foods which were gradually released when supplies began to run short. Thus, the lessons of the French Revolutionary and Napoleonic wars had been finally learnt and fully acted upon.

DID YOU KNOW THAT...?

For the first 200 years of existence the naval dockyard at Chatham was an all-male preserve. It was not until the early nineteenth century that women were first employed in the yard, given the task of sewing flags in the colour loft. Employing roughly twenty women, in any one month they typically produced some 1,200 flags of different size and purpose.

The employment of women in the ropery did not begin until 1864 when women began to operate newly installed spinning machines in the hemp house.

A distinct difference was drawn between these two groups of women, with employment in the colour loft restricted to the wives and daughters of those either incapacitated or killed in naval service. As a result, those employed in the colour loft were treated with a good deal of respect and were referred to as 'the ladies of the colour loft'. The newly employed females entering the ropery were not accorded this same level of respect, referred to as 'the women of the ropery' through not being widows or daughters of those in Admiralty service and generally of a lower social background.

During the First World War, large numbers of women were employed in the dockyard but were laid off once the war ended. At that time they were trained to undertake very specific tasks rather than the broad range normally acquired by an apprentice.

In the Second World War, approximately 2,000 women were eventually employed, this representing around 15 per cent of the total workforce of the dockyard.

10. Cold War Secrets

One secret and highly classified document from the Cold War period makes one thing absolutely clear: the British government was certain that, in the event of a nuclear war with the Soviet Union, Chatham would very definitely be a target. Although, of course, it didn't take a high-level defence analyst to work this out, most people living in Chatham during this period, including me, had already reached this same conclusion. The only question that needed to be asked was what would be the size of the warhead and where exactly it would hit. To this, the probable answer was the dockyard, but accuracy would be an overriding factor, with the scale of devastation total and unremitting.

A secret British government assessment carried out in 1972 named Chatham as just one of 100 likely targets in the UK and went on to suggest that the town would be the recipient of at least one missile carrying a 1 megaton warhead designed to explode 8,000 feet above the town. This would cause a maximum amount of devastation, the blast destroying everything within a radius of three miles and causing considerable damage to all buildings to a radius of twelve miles. In other words, an air burst over Chatham would totally obliterate the town with the entire Medway area also becoming totally uninhabitable. As for human survival, this would have been totally impossible in the immediate area of the blast as irradiation would be total. Further out, more deaths would have been brought about by collapsing buildings and other similar hazards, while radioactivity would complicate rescue efforts. The overall effect of radiation is less clear, but such an explosion would also have resulted in deaths due to the long-term effects – if not from the fallout of the blast over Chatham, then from the fallout of nuclear air burst explosions elsewhere and brought to Chatham on the wind.

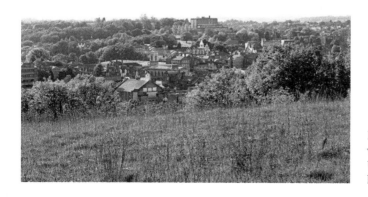

In the event of a nuclear war with the Soviet Union, none of this would have survived.

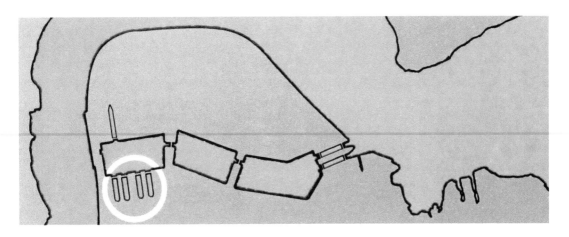

The Nuclear Refit Centre, as shown by this outline map of the yard, was added onto the already existing facilities that had been created during the nineteenth century with the help of convict labour (*see* Chapter 8). The highly vulnerable Health Physic Centre was located between docks 6 and 7, making this the area of the yard with particularly high security during the Cold War.

It was no secret that in Chatham there were no nuclear bunkers that might protect the civil population, whereas in the Soviet bloc large sheaths of the population were given the possibility of such protection. Instead, the only underground bunkers designed to serve the Chatham area in the event of a nuclear attack were one for use by the Flag Officer Medway and his naval support staff and another built by Southern Water as their emergency control centre. While both were actually in Gillingham, the naval bunker to the south-east of the dockyard off Medway Road and the Southern Water bunker just south of Farthing Corner on the M2, they were closely connected to Chatham in terms of their role and purpose.

DID YOU KNOW THAT...?

If war with the Soviet Union had broken out, an underground bunker beneath the surface of HMS *Wildfire* (the naval shore base to the south-east of the dockyard that was responsible for communication training) would have served as the Navy's local command centre. Known as Local Command Head Quarters (LCHQ) it was, as a result of the imminent closure of the dockyard, closed in 1983. Given that the underground bunker had been built immediately prior to the outbreak of the Second World War, it is debateable as to whether it would have survived the possible nuclear strike on Chatham that recently released government papers seemed to predict. In 1981, further recently released secret documents revealed that concerns existed as to the safety of LCHQ as although HMS *Wildfire* was enclosed by a security fence, it had a number of weak points that meant it could be easily climbed by a potential saboteur.

A likely purpose in aiming a nuclear missile at Chatham was that of disrupting the naval command structure in home waters and the activation of retaliatory measures. Presumably, if Chatham was ignored by the Soviet war machine as a target and the naval communications not rendered useless, then it might have allowed the Local Command Headquarters (LCHQ), ensconced in its underground bunker within the confines of HMS *Wildfire*, to continue masterminding Britain's nuclear response. Otherwise, an attack on Chatham would not have made any real sense, given that the main task of the dockyard was the refitting of hunter-killer submarines, with each refit taking nearly two years. During any point of the refit, it was impossible to rapidly get one of these hunter-killer submarines back into service, and so they would be completely unavailable for a war that would have been over in days rather than years. So perhaps, and for this reason, Chatham might just have been spared on the grounds of there being more important targets, such as the Polaris missile submarine base at Faslane or the cruise missiles housed at Greenham Common and elsewhere.

Whether or not Chatham would have been obliterated by a nuclear attack, another possibility was on the minds of defence planners, that of the dockyard being put out of action during an earlier non-nuclear phase of a war with the Soviet Union. Here, sabotage was the feared weapon with a detailed analysis undertaken in 1981 showing how it was

The security fence that once enclosed HMS *Wildfire,* which was also supposed to prevent entry to the command bunker (LCHQ); it was designed to play an essential role if war had broken out with the Soviet Union. Here, undulating ground nullifies the height of the fence.

A further weakness in security was this fence support that would also help a saboteur enter HMS *Wildfire* and the naval dockyard immediately beyond.

planned to neutralise such a threat. Again, it was a highly secret document that first set about describing the most effective means by which a saboteur could bring the dockyard to a complete standstill. Not only does it detail the easiest points of clandestine entry into the yard but also where explosives might be laid to cause the greatest damage.

Specifically, the report highlighted five key areas that might attract the attention of a trained saboteur originating from the Soviet Union or from 'a dissident group motivated by a hostile intelligence service'. These key areas, each of which if attacked might result in bringing the work of the dockyard to a complete standstill, were listed as follows, with an attack coming in the form of the use of explosive, mechanical or incendiary devices:

- An attack on the electrical power system to immobilise the yard through destruction of the electrical distribution centre or damage to the supply lines that fed electricity into the yard from both Kingsnorth and Northfleet power stations via sub stations at Chatham and Lower Upnor.
- The blocking of the entrance to the basins through damage to the two locks, known as the Bull Nose, of which the one on the north side was viewed as the more important of the two. This would then prevent ships entering and leaving the yard.

- An attack on the Nuclear Refit Complex to create a radiation hazard that would result in the necessity to evacuate the entire yard.
- An attack on the caissons that sealed the main basin and dry docks and which if damaged could result in the loss of water in both these facilities and damage to vessels held in either the basins or dry docks.
- An attack on the communication facilities to disrupt the command and control of the yard and probably best achieved through disrupting the telephone exchange and through which all of the alarm systems of the yard also ran.

The report also turned its attention as to how such attacks might be carried out and the seriousness with which each was viewed. Each scenario required a degree of skill and determination, but nothing that was viewed beyond the capabilities of a well-trained operative emanating from one of the Warsaw Pact nations. Explosive devices could be used against all these vulnerable points, but it was considered that in a worse-case scenario and if a saboteur did get through, the workforce had the skills to repair any damage inflicted on most of these potential targets within forty-eight hours. However, the Nuclear Refit Centre was the only exception, especially if damage was done to the core pond inside the Health Physic building.

The core pond was where the highly radioactive submarines reactor cores were held during a period of refit, with the pond resembling a large swimming pool some thirty feet in depth and lined with concrete four feet thick. To allow the core to be placed in the pond and later retrieved, the roof of the building has a sliding hatch that allows the cores to be transported by crane. Any explosion in this area had the potential for causing a major

The Health Physic Centre building that once stood between Docks 6 and 7.

The former Nuclear Refit Centre was totally removed prior to the closure of the yard, with docks 6 and 7 running off the No. 1 Basin, as seen in this modern photograph. The classified early 1980s security report indicated that devastation would result from the effects of the successful detonation of an explosive device alongside the Core Pond within the Health Physic Centre building. The fear was that, in a non-nuclear war, and with the Warsaw Pact, saboteurs would attempt to enter the yard.

With its south and north locks that allowed ships to enter the dockyard through the No. 3 Basin, the Bull Nose was viewed as a further point of weakness seen here in 1980 when the security of the yard was under review. If disabled in some way by sabotage, the inability of the locks to open or close would prevent ships entering or leaving the yard.

radiation leak as it would be possible that such an explosion would not only drain the pond but would displace and crack the core units. A further worthwhile objective within the area of the Nuclear Refit Complex was viewed as a direct explosive attack on one of the nuclear submarines while in dock, thus rendering the vessel unseaworthy.

It was considered that an attack on any of the yard's vulnerable points would best be achieved by person or persons masquerading as a member of the workforce. To carry explosives into the yard would not really be feasible through one of the main entrances, but might be achieved by frogmen landing at night on the unprotected shoreline of St Mary's Island and changing into overalls so as to approach the chosen target during working hours. It was further suggested that a two-man team, without due hindrance, might carry into the dockyard some 100 lbs of explosive, this being sufficient to achieve any of the suggested objectives.

In order to reduce the possibility of sabotage, a number of recommendations were made that included the introduction of more security doors, alarms and lighting. However, only during a period of heightened emergency would the level of active security be increased through the introduction of more river patrols along the shore line of St Mary's Island,

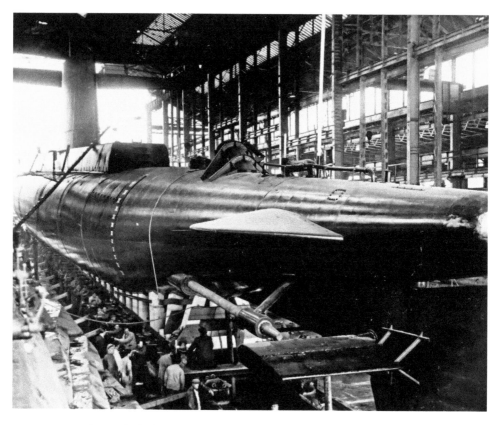

A major specialism of Chatham dockyard that continued into the Cold War years was the construction of submarines, with HMS *Ocelot* the last of three Oberon-class submarines built for the Royal Navy, seen here prior to her launch from No. 7 Slip in May 1962.

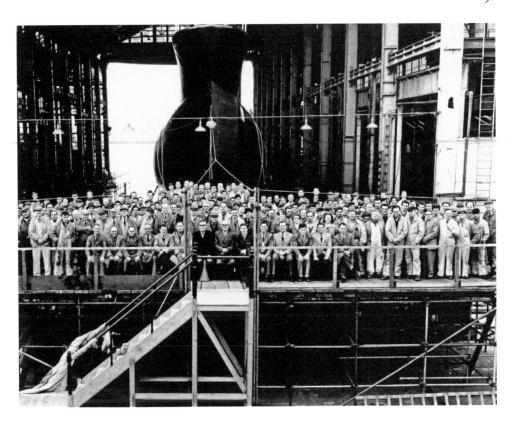

Above: Those responsible for the construction of *Ocelot* pose for a press photograph on 5 May 1962, the day of her launch.

Right: Dockyard workers hammer away the dog shores that will allow *Ocelot* to be floated out into the Medway on the day of her launch.

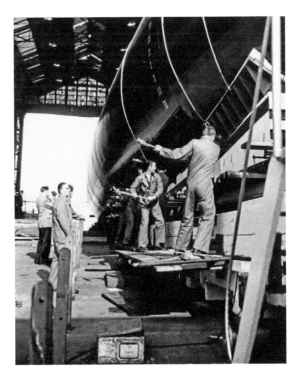

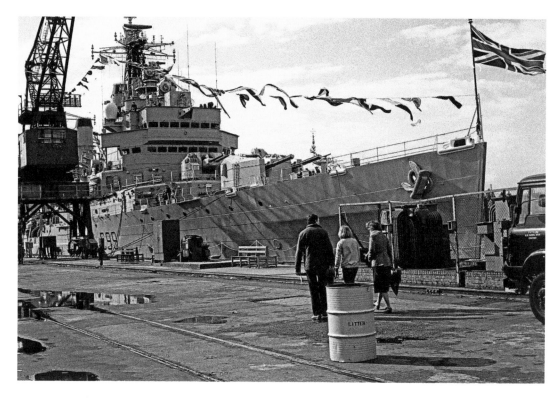

During the Cold War, the dockyard at Chatham had a further role – that of carrying out refits on warships. In this 1970s photograph, the helicopter cruiser HMS *Tiger* is on display during Navy Days but had been brought to the yard for refitting and remained at Chatham as part of the Standby Squadron.

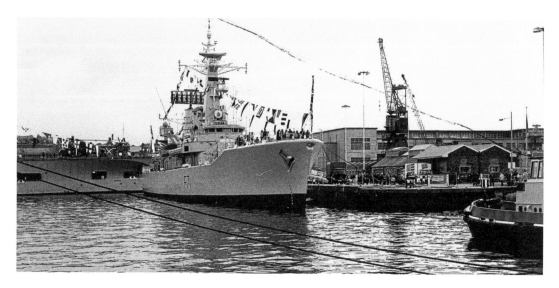

A particular refit specialism that Chatham dockyard performed during the Cold War was on Leander class frigates. Here *Scylla* (F.71) is seen in Basin No. 3.

increased security patrols within the yard, the more frequent checking of the various vulnerable points for explosives and the removal of all direction signs.

In the event, of course, few of the recommendations were ever carried out, primarily because even before the report was completed and distributed the government had announced that both Chatham dockyard and neighbouring HMS *Pembroke* were to be closed. All this was included in a statement made by Secretary of State for Defence John Nott, with closure to be completed by the end of March 1984. Thus, if the Warsaw Pact did have a plan for sabotaging the dockyard in any of the ways suggested, the British government had beaten them to it!

On the eve of the yard's final closure, with the Cold War still at its height, this poignant message was left on the wall of the Sail Loft.

On the yard's closure some less useful items were simply abandoned, as with the No. 1 Smithery, which had actually ceased operating in 1974.

DID YOU KNOW THAT...?

During the twentieth century Chatham came to specialise in the construction of submarines. Fifty-seven were launched from the yard between 1908 and 1966, almost one new submarine for every year that Chatham was building them.

The first submarine to be built at Chatham, *C.17*, had a surface displacement of 290 tons and carried a crew of sixteen. The last submarine to be built at the yard, *Okanagan*, was a giant by comparison, having a displacement of 1,610 tons and a crew of sixty-eight.

The most unusual submarine to be built at Chatham was *X-1*, launched in 1923. Designed as a submarine cruiser, she carried a large 5.2-inch gun that gave her the ability to surface and engage enemy destroyers. Her launch was shrouded in secrecy, with newspapers banned from publishing pictures. The problem for the Admiralty and the reason for this embargo on newspaper photos was that the submarine was primarily designed for attacking merchant shipping at a time when it had been agreed that navies should not use submarines to attack merchant ships, and so making the vessel technically illegal.

Bibliography

National Archives (Kew)

ADM1/3794	Memorial of Dr William Burnett
ADM98/224	Letters relating to prisoners of war held at Chatham
ADM103/64	Muster Book of Danish Prisoners held at Chatham, 1814
ADM106/1836	Employment of convicts in Chatham Dockyard (January 1828)
ADM106/1841	Services upon which convicts employed (July 1831)
HO129/54	Religious census (Chatham), 1851
PC2/156, 431	Privy Council Records

Newspapers

Chatham News, 1866, 1885, 1881–82, 1914, 1936–39
Chatham Standard, 1962
Chatham Observer, 1881–82, 1885
East Kent Mercury, September 1939
Illustrated London News, 1840–80
Kentish Gazette, 24 July 1849
Kentish Mercury, 20 February 1838
The Lancet, 23 February 1861
Maidstone Journal and Kentish Advertiser, 1842
Medical Times and Gazette, 2 March 1861
West Kent Guardian, 1830–42

Primary Printed

Ferrer, Major M. L. (ed.), *The Diary of Colour-Sergeant George Calladine* (London, 1922)
Jones, Gale, *A Political Tour through Rochester, Chatham,* Maidstone (Rochester, 1996 reprint)
O'Donovan Rossa, Jeremiah, *My Years in English Jails* (Kerry, 1967 reprint)

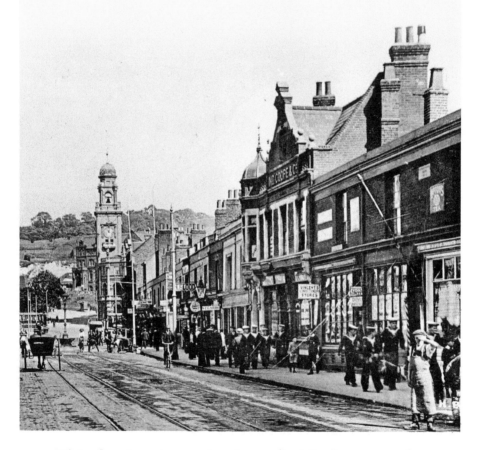

Catforth · Lancaster Canal · B5269 · Broughton · Woodplumpton · B5269 Goosargh · M6 · Grimsargh · M55 · Sharoe Green · **1** · **2** Cottam · **3** · **4** · **5** Red Scar · B6243 · Ribble · A59 · Cadley · Fulwood · Brookfield · B6241 · **32** · River Ribble · Lea Town · Lea · A5085 · Holme Slack · Ribbleton A59 · Samlesbury · A583 · Larches · **6** · **7** · Deepdale · **8** Fishwick · **9** · **31** · B6230 · A677 · Darwen · A584 · **PRESTON** · Frenchwood · Higher Penwortham · Coup Green · Howick Cross · Middleforth Green · **BAMBER BRIDGE** · Higher Walton · M6 · Hutton · White Stake · **10** · **11** · **12** · **30** · **13** · Gregson Lane · A675 · Longton · New Longton · Farington · Lostock Hall · Walton Summit · M65 · Walmer Bridge · **29** · **9** · Brindle · Leeds & Liverpool Canal · Much Hoole · **14** · **15** · Clayton Green · **16** Clayton le-Woods · **17** · B5256 · A674 · Higher Wheelton · **LEYLAND** · B5253 · Broadfield · **28** · A6 · M61 · Moss Side · Wade Hall · Whittle-le-Woods · Brinscall · Tarleton · B5248 · B5248 · Wheelton · Bretherton · R. Lostock · Great Knowley · **18** · Shaw Green · **19** · **20** Euxton · **21** Hartwood · **18** · Anglezarke Resr. · A581 · Newtown · Yarrow · A581 · Croston · River · Eccleston · M6 · **CHORLEY** · Cowling · M61 · Mawdesley · **22** Heskin Green · **23** · **24** · Weld Bank · **25** · B5246 · Andertons Mill · B5250 · Charnock Richard · Heath Charnock · Coppull · Adlington · A49 · A5106 · A6 · Wrightington Bar

0 1 2 Miles
0 1 2 3 Kilometres

SCALE
1:19,000 3.33 inches to 1 mile

0 ¼ ½ ¾ 1 Mile
0 250 500 750 Metres 1 Kilometre

Geographers' A-Z Map Co. Ltd.

Head Office : Fairfield Road, Borough Green, Sevenoaks, Kent TN15 8PP
Telephone 01732 781000
Showrooms : 44 Gray's Inn Road, Holborn, London WC1X 8HX
Telephone 0171 242 9246

The Maps in this Atlas are based upon the Ordnance Survey 1 :10,000 Maps
with the permission of the Controller of Her Majesty's Stationery Office.
© Crown Copyright

© Edition 3 1996 Copyright of the Publishers
Edition 3A (Part Revision) 1997

A Road	
Under Construction	
Proposed	
B Road	B6241
Dual Carriageway	
One Way A Roads	
Traffic flow is indicated by a heavy line on the Drivers left.	
Pedestrianized Road	I‑‑‑‑‑‑‑I
Restricted Access	
Track	=======
Footpath	‑‑‑‑‑‑‑
Residential Walkway	··········
Railway Level Crossing Station	
Built Up Area	HYDE RD.
Local Authority Boundary	‑ · ‑ · ‑
Posttown Boundary	
By arrangement with the Post Office	
Postcode Boundary	‑ ‑ ‑
Within Posttown	
Map Continuation	▲ 10
Ambulance Station	✛
Car Park Selected	P
Church or Chapel	†
Fire Station	■
Hospital	H
House Numbers	246 213
A & B Roads only	
Information Centre	i
National Grid Reference	⁴25
Police Station	▲
Post Office	★
Toilet	▽
With facilities for the Disabled	♿

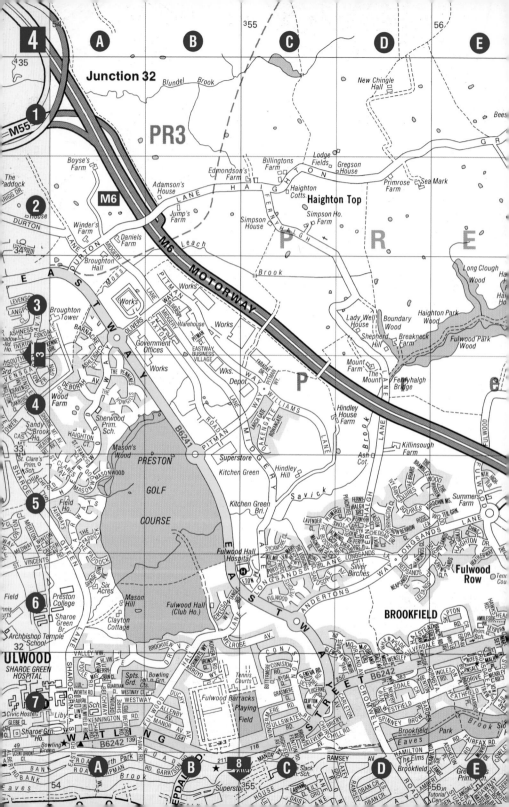

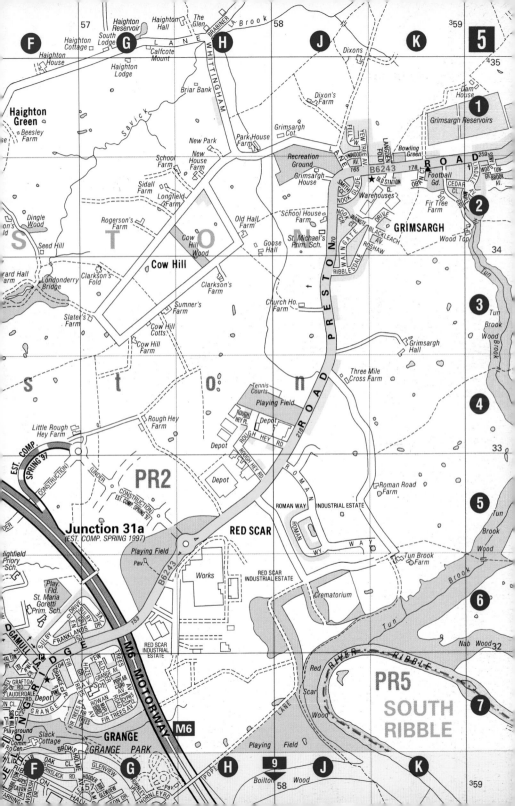

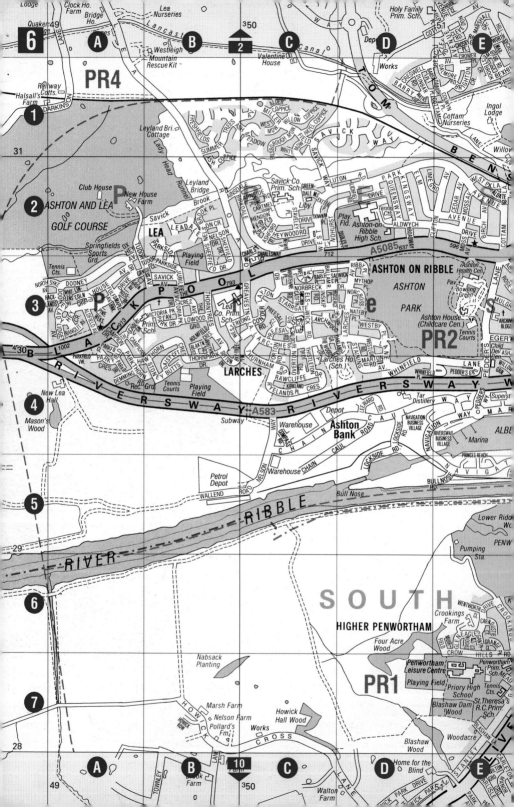

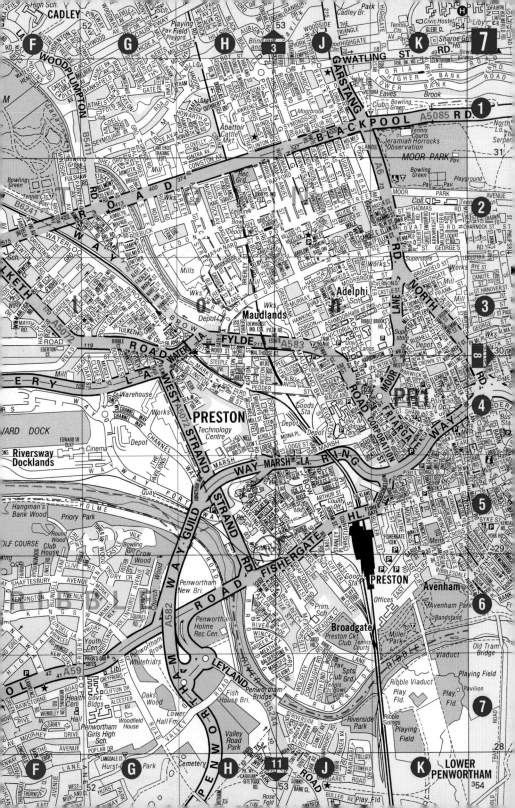

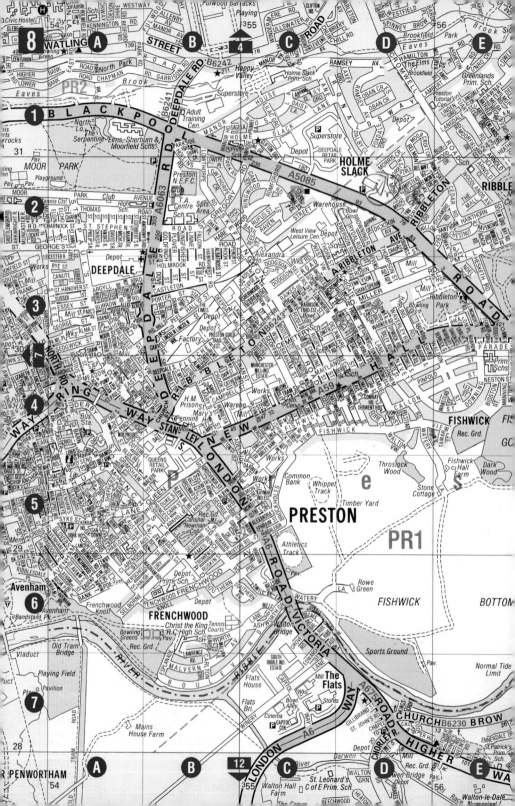

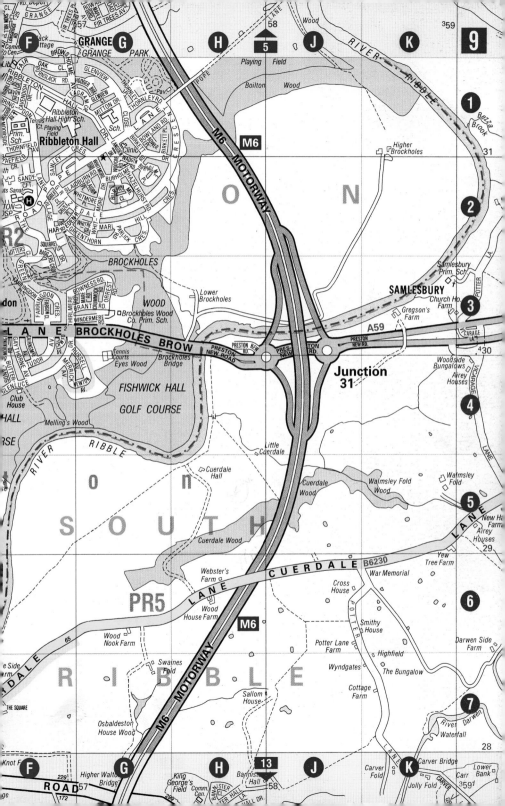

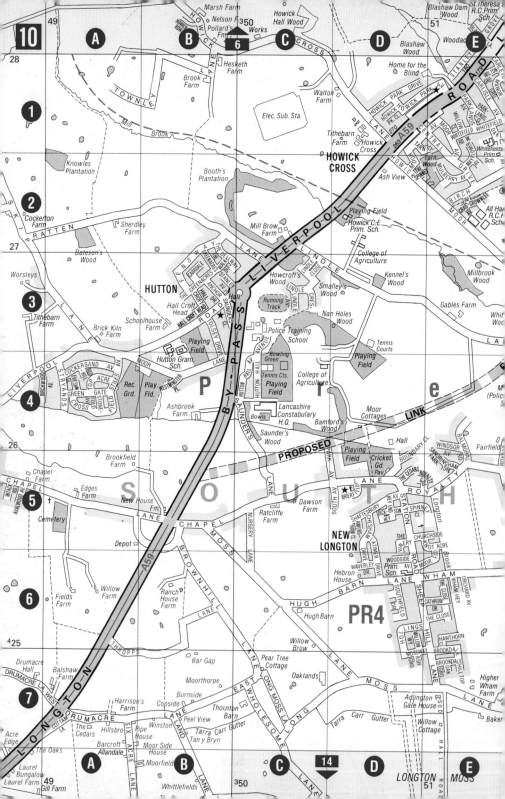

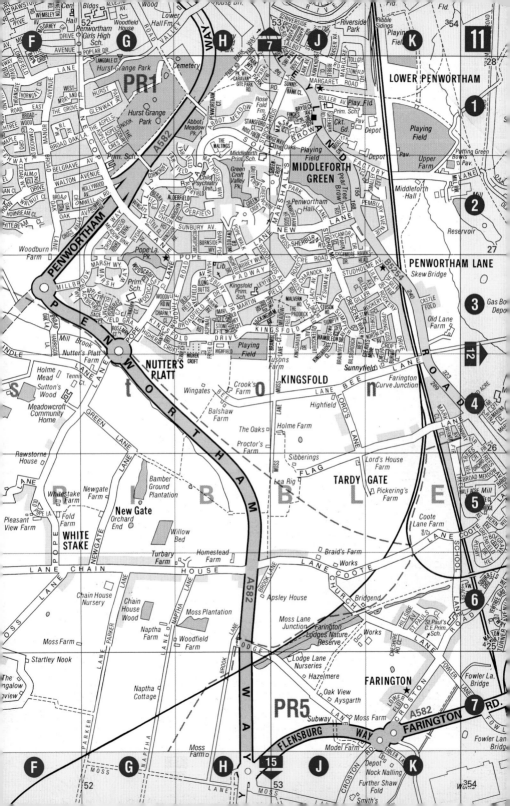

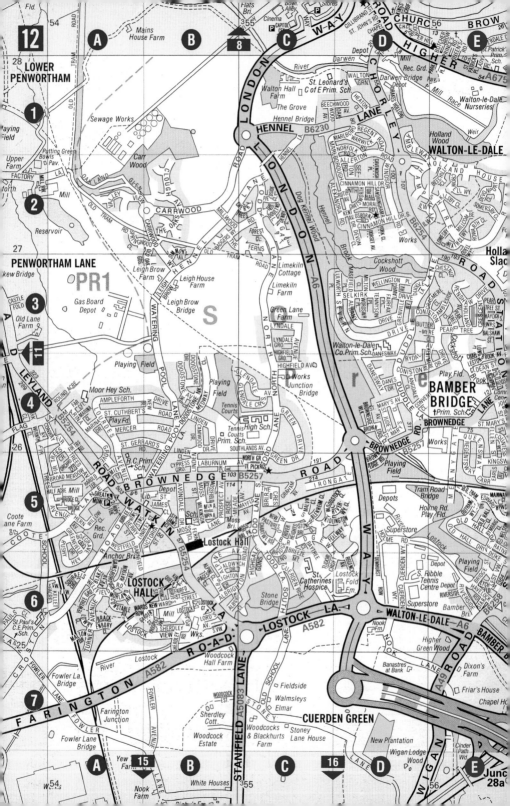

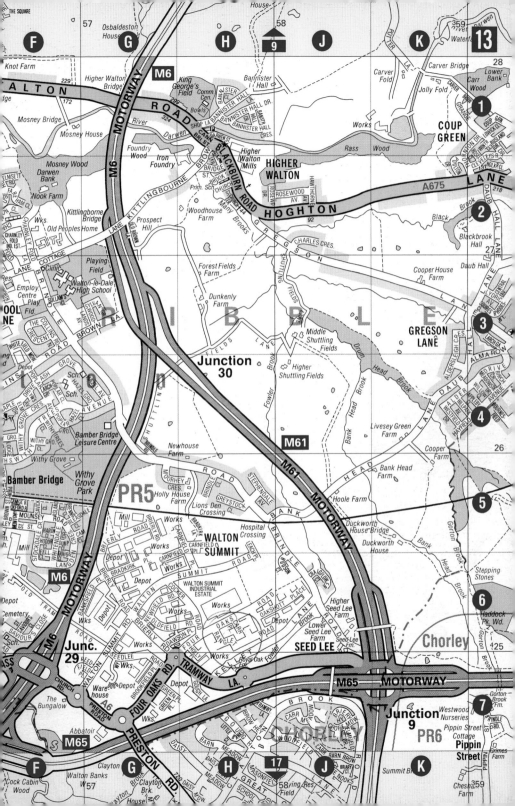

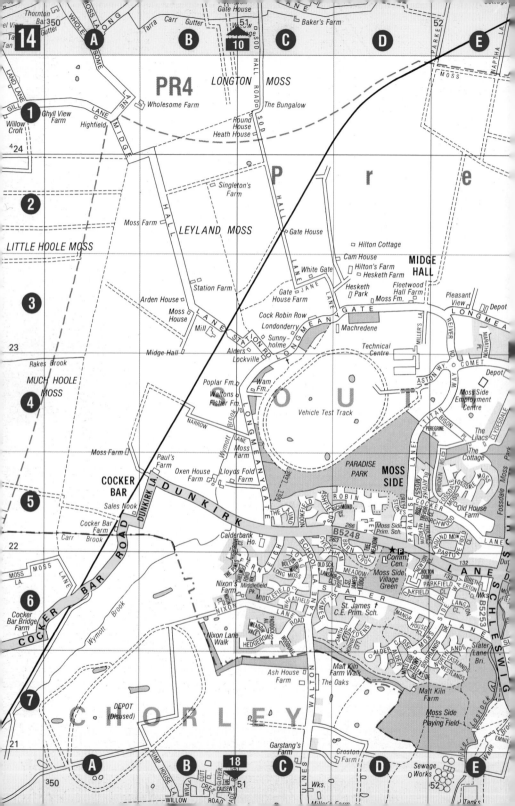

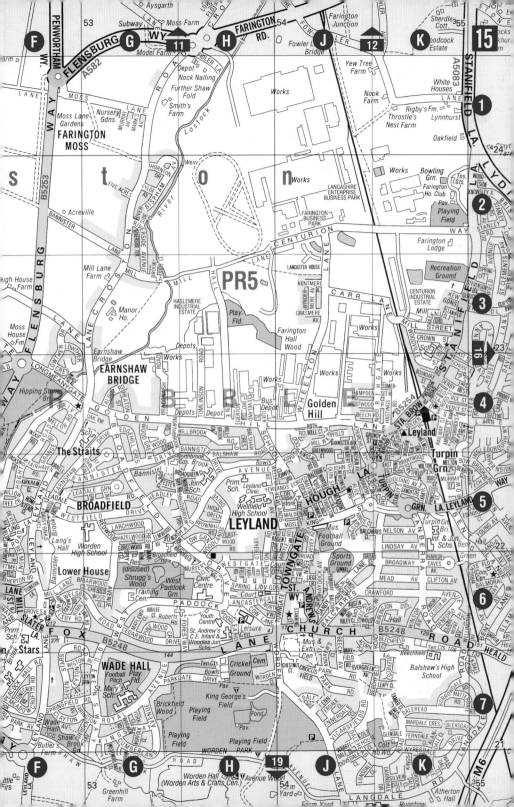

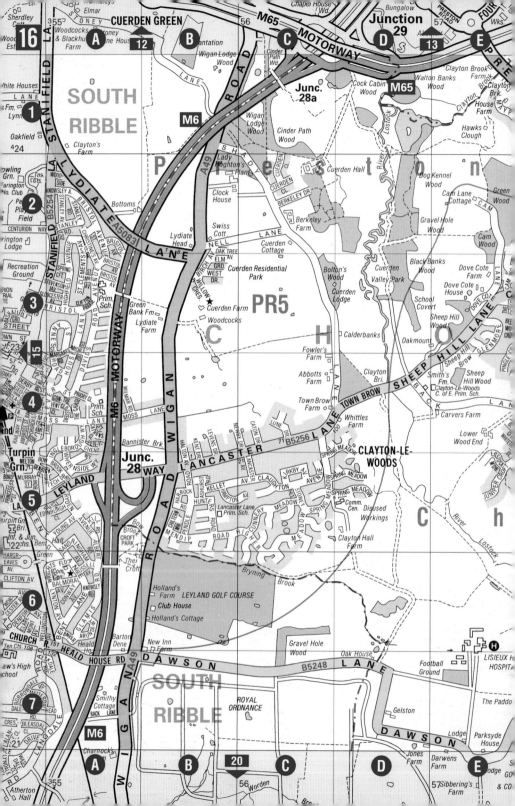

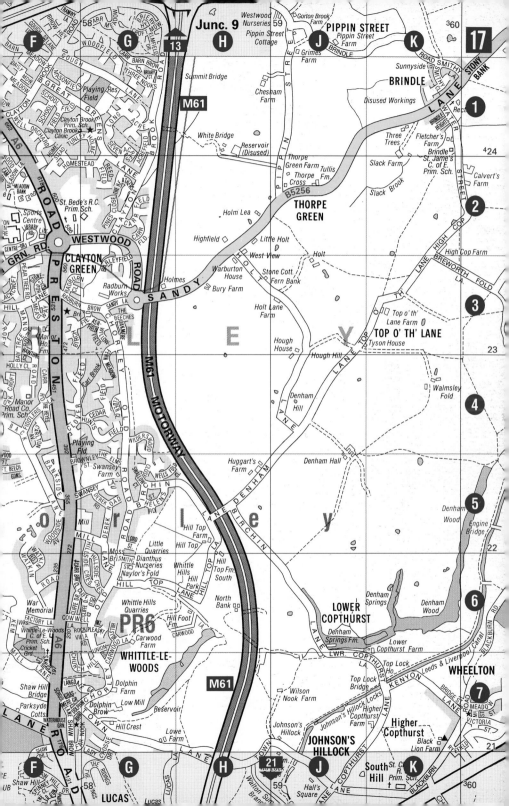

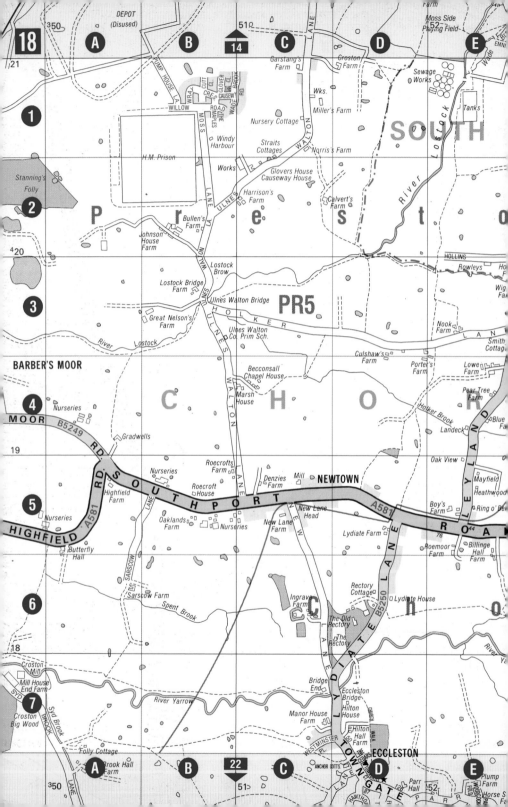

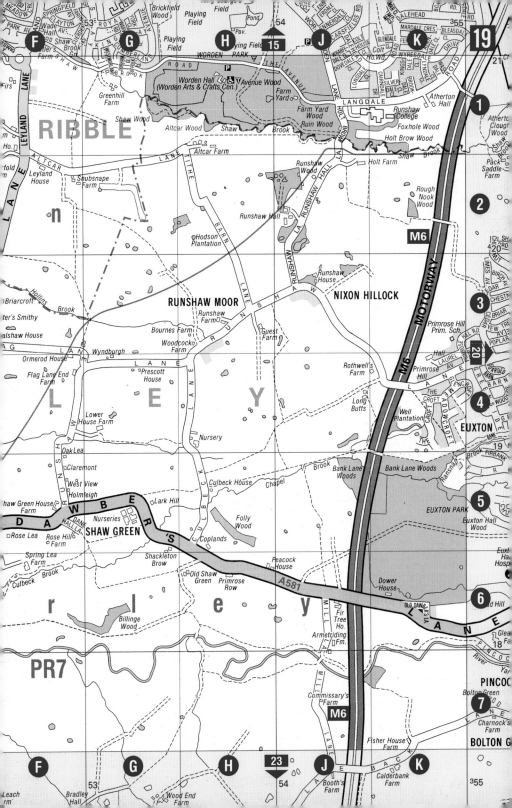

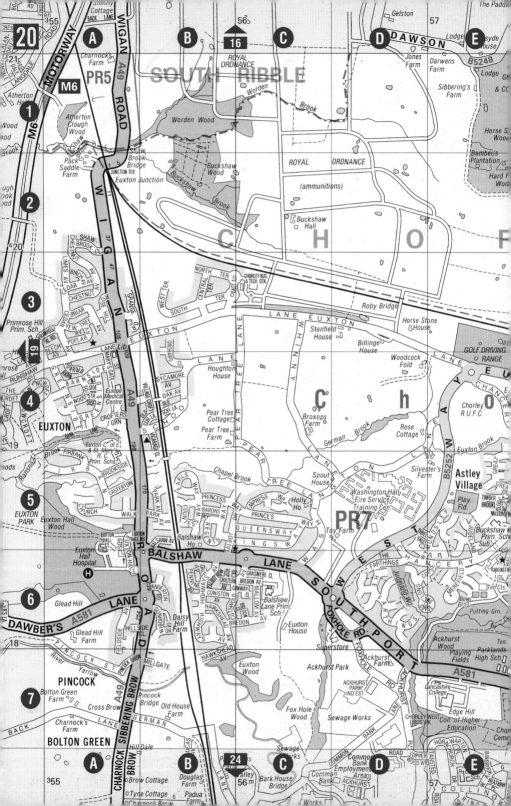

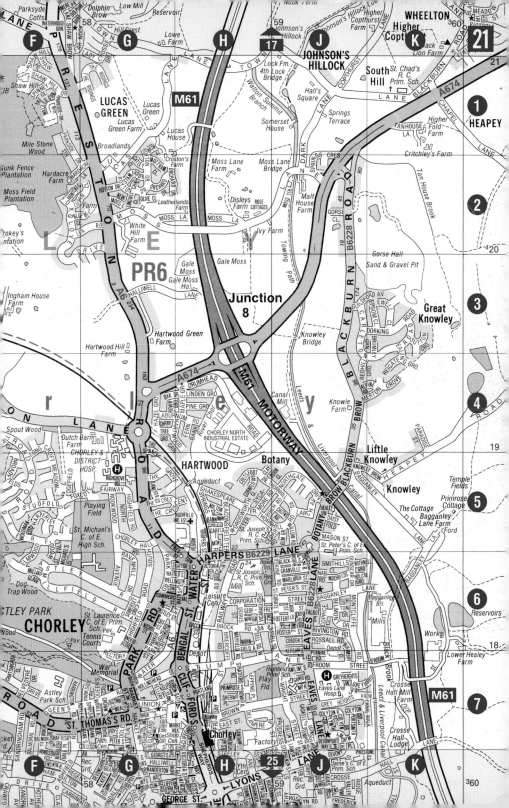

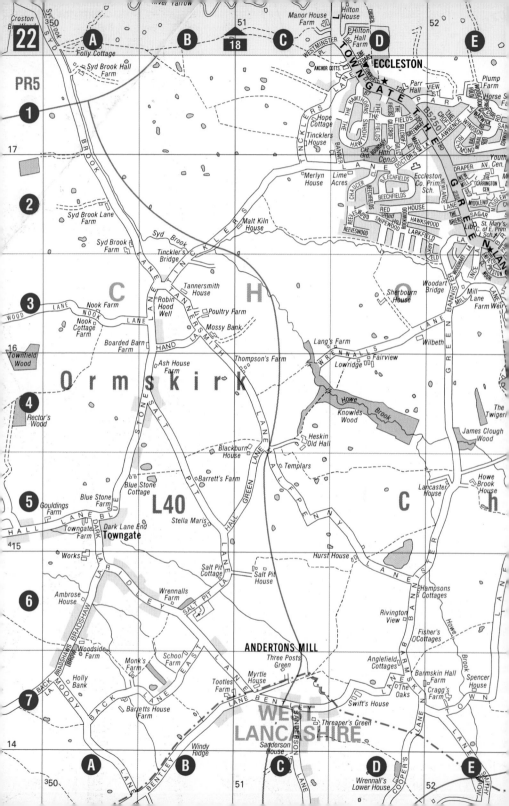

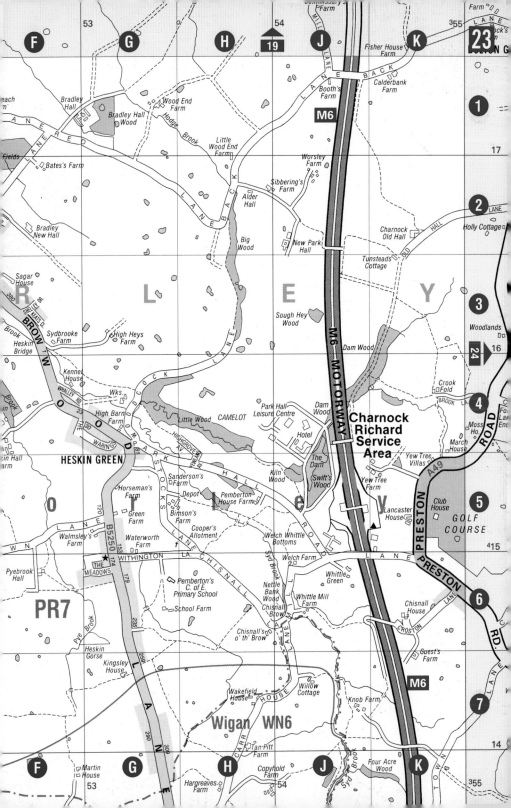

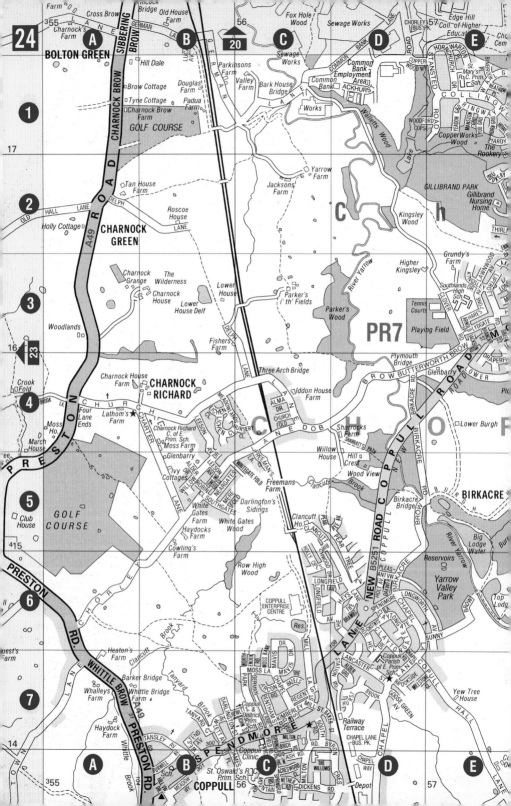

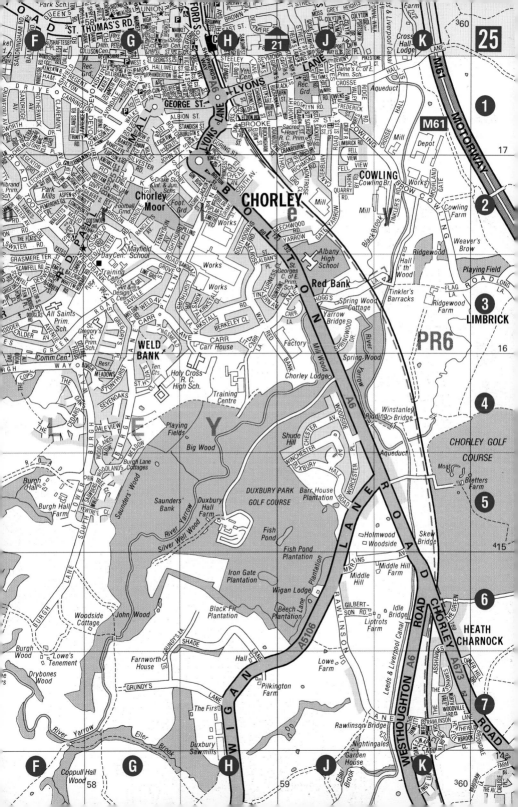

INDEX TO STREETS

HOW TO USE THIS INDEX

1. Each street name is followed by its Posttown or Postal Locality and then by its map reference; e.g. Abbot Meadow. *Pen* —1H **11** is in the Penwortham Postal Locality and is to be found in square 1H on page **11**. The page number being shown in bold type.
 A strict alphabetical order is followed in which Av., Rd., St., etc. (though abbreviated) are read in full and as part of the street name; e.g. Ashmoor St. appears after Ash Meadow but before Ashness Clo.

2. Streets and a selection of Subsidiary names not shown on the Maps, appear in the index in *Italics* with the thoroughfare to which it is connected shown in brackets; e.g. *Adelphi Ho. Pres* —3J **7** *(off Adelphi St.)*

GENERAL ABBREVIATIONS

All : Alley
App : Approach
Arc : Arcade
Av : Avenue
Bk : Back
Boulevd : Boulevard
Bri : Bridge
B'way : Broadway
Bldgs : Buildings
Bus : Business
Cen : Centre
Chu : Church
Chyd : Churchyard
Circ : Circle
Cir : Circus

Clo : Close
Comn : Common
Cotts : Cottages
Ct : Court
Cres : Crescent
Dri : Drive
E : East
Embkmt : Embankment
Est : Estate
Gdns : Gardens
Ga : Gate
Grn : Green
Gro : Grove
Gt : Great
Ho : House

Ind : Industrial
Junct : Junction
La : Lane
Lit : Little
Lwr : Lower
Mnr : Manor
Mans : Mansions
Mkt : Market
M : Mews
Mt : Mount
N : North
Pal : Palace
Pde : Parade
Pk : Park
Pas : Passage

Pl : Place
Rd : Road
S : South
Sq : Square
Sta : Station
St : Street
Ter : Terrace
Up : Upper
Vs : Villas
Wlk : Walk
W : West
Yd : Yard

POSTTOWN AND POSTAL LOCALITIES ABBREVIATIONS

Adl : Adlington
Ash R : Ashton-on-Ribble
Bam B : Bamber Bridge
Breth : Bretherton
Brind : Brindle
Brins : Brinscall
Brou : Broughton
Brtn : Barton
Char R : Charnock Richard
Chor : Chorley
Clay W : Clayton-le-Woods
Cop : Coppull
Cot : Cottam

Ecc : Eccleston
Eux : Euxton
Far : Farington
Far M : Farington Moss
Ful : Fulwood
Grims : Grimsargh
Haig : Haighton
Heap : Heapey
Hesk : Heskin
High B : Higher Bartle
High W : Higher Walton
Hogh : Hoghton
Hth C : Heath Charnock

Hut : Hutton
Ing : Ingol
L Grn : Lightfoot Green
Lea : Lea
Lea T : Lea Town
Ley : Leyland
Longt : Longton
Los H : Lostock Heath
Lwr B : Lower Bartle
Maw : Mawdesley
Midg H : Midge Hall
Mos S : Moss Side
New L : New Longton

Pen : Penwortham
Pres : Preston
Rib : Ribbleton
Sam : Samlesbury
W Sta : White Stake
Walt D : Walton-le-Dale
Wheel : Wheelton
Whit W : Whittle-le-Woods
Wood : Woodplumpton
Wrig : Wrightington

INDEX TO STREETS

Abbey St. *Ash R* —4H **7**
Abbey Wlk. *Pen* —3H **11**
Abbot Meadow. *Pen* —1H **11**
Abbotsway. *Pen* —7G **7**
Abbott Croft. *Ful* —4E **2**
Abingdon Dri. *Ash R* —3E **6**
Acacia Rd. *Rib* —2E **8**
Ackhurst Pk. Ind. Est. *Chor*
　　　　　　　　　　—7D **20**
Ackhurst Rd. *Chor* —7D **20**
Acorn Clo. *Ley* —6J **15**
Acrefield. *Bam B* —2G **17**
Acregate La. *Pres* —3D **8**
Acreswood Clo. *Cop* —7C **24**
Adelaide St. *Pres* —4B **8**
Adelphi Ho. Pres —3J **7**
　(off Adelphi St.)
Adelphi Pl. *Pres* —4K **7**
Adelphi St. *Pres* —3J **7**
Agnes St. *Pres* —4A **8**
Ainsdale Dri. *Ash R* —2B **6**
Ainslie Rd. *Ful* —1J **7**
Alandale Clo. *Ley* —7K **15**
Albany Dri. *Walt D* —3D **12**
Albatross St. *Pres* —3B **8**
Albert Rd. *Ful* —1K **7**
Albert Rd. *Ley* —5A **16**
Albert Rd. *Pres* —2K **7**
Albert St. *Chor* —1H **25**
Albert Ter. *High W* —1H **13**
Albert Ter. *Pres* —3A **8**
Albion St. *Chor* —1G **25**
Albrighton Clo. *Los H* —6B **12**
Albrighton Cres. *Los H* —6B **12**
Albrighton Rd. *Los H* —6B **12**
Albyn Bank Rd. *Pres* —5B **8**

Albyn St. E. *Pres* —5B **8**
Alcester Av. *Pen* —7G **7**
Aldate Gro. *Ash R* —2E **6**
Aldcliffe Rd. *Ash R* —3C **6**
Alder Clo. *Ley* —7D **14**
Alder Coppice. *Lea* —1C **6**
Alder Dri. *Char R* —5B **24**
Alder Dri. *Hogh* —4K **13**
Alderfield. *Pen* —2H **11**
Alder Gro. *Cop* —7D **24**
Alder Rd. *Rib* —7G **5**
Aldersleigh Cres. *Hogh* —4K **13**
Aldfield Av. *Lea* —3A **6**
Aldred St. *Chor* —1H **25**
Aldwych Dri. *Ash R* —2D **6**
Aldwych Dri. *Los H* —6B **12**
Alert St. *Ash R* —3G **7**
Alexandra Rd. *Walt D* —2D **12**
Alexandra St. *Pres* —5C **8**
Alexandre Pavilions. *Pres* —3A **8**
Alford Fold. *Ful* —4A **3**
Alfred's Ct. *Chor* —1G **25**
Alice Av. *Ley* —5J **15**
Alice Sq. *Pres* —3A **8**
Alker La. *Chor* —4E **20**
Alker St. *Chor* —1G **25**
Allenby Av. *Ful* —7B **4**
Allengate. *Ful* —7K **3**
Allerton Rd. *Walt D* —2D **12**
Allington Clo. *Walt D* —2F **13**
Alma Dri. *Char R* —4C **24**
Alma Row. *Hogh* —4K **13**
Alma St. *Pres* —3A **8**
Almond Clo. *Ful* —5D **4**
Almond Clo. *Pen* —2F **11**
Almond St. *Pres* —4B **8**

Alpine Av. *Los H* —6B **12**
Alpine Clo. *Los H* —6B **12**
Alpine Rd. *Chor* —4J **21**
Alsop St. *Pres* —2K **7**
Alston St. *Pres* —3D **8**
Altcar La. *Ley* —2F **19**
Alvern Av. *Ful* —7H **3**
Alvern Cres. *Ful* —7H **3**
Ambergate. *Ing* —5D **2**
Ambleside Av. *Eux* —6B **20**
Ambleside Clo. *Walt D* —3E **12**
Ambleside Rd. *Rib* —6E **4**
Ambleside Wlk. *Rib* —6E **4**
Ambleway. *Walt D* —1D **12**
Ambrose St. *Ley* —4K **15**
Amersham Clo. *New L* —5D **10**
Ampleforth Dri. *Los H* —4A **12**
Anchor Cotts. *Ecc* —1D **22**
Anchor Ct. *Pres* —5K **7**
Anchor Dri. *Hut* —3B **10**
Anderton Rd. *Eux* —6B **20**
Anderton St. *Chor* —1G **25**
Andertons Way. *Ful* —6C **4**
Andrew St. *Pres* —3C **8**
Aniline St. *Chor* —7J **21**
Annis St. *Pres* —4C **8**
Ansdell Gro. *Ash R* —1G **7**
Ansdell St. *Pres* —3C **8**
Appleby Clo. *Hogh* —4K **13**
Appleby St. *Pres* —3K **7**
Applefields. *Ley* —7K **15**
Appletree Clo. *Pen* —1G **25**
Aqueduct St. *Pres* —3H **7**
Archibald All. *Pres* —4K **7**
Archway Bldgs. *Ash R* —3E **6**
Arcon Rd. *Cop* —7C **24**

Ardee Rd. *Pres* —6H **7**
Argyle Rd. *Ley* —6J **15**
Argyll Rd. *Pres* —3A **8**
Arkwright Rd. *Pres* —2K **7**
Arley St. *Chor* —7H **21**
Armstrong St. *Ash R* —2F **7**
Arnhem Rd. *Pres* —4D **8**
Arnold Clo. *Rib* —2E **8**
Arnold Pl. *Chor* —3E **24**
Arno St. *Pres* —6B **8**
Arnott Rd. *Ash R* —2G **7**
Arnside Rd. *Ash R* —2C **6**
Arnside Rd. *Brou* —1H **3**
Arroyo Way. *Ful* —7B **4**
Arthur St. *Chor* —1H **25**
Arthur St. *Pres* —1J **7**
Arundel Pl. *Pres* —5A **8**
Arundel Way. *Ley* —6A **16**
Ashbourne Cres. *Ing* —6E **2**
Ashby St. *Chor* —2G **25**
Ash Coppice. *Lea* —2B **6**
Ashdown M. *Ful* —5E **4**
Asheldon St. *Pres* —3D **8**
Ashfield. *Clay W* —3G **17**
Ashfield. *Ful* —3K **3**
Ashfield Ct. *Ing* —5D **2**
Ashfield Rd. *Chor* —1F **25**
Ashfields. *Ley* —5C **14**
Ashford Cres. *Brtn* —1G **3**
Ashford Rd. *Ash R* —2C **6**
Ash Gro. *Bam B* —4F **13**
Ash Gro. *Chor* —3G **25**
Ash Gro. *New L* —7D **10**
Ash Gro. *Pres* —3E **8**
Ashleigh Ct. *Ful* —4A **4**
Ashleigh St. *Pres* —5C **8**

Ash Meadow. *Lea* —1B **6**
Ashmoor St. *Pres* —3J **7**
Ashness Clo. *Ful* —3K **3**
Ash Rd. *Cop* —7C **24**
Ashton Clo. *Ash R* —3E **6**
Ashtongate. *Ash R* —3C **6**
Ashton St. *Ash R* —4H **7**
Ashtree Ct. *Ful* —7E **2**
Ashtree Gro. *Pen* —1F **11**
Ashurst Rd. *Ley* —5B **16**
Ashwood Rd. *Ful* —4H **3**
Ashworth Ct. *Pres* —6B **8**
Ashworth Gro. *Pres* —6C **8**
Ashworth La. *Pres* —6B **8**
Ashworth St. *Pres* —5B **8**
Asland Clo. *Bam B* —5F **13**
Aspden St. *Bam B* —4E **12**
Aspels Cres. *Pen* —1G **11**
Aspels Nook. *Pen* —1G **11**
Aspels, The. *Pen* —1G **11**
Aspen Gdns. *Chor* —2D **22**
Aspen St. *Bam B* —4E **12**
Aspinall Clo. *Pen* —3H **11**
Asshawes, The. *Hth C* —7K **25**
Assheton Pl. *Rib* —7E **4**
Astley Rd. *Chor* —6F **21**
Astley St. *Chor* —6G **21**
Aston Way. *Mos S* —4D **14**
Athelstan Fold. *Ful* —1G **7**
Atherton Rd. *Ley* —6F **15**
Athol Gro. *Chor* —2J **25**
Atholl St. *Pres* —4H **7**
Aubigny Dri. *Ful* —7H **3**
Aughton Wlk. *Pres* —4K **7**
Austin Clo. *Ley* —6J **15**
Austin Cres. *Ful* —7F **3**
Avalwood Av. *Longt* —5A **10**
Avenham Colonnade. *Pres* —6A **8**
Avenham Ct. *Pres* —5A **8**
Avenham La. *Pres* —6A **8**
Avenham Pl. *Pres* —6A **8**
Avenham Rd. *Chor* —1G **25**
Avenham Rd. *Pres* —5K **7**
Avenham St. *Pres* —5A **8**
Avenham Ter. *Pres* —6A **8**
Avenham Wlk. *Pres* —6A **8**
Avenue, The. *Adl* —7K **25**
Avenue, The. *Ley* —5E **2**
Avenue, The. *Lea* —3B **6**
Avenue, The. *Ley* —1J **19**
Avenue, The. *Pen* —1F **11**
Avon Bri. *Ful* —3G **3**
Avondale Dri. *Los H* —5B **12**
Avondale Rd. *Chor* —1G **25**
Avon Ho. *Pres* —4D **8**
Aysgarth Av. *Ful* —4K **3**
Azalea Clo. *Ful* —5C **4**

Bk. Fazakerley St. *Chor* —7G **21**
Bk. Grimshaw St. *Pres* —5A **8**
Back La. *Char R* —2H **23**
Back La. *Clay W* —4D **16**
Back La. *Ley* —7A **16**
Back La. E. *Maw* —7A **22**
Back Mt. *Chor* —7G **21**
Bk. Seed St. *Pres* —4K **7**
Bk. Starkie St. *Pres* —6K **7**
Badgers Croft. *Rib* —2F **9**
Badgers Way. *Los H* —2B **12**
Bagganley La. *Chor* —5J **21**
(in two parts)
Bagnold Rd. *Pres* —3D **8**
Bairstow St. *Pres* —5K **7**
Baker St. *Cop* —7C **24**
Baker St. *Ley* —4K **15**
Balcarres Clo. *Ley* —5J **15**
Balcarres Pl. *Ley* —6J **15**
Balcarres Rd. *Chor* —3F **25**

Balcarres Rd. *Ley* —6J **15**
Balcarres Rd. *Pres* —1G **7**
Balderstone Rd. *Pres* —7H **7**
Baldwin. *Bam B* —4E **12**
Balfour Av. *Chor* —2F **25**
Balfour Rd. *Ful* —1J **7**
Balfour St. *Ley* —5J **15**
Ballam Rd. *Ash R* —3C **6**
Balmoral Av. *Ley* —6A **16**
Balmoral Ct. *Chor* —7F **21**
Balmoral Rd. *Chor* —7F **21**
Balmoral Rd. *Ecc* —1E **22**
Balmoral Rd. *New L* —4E **10**
Balmoral Rd. *Walt D* —2D **12**
Balniel Clo. *Chor* —1F **25**
Balshaw Av. *Eux* —5B **20**
Balshaw Cres. *Ley* —4H **15**
Balshaw La. *Eux* —6B **20**
Balshaw Rd. *Ley* —5H **15**
Balshaw St. *Bam B* —3E **12**
Bamber Bri. By-Pass. *Bam B*
—6E **12**
Bamber St. *Chor* —3F **25**
Bambers Yd. *Pres* —5K **7**
Banastre. *Chor* —5E **20**
Banbury Dri. *Ful* —7J **3**
Bangal St. *Chor* —6G **21**
Bank Head La. *Bam B* —5J **13**
Bank La. *Eux* —4A **20**
Bank Pde. *Pen* —2H **11**
Bank Pde. *Pres* —6A **8**
Bank Pl. *Ash R* —3G **7**
Banksfield Av. *Ful* —1G **7**
Banksfield Pl. *Bam B* —6G **13**
Bankside. *Clay W* —5F **17**
Banks Rd. *Ful* —1G **7**
Bannell St. *Chor* —7G **21**
Banner Clo. *Ecc* —1D **22**
Bannerman Ter. *Chor* —5H **21**
Bannister Brook Ho. *Ley* —4J **15**
Bannister Clo. *High W* —1H **13**
Bannister Dri. *Ley* —5G **15**
Bannister Grn. *Hesk* —6D **22**
Bannister Hall Cres. *High W*
—1H **13**
Bannister Hall Dri. *High W*
—1H **13**
Bannister Hall La. *High W* —1H **13**
Bannister La. *Ecc* —3E **22**
Bannister La. *Far M* —2F **15**
Bannisters Bit. *Pen* —3G **11**
Bannister St. *Chor* —1G **25**
Bar Club St. *Bam B* —6E **12**
Barden Pl. *Rib* —7D **4**
Bardsea Pl. *Ing* —1D **6**
Barleyfield. *Bam B* —3G **17**
Barlow St. *Pres* —3J **7**
(in three parts)
Barmskin La. *Hesk* —6D **22**
Barnacre Clo. *Ful* —3A **4**
Barn Croft. *Ley* —5D **14**
Barn Croft. *Pen* —1F **11**
Barnfield. *Los H* —5A **12**
Barn Meadow. *Bam B* —7H **13**
Barnsfold. *Ful* —5H **3**
Barnside. *Eux* —4A **20**
Barons Way. *Eux* —5B **20**
Barry Av. *Ing* —1D **6**
Bartle La. *Lwr B* —4A **2**
Bartle Pl. *Ash R* —3C **6**
Bashall Gro. *Far* —3K **15**
Basil St. *Pres* —2C **8**
Bath St. *Ash R* —3H **7**
Bay Rd. *Rib* —2E **8**
Baytree Clo. *Los H* —5C **12**
Bay Tree Farm. *Lea* —4B **6**
Bay Tree Rd. *Clay W* —4F **17**
Beachley Rd. *Ing* —7E **2**
Beacon Av. *Ful* —7H **3**
Beacon Gro. *Ful* —7H **3**
Beaconsfield Av. *Pres* —4F **9**

Beaconsfield Ter. *Chor* —5H **21**
Beacon St. *Chor* —1H **25**
Beamont Dri. *Pres* —4H **7**
Bearswood Croft. *Clay W* —4F **17**
Beatty Av. *Chor* —2F **25**
Beaumaris Rd. *Ley* —6A **16**
Beckett Ct. *Pres* —3K **7**
Bedford Rd. *Ful* —7A **4**
Bedford St. *Chor* —2G **25**
Beech Av. *Eux* —3A **20**
Beech Av. *Ley* —6J **15**
Beech Dri. *Ful* —3H **3**
Beeches, The. *Brind* —3G **17**
Beechfield Ct. *Ley* —6K **15**
Beechfield Rd. *Ley* —6J **15**
Beechfields. *Ecc* —2D **22**
Beech Gdns. *Clay W* —5F **17**
Beech Gro. *Ash R* —3F **7**
Beechill Clo. *Walt D* —2E **12**
Beech Rd. *Ley* —4J **15**
Beech St. *Pres* —6H **7**
Beech St. S. *Pres* —6J **7**
Beech Ter. *Pres* —6J **7**
Beechway. *Ful* —7A **4**
Beechway. *Pen* —1F **11**
Beechwood Av. *Ful* —7G **3**
Beechwood Av. *Walt D* —1C **12**
Beechwood Croft. *Clay W* —3E **16**
Beechwood Rd. *Chor* —2J **25**
Bee La. *Pen* —4H **11**
Beenland St. *Pres* —4D **8**
Belgrave Av. *Pen* —2F **11**
Belgrave Rd. *Ley* —6H **15**
Belmont Av. *Rib* —1D **8**
Belmont Clo. *Rib* —2D **8**
Belmont Cres. *Rib* —2D **8**
Belmont Dri. *Chor* —7F **21**
Belmont Rd. *Ash R* —2G **7**
Belmont Rd. *Ley* —5F **15**
Belton Hill. *Ful* —3H **3**
Belvedere Dri. *Chor* —7F **21**
Belvedere Rd. *Ley* —4K **15**
Bence Rd. *Pres* —5B **8**
Bengal St. *Chor* —6H **21**
Bentham St. *Cop* —7C **24**
Bent La. *Ley* —6A **16**
Bentley La. *Bis* —7B **22**
Benton Rd. *Rib* —7D **4**
Berkeley Clo. *Chor* —3H **25**
Berkeley Dri. *Bam B* —2C **16**
Berkeley St. *Pres* —3J **7**
Berry Field. *Pen* —2G **11**
Berry St. *Los H* —5A **12**
Berry St. *Pres* —5A **8**
Berwick Dri. *Ful* —7H **3**
Berwick Rd. *Pres* —6A **8**
Berwick St. *Pres* —3E **8**
Beverley Clo. *Ash R* —3G **7**
Bexhill Rd. *Ing* —1E **6**
Bidston St. *Pres* —4E **8**
Bilsborough Hey. *Pen* —4J **11**
Bilsborough Meadow. *Lea* —1C **6**
Binbrook Pl. *Chor* —1E **24**
Birch Av. *Ash R* —2E **6**
Birch Av. *Eux* —3A **20**
Birch Av. *Ley* —3B **16**
Birch Av. *Pen* —2E **10**
Birch Cres. *Hogh* —4K **13**
Birches, The. *Pres* —3C **8**
Birch Field. *Clay W* —3F **17**
Birchin La. *Clay W* —5G **17**
Birchover Clo. *Ing* —6E **2**
Birch Rd. *Chor* —5H **21**
Birch Rd. *Cop* —7C **24**
Birchwood. *Pres* —5E **14**
Birchwood Av. *Hut* —4A **10**
Birchwood Dri. *Cop* —5C **24**
Birchwood Dri. *Ful* —4H **3**
Bird St. *Pres* —6H **7**
Birkacre Brow. *Cop* —6D **24**
Birkacre Rd. *Chor* —4D **24**

Birkdale Dri. *Ash R* —2B **6**
Birkett Dri. *Rib* —1G **9**
Birkett Pl. *Rib* —1G **9**
Birk St. *Pres* —5J **7**
Birley Bank. *Pres* —4C **8**
Birley St. *Pres* —5K **7**
Birtwistle St. *Los H* —6B **12**
Bishopgate. *Pres* —4A **8**
Bishopsway. *Pen* —2H **11**
Bison Pl. *Ley* —4E **14**
Bispham Av. *Far M* —2G **15**
Bispham St. *Pres* —4K **7**
Blackberry Way. *Pen* —3G **11**
Black Bull La. *Ful* —6H **3**
Blackburn Brow. *Chor* —5J **21**
Blackburn Rd. *Chor* —4J **21**
(in three parts)
Blackburn Rd. *High W* —1H **13**
Blackburn St. *Chor* —1J **25**
Blackcroft. *Clay W* —3F **17**
Blackenbury Clo. *Los H* —6A **12**
Black Horse St. *Chor* —2F **25**
Blackleach Av. *Grims* —2K **5**
Blackpool Rd. *Lea & Pres* —3A **6**
Blackstone Rd. *Chor* —6J **21**
Blackthorn Clo. *Lea* —3B **6**
Blackthorn Croft. *Clay W* —4E **16**
Blackthorn Dri. *Pen* —2F **11**
Blake Av. *Los H* —6A **12**
Blanche St. *Ash R* —3G **7**
Blashaw La. *Pen* —7E **6**
Blaydike Moss. *Ley* —5D **14**
Bleachers Dri. *Ley* —5G **15**
Bleasdale Clo. *Bam B* —5F **13**
Bleasdale Clo. *Ley* —7K **15**
Bleasdale St. E. *Pres* —3B **8**
Blelock St. *Pres* —5A **8**
Blenheim Clo. *Los H* —5C **12**
Bloomfield Ct. *Pres* —2J **7**
Bloomfield Grange. *Pen* —3G **11**
Blossoms, The. *Ful* —5C **4**
Bluebell Clo. *Whit W* —2F **21**
Bluebell Pl. *Pres* —5A **8**
Blue Stone La. *Maw* —5A **22**
Blundell La. *Pen* —6F **7**
Blundell Rd. *Ful* —1J **7**
Boarded Barn. *Eux* —4A **20**
Bodmin St. *Pres* —3D **8**
Boegrave Av. *Los H* —5A **12**
Bold St. *Pres* —2H **7**
Bolton Croft. *Ley* —6D **14**
Bolton Meadow. *Ley* —6C **14**
Bolton Rd. *Chor* —2H **25**
Bolton's Ct. *Pres* —5A **8**
Bolton St. *Chor* —1G **25**
Bone Croft. *Clay W* —4F **17**
Bootle St. *Pres* —3C **8**
(in two parts)
Borrowdale Rd. *Ley* —7K **15**
Bostock St. *Pres* —5A **8**
Botany Brow. *Chor* —5J **21**
Boulevard. *Pres* —7B **8**
Boundary Clo. *Ecc* —1D **22**
Boundary Clo. *New L* —5D **10**
Boundary Rd. *Ful* —1H **7**
Boundary St. *Ley* —4K **15**
Bournesfield. *Hogh* —4K **13**
Bouverie St. *Pres* —3E **8**
Bow Brook Rd. *Ley* —5K **15**
Bowland Av. *Chor* —7H **21**
Bowland Pl. *Rib* —1G **9**
Bowland Rd. *Rib* —1G **9**
Bow La. *Ley* —5K **15**
Bow La. *Pres* —5J **7**
Bowlers Clo. *Ful* —5C **4**
Bowlingfield. *Ing* —5E **2**
Bowness Rd. *Pres* —3G **9**
Bowran St. *Pres* —4J **7**
Bow St. *Ley* —4K **15**
Boxer Pl. *Ley* —3E **14**
Boys La. *Ful* —6G **3**

Brabiner La. *Haig* —1H **5**
Bracewell Rd. *Rib* —6E **4**
Brackenbury Clo. *Los H* —6A **12**
Brackenbury Rd. *Ful & Pres* —1J **7**
Brackenbury St. *Pres* —2J **7**
Braconash Rd. *Ley* —4G **15**
Braddon St. *Pres* —3D **8**
Bradkirk La. *Bam B* —5H **13**
Bradkirk Pl. *Bam B* —6G **13**
Bradley La. *Ecc* —2E **22**
Bradshaw La. *Hth C* —7K **25**
Bradshaw La. *Maw* —6A **22**
Bradshaws Brow. *Maw* —7A **22**
Braefield Cres. *Rib* —2F **9**
Braintree Av. *Pen* —4J **11**
Bramble Ct. *Pen* —3J **11**
Brambles, The. *Cop* —6D **24**
Brambles, The. *Ful* —5D **4**
Brampton St. *Ash R* —3G **7**
Brancker St. *Chor* —3E **24**
Brandiforth St. *Bam B* —2F **13**
Brant Rd. *Pres* —3G **9**
Brantwood Dri. *Ley* —5K **15**
Brayshaw Pl. *Rib* —7E **4**
Bray St. *Ash R* —3G **7**
Bredon Av. *Eux* —6C **20**
(in two parts)
Bredon Clo. *Eux* —6C **20**
Breeze Mt. *Los H* —6C **12**
Brennand Clo. *Bam B* —5F **13**
Bretherton Clo. *Ley* —6E **14**
Bretherton Ter. *Ley* —5J **15**
Breworth Fold La. *Brind* —3K **17**
Briar Av. *Eux* —3A **20**
Briar Gro. *Ing* —7E **2**
Briars, The. *Ful* —5D **4**
Briarwood Clo. *Ley* —6G **15**
Briary Ct. *Bam B* —1G **17**
Bridge Bank. *Walt D* —6C **8**
Bridge Clo. *Los H* —5A **12**
Bridge Ct. *Los H* —5A **12**
Bridge End. *Los H* —5C **12**
Bridge Rd. *Ash R* —2G **7**
Bridge Rd. *Los H* —5C **12**
Bridge St. *Bam B* —6E **12**
Bridge St. *High W* —2H **13**
Bridge St. *Wheel* —7K **17**
Bridge Ter. *Walt D* —6C **8**
Bridgeway. *Los H* —5C **12**
Briercliffe Rd. *Chor* —6H **21**
Brierfield. *New L* —5D **10**
Brierley St. *Ash R* —3H **7**
Brierly Rd. *Bam B* —5G **13**
Briers, The. *Ecc* —2E **22**
Briery Clo. *Ful* —7C **4**
Brieryfield Rd. *Pres* —4H **7**
Briery Hey. *Bam B* —7J **13**
Briggs Rd. *Ash R* —2G **7**
Brighton Cres. *Ing* —1E **6**
Brighton St. *Chor* —7J **21**
Brindle Clo. *Bam B* —5H **13**
Brindle Heights. *Brind* —1K **17**
Brindle Rd. *Bam B* —3F **13**
Brindle Rd. *Brind* —7K **13**
Brindle St. *Chor* —2G **25**
Brindle St. *Pres* —4C **8**
Bristol Av. *Far* —2A **16**
Bristow Av. *Ash R* —2F **7**
Brixey St. *Pres* —6H **7**
Brixton Rd. *Pres* —6B **8**
Broadfield. *Brou* —1F **3**
Broadfield Dri. *Ley* —4G **15**
Broadfield Dri. *Pen* —3H **11**
Broadfields. *Chor* —7E **21**
Broadfield Wlk. *Ley* —5H **15**
Broadgate. *Pres* —6H **7**
Broadgreen Clo. *Ley* —5H **15**
Broad Meadow. *Los H* —5A **12**
Broad Oak Grn. *Pen* —2F **11**
Broad Oak La. *Pen* —2F **11**
(in two parts)

Broad Sq. *Ley* —6J **15**
Broad St. *Ley* —6J **15**
Broadway. *Ash R* —2D **6**
Broadway. *Ful* —4H **3**
Broadway. *Ley* —6K **15**
Broadwood Clo. *Pen* —1F **11**
Broadwood Dri. *Ful* —4J **3**
Brockholes Brow. *Pres* —3G **9**
Brockholes View. *Pres* —5C **8**
Brock Rd. *Chor* —6H **21**
Bromley Grn. *Chor* —3K **21**
Bromley St. *Pres* —4H **7**
Brook Croft. *Ing* —7F **3**
Brookdale. *Hth C* —7K **25**
Brookdale. *New L* —7E **10**
Brookdale Clo. *Ley* —1K **19**
Brooke St. *Chor* —1H **25**
Brookfield Av. *Ful* —7C **4**
Brookfield Dri. *Ful* —3J **3**
Brookfield Pl. *Bam B* —7G **13**
Brookfield St. *Pres* —3K **7**
Brookhouse St. *Ash R* —3H **7**
Brooklands. *Ash R* —3E **6**
Brooklands Av. *Ful* —4J **3**
Brook La. *Char R* —4K **23**
Brook La. *W Sta* —7H **11**
(in two parts)
Brookmeadow. *High B* —5D **2**
Brook Pl. *Lea* —2B **6**
Brookside. *Cop* —7D **24**
Brookside. *Eux* —5A **20**
Brookside Clo. *Far M* —3G **15**
Brookside Rd. *Ful* —4H **3**
Brook St. *Ful & Pres* —1H **7**
Brook St. *High W* —2H **13**
Brook St. N. *Ful* —1H **7**
Brookview. *Ful* —6B **4**
Broomfield Mill St. *Pres* —3K **7**
Broughton St. *Pres* —1J **7**
Brow Hey. *Bam B* —7H **13**
Brownedge Clo. *Walt D* —4D **12**
Brownedge La. *Bam B* —4E **12**
Brownedge Rd. *Los H* —5A **12**
(in two parts)
Brownedge Wlk. *Walt D* —4D **12**
Brownhill La. *Longt* —6B **10**
Brownhill Rd. *Ley* —5H **15**
Browning Cres. *Pres* —2D **8**
Browning Rd. *Pres* —2D **8**
Brown La. *Bam B* —3G **13**
Brownley St. *Chor* —1J **25**
Brownley St. *Clay W* —5F **17**
Browns Hey. *Chor* —5E **20**
Brown St. *Bam B* —5F **13**
Brown St. *Chor* —7H **21**
Browsholme Av. *Rib* —1F **9**
Brunswick Pl. *Ash R* —3G **7**
Brunswick St. *Chor* —7H **21**
Brydeck Av. *Pen* —1J **11**
Buchannan St. *Chor* —1H **25**
Buckingham Av. *Pen* —3H **11**
Buckingham St. *Chor* —1H **25**
Bucklands Av. *Ash R* —2H **7**
Buckshaw Hall Clo. *Chor* —5F **21**
Buckton Clo. *Whit W* —1G **21**
Buller Av. *Pen* —1J **11**
Bullfinch St. *Pres* —3B **8**
Bullnose Rd. *Ash R* —5E **6**
Bulmer St. *Ash R* —2G **7**
Burgh Hall Rd. *Chor* —5E **24**
Burgh La. *Chor* —4G **25**
Burgh La. S. *Chor* —6F **25**
Burghley Ct. *Ley* —5K **15**
Burgh Meadows. *Chor* —4G **25**
Burholme Clo. *Rib* —2G **9**
Burholme Pl. *Rib* —2G **9**
Burholme Rd. *Rib* —2G **9**
Burleigh Rd. *Pres* —5H **7**
Burlington Gdns. *Ley* —6K **15**
Burlington St. *Chor* —1H **25**
Burnsall Pl. *Rib* —7E **4**

Burnside Av. *Rib* —1F **9**
Burnside Way. *Pen* —2H **11**
Burnslack Rd. *Rib* —1F **9**
Burns St. *Pres* —2D **8**
Burrington Clo. *Ful* —5D **4**
Burrow Rd. *Pres* —3A **8**
Burwell Av. *Cop* —7B **24**
Burwood Clo. *Pen* —4K **11**
Burwood Dri. *Rib* —1E **8**
Bushell Pl. *Pres* —6A **8**
Bushell St. *Pres* —3K **7**
Bussel Rd. *Pen* —3J **11**
Butcher Brow. *Walt D* —7E **8**
Butler Pl. *Pres* —2K **7**
Butler St. *Pres* —5K **7**
Butterlands. *Pres* —4F **9**
Buttermere Av. *Chor* —2E **24**
Buttermere Clo. *Ful* —7C **4**
Buttermere Clo. *Walt D* —3D **12**
Butterworth Brow. *Chor* —4D **24**
Bymbrig Clo. *Bam B* —5E **12**
Byron Cres. *Cop* —7D **24**
Byron St. *Chor* —7G **21**

Cadley Av. *Ful* —1F **7**
Cadley Causeway. *Ful* —1G **7**
Cadley Dri. *Ful* —1F **7**
Cadogan Pl. *Pres* —6A **8**
Cage La. *New L* —5F **11**
Cairndale Dri. *Ley* —1K **19**
Cairnsmore Av. *Pen* —3F **9**
Calder Av. *Chor* —3F **25**
Calder Av. *Ful* —6K **3**
Calder St. *Ash R* —4F **7**
Callon St. *Pres* —4D **8**
Calverley St. *Pres* —3D **8**
Cambridge Clo. *Pres* —2J **7**
Cambridge Ct. *Pres* —2J **7**
Cambridge Rd. *Bam B* —5F **13**
Cambridge St. *Chor* —1G **25**
Cambridge St. *Pres* —2J **7**
Cambridge Wlk. *Pres* —2J **7**
Cam Clo. *Bam B* —5F **13**
Camden Pl. *Pres* —5K **7**
Cam La. *Bam B* —2E **16**
Campbell St. *Pres* —4B **8**
Campion Dri. *Lea* —3A **6**
Campions, The. *Lea* —3A **6**
Cam St. *Pres* —2C **8**
Camwood. *Bam B* —2F **17**
Camwood Dri. *Los H* —4B **12**
Cam Wood Fold. *Clay W* —3E **16**
Canal Wlk. *Chor* —7K **21**
Canberra Rd. *Ley* —5K **15**
Cann Bri. St. *High W* —1H **13**
Cannon Hill. *Ash R* —3G **7**
Cannon St. *Chor* —7G **21**
Cannon St. *Pres* —5K **7**
Canterbury Rd. *Pres* —3D **8**
Canterbury St. *Chor* —2J **25**
Cantsfield Av. *Ing* —7F **3**
Canute St. *Pres* —3A **8**
Capital Way. *Walt D* —7C **8**
Capitol Cen. *Walt D* —7C **8**
Cardigan St. *Ash R* —3H **7**
Carleton Av. *Ful* —7D **4**
Carleton Dri. *Pen* —1E **10**
Carleton Rd. *Chor* —3J **21**
Carlisle Av. *Pen* —1E **10**
Carlisle Ho. *Pres* —5A **8**
Carlisle Pl. *Adl* —7K **25**
Carloway Av. *Ful* —6C **4**
Carlton Av. *Clay W* —4F **17**
Carlton Dri. *Pres* —7B **8**
Carlton Rd. *Ley* —6H **15**
Carlton St. *Ash R* —4H **7**
Carnarvon Rd. *Pres* —5H **7**
Carnfield Pl. *Bam B* —5H **13**
Carnoustie Clo. *Ful* —4F **3**
Carnoustie Ct. *Pen* —6E **6**

Caroline St. *Pres* —3C **8**
Carr Barn Brow. *Bam B* —1G **17**
Carr Brook Clo. *Whit W* —6F **17**
Carrdale. *Hut* —3B **10**
Carr Field. *Bam B* —2G **17**
Carr Ho. La. *Wrig* —7H **23**
Carrington Cen., The. *Ecc* —2E **22**
Carrington Rd. *Chor* —1F **25**
Carr La. *Chor* —3G **25**
(in three parts)
Carr La. *Far* —3J **15**
Carr Meadow. *Bam B* —7J **13**
Carrol St. *Pres* —3B **8**
Carr Pl. *Bam B* —6H **13**
Carr Rd. *Clay W* —4F **17**
Carr St. *Bam B* —5E **12**
Carr St. *Chor* —6J **21**
Carr St. *Pres* —5B **8**
Carrwood Rd. *Walt D* —2B **12**
Carrwood Way. *Walt D* —2B **12**
Carter St. *Pres* —5H **7**
Cartmel Pl. *Ash R* —2C **6**
(in two parts)
Cartmel Rd. *Ley* —6F **15**
Carver Brow. *Hogh* —1K **13**
Carwood La. *Whit W* —7G **17**
(in two parts)
Casterton. *Eux* —5A **20**
Castle Fold. *Pen* —3K **11**
Castle Mt. *Ful* —4K **3**
Castle St. *Chor* —1H **25**
Castle St. *Pres* —3K **7**
Castleton Rd. *Pres* —3B **8**
Castle Wlk. *Pen* —5G **7**
Catforth Rd. *Ash R* —3C **6**
Catherine St. *Chor* —2G **25**
Catherine St. *Pres* —4B **8**
Cathrow Dri. *New L* —6E **10**
Catley Clo. *Whit W* —2G **21**
Caton Dri. *Ley* —4C **16**
Causeway Av. *Ful* —7F **3**
Causeway, The. *Ley* —1B **18**
Cavendish Cres. *Rib* —1F **9**
Cavendish Dri. *Rib* —1F **9**
Cavendish Pl. *Walt D* —2D **12**
Cavendish Rd. *Pres* —3E **8**
Cavendish St. *Chor* —1J **25**
Cave St. *Pres* —4D **8**
Caxton Rd. *Ful* —3B **4**
Cecilia St. *Pres* —3D **8**
Cedar Av. *Ash R* —2E **6**
Cedar Av. *Eux* —3A **20**
Cedar Av. *Los H* —5B **12**
Cedar Clo. *Grims* —2K **5**
Cedar Field. *Clay W* —4G **17**
Cedar Rd. *Chor* —5H **21**
Cedar Rd. *Rib* —2E **8**
Cedars, The. *Chor* —4F **25**
Cedars, The. *Ecc* —1D **22**
Cedars, The. *New L* —5D **10**
Cedar Way. *Pen* —2F **11**
Cedarwood Dri. *Ley* —6G **15**
Cemetery Rd. *Pres* —3C **8**
Central Av. *Hogh* —3K **13**
Central Dri. *Pen* —1D **10**
Central Ter. *Eux* —3B **20**
Centre Dri. *Clay W* —3F **17**
Centurion Ct. *Ful* —7K **3**
Centurion Ind. Est. *Far* —3K **15**
Centurion Way. *Far* —2J **15**
Chaddock St. *Pres* —5K **7**
Chain Caul Rd. *Ash R* —5C **6**
Chain Caul Way. *Ash R* —4C **6**
Chain Ho. La. *W Sta* —6G **11**
Chalfont Field. *Ful* —6G **3**
Chancery Rd. *Chor* —6D **20**
Chandler St. *Pres* —4J **7**
Channel Way. *Ash R* —4G **7**
Chapel Brow. *Ley* —5J **15**
Chapel La. *Cop* —6D **24**
Chapel La. *Heap* —1K **21**

Chapel La. *Longt* —5A **10**
Chapel La. *New L* —5B **10**
Chapel La. Bus. Pk. *Cop* —7D **24**
Chapel Rd. *Ful* —7A **4**
Chapel St. *Chor* —7G **21**
Chapel St. *Cop* —7C **24**
Chapel St. *Pres* —5K **7**
Chapel Walks. *Pres* —5K **7**
Chapel Way. *Cop* —7D **24**
Chapel Yd. *Cop* —6D **24**
Chapel Yd. *Walt D* —7D **8**
Chapman Rd. *Ful* —1A **8**
Charles Cres. *Hogh* —2J **13**
Charleston Ct. *Bam B* —4E **12**
Charles Way. *Ash R* —2C **6**
Charlesway Ct. *Lea* —2C **6**
Charlotte Pl. *Pres* —5A **8**
Charlotte St. *Pres* —6A **8**
Charnley Clo. *Pen* —5K **7**
Charnley Fold. *Walt D* —2F **13**
Charnley Fold Ind. Est. *Bam B*
—2F **13**
Charnley Fold La. *Bam B* —2F **13**
Charnley St. *Pres* —5K **7**
Charnock Av. *Pen* —3J **11**
Charnock Brow. *Chor* —1A **24**
Charnock Fold. *Pres* —2A **8**
Charnock St. *Chor* —1H **25**
Charnock St. *Ley* —5J **15**
Charnock St. *Pres* —2A **8**
Charter La. *Char R* —4B **24**
Chartwell Rise. *Los H* —5C **12**
Chasden Clo. *Whit W* —2G **21**
Chase, The. *Ley* —4A **16**
Chatburn Rd. *Rib* —7E **4**
Chatham Pl. *Chor* —7J **21**
Chatham Pl. *Pres* —2B **8**
Chatsworth Clo. *Chor* —7F **21**
Chatsworth Ct. *Hth C* —7K **25**
Chatsworth Rd. *Ley* —5J **15**
Chatsworth Rd. *Walt D* —2D **12**
Chatsworth St. *Pres* —4C **8**
Chaucer Clo. *Ecc* —2D **22**
Chaucer St. *Pres* —2D **8**
Cheam Av. *Chor* —2H **25**
Cheapside. *Chor* —1G **25**
Cheapside. *Pres* —5K **7**
Cheddar Dri. *Ful* —5D **4**
Cheetham Meadow. *Ley* —5C **14**
Chelford Clo. *Pen* —4K **11**
Chelmsford Gro. *Chor* —1F **25**
Chelmsford Pl. *Chor* —1F **25**
Chelmsford Wlk. *Ley* —6C **14**
Cheriton Field. *Ful* —4G **3**
Cherry Clo. *Ful* —5D **4**
Cherry Tree Gro. *Chor* —4G **21**
Cherry Trees. *Los H* —2C **12**
Cherrywood. *Pen* —2E **10**
Cherrywood Clo. *Ley* —6G **15**
Chesham Dri. *New L* —5D **10**
Cheshire Ho. Clo. *Far M* —6K **11**
Chesmere Dri. *Pen* —7F **7**
Chester Av. *Chor* —4J **25**
Chester Rd. *Pres* —3C **8**
Chestnut Av. *Chor* —5J **21**
Chestnut Av. *Eux* —3A **20**
Chestnut Av. *Pen* —1E **10**
Chestnut Clo. *Walt D* —3E **12**
Chestnut Ct. *Ley* —7J **15**
Chestnut Cres. *Rib* —2E **8**
Chestnut Dri. *Ful* —4H **3**
Chestnuts, The. *Cop* —6D **24**
Cheviot Av. *Pres* —4H **7**
Chiltern Av. *Eux* —6B **20**
Chiltern Meadow. *Ley* —5B **16**
Chindits Way. *Ful* —7B **4**
Chines, The. *Ful* —7J **3**
Chingle Clo. *Ful* —5E **4**
Chisnall La. *Hesk* —6H **23**
Chorley Bus. & Technical Cen. *Eux*
—3C **20**

Chorley Hall Rd. *Chor* —5G **21**
Chorley La. *Char R* —6A **24**
Chorley N. Ind. Est. *Chor* —4H **21**
Chorley Old Rd. *Clay W* —5G **17**
Chorley Rd. *Hth C* —6K **25**
Chorley Rd. *Walt D* —1D **12**
Chorley W. Bus. Pk. *Chor* —7D **20**
Christ Chu. St. *Pres* —5J **7**
Christian Rd. *Pres* —5J **7**
Church Av. *Pen* —6G **7**
Church Av. *Pres* —4E **8**
Church Brow. *Chor* —7G **21**
Church Brow. *Walt D* —7D **8**
Churchfield. *Ful* —5K **3**
Church Fold. *Char R* —4C **24**
Church Hill. *Whit W* —7F **17**
Churchill Rd. *Ful* —7C **4**
Churchill Way. *Ley* —4J **15**
Church La. *Brou* —2H **3**
Church La. *Char R* —4A **24**
Church La. *W Sta & Far M* —6J **11**
Church La. *Chor* —6J **15**
(in three parts)
Church Rd. *Ley* —6J **15**
Church Row. *Pres* —5A **8**
Churchside. *New L* —5D **10**
Church St. *Chor* —1G **25**
Church St. *High W* —2H **13**
Church St. *Ley* —4K **15**
Church St. *Pres* —5A **8**
Church Ter. *High W* —2H **13**
Church Wlk. *Ecc* —7D **18**
Church Wlk. *Eux* —5A **20**
Cinnamon Ct. *Pen* —3G **11**
Cinnamon Hill Dri. N. *Walt D*
—2D **12**
Cinnamon Hill Dri. S. *Walt D*
—2D **12**
Cintra Av. *Ash R* —1H **7**
Cintra Ter. *Ash R* —1H **7**
Clairane Av. *Ful* —5J **3**
Clancutt La. *Cop* —5C **24**
Clanfield. *Ful* —4J **3**
Clara St. *Pres* —5C **8**
Claremont Av. *Chor* —1F **25**
Claremont Av. *Ley* —6K **15**
Claremont Rd. *Chor* —3F **25**
Clarence St. *Chor* —1H **25**
Clarence St. *Ley* —4K **15**
Clarence St. Ind. Est. *Chor* —1H **25**
(off Clarence St.)
Clarendon St. *Chor* —1J **25**
Clarendon St. *Pres* —6A **8**
Claughton Av. *Ley* —5C **16**
Clayburn Clo. *Chor* —5H **21**
Clayton Av. *Ley* —7F **15**
Clayton Brook Rd. *Bam B* —1F **17**
Claytongate. *Cop* —6D **24**
Clayton Grn. Cen. *Clay W* —2F **17**
Clayton Grn. Rd. *Clay W* —3E **16**
Clayton's Ga. *Pres* —4K **7**
Clayton St. *Bam B* —4E **12**
Clevedon Rd. *Ing* —7E **2**
Cleveland Av. *Ful* —7C **4**
Cleveland Rd. *Ley* —4H **15**
Cleveland St. *Chor* —7G **21**
Cleveland St. *Cop* —7C **24**
Cleveleys Av. *Ful* —7G **3**
Cleveleys Rd. *Hogh* —2K **13**
Cliffe Ct. *Pres* —4D **8**
Cliffe Dri. *Whit W* —6F **17**
Clifford St. *Chor* —7H **21**
Cliff St. *Pres* —6J **7**
Clifton Av. *Ash R* —2E **6**
Clifton Av. *Ley* —6K **15**
Clifton Dri. *Pen* —7G **7**
Clifton Gro. *Chor* —1F **25**
Clifton Gro. *Pres* —1C **8**
Clifton Ho. *Ful* —7C **4**
Clifton Pde. *Far* —3A **16**
Clifton Pl. *Ash R* —2F **7**

Clifton St. *Pres* —6H **7**
Clitheroe St. *Pres* —5C **8**
Clive Rd. *Pen* —6F **7**
Cloisters, The. *Ash R* —4H **7**
Cloisters, The. *Ley* —4A **16**
Close, The. *Ful* —5E **4**
Close, The. *New L* —6E **10**
(in two parts)
Clough Acre. *Chor* —5E **20**
Clough Av. *Walt D* —2B **12**
Clough, The. *Clay W* —3E **16**
Clovelly Av. *Ash R* —1H **7**
Clovelly Dri. *Pen* —7E **6**
Clover Field. *Clay W* —4F **17**
Cloverfield. *Pen* —1F **11**
Clover Rd. *Chor* —3E **24**
Club St. *Bam B* —6E **12**
Clydesdale Pl. *Ley* —4E **14**
Clyde St. *Ash R* —4G **7**
Cobden St. *Chor* —6J **21**
Cocker Bar Rd. *Ley* —6A **14**
Cocker La. *Ley* —5D **14**
Cocker Rd. *Bam B* —6G **13**
Cockersand Av. *Hut* —4A **6**
Cold Bath St. *Pres* —4J **7**
Colebatch. *Ful* —6H **3**
Colenso Rd. *Ash R* —2G **7**
Colliery Rd. *Chor* —1G **25**
Collingwood Rd. *Chor* —1E **24**
Collinson St. *Pres* —3C **8**
Collins Rd. *Bam B* —4F **13**
Collins Rd. N. *Bam B* —3F **13**
Collison Av. *Chor* —7G **21**
Colman Ct. *Pres* —6H **7**
Colman St. *Pres* —6H **7**
Colt Ho. Clo. *Ley* —7J **15**
Coltsfoot Dri. *Chor* —5H **21**
Colwyn Pl. *Ing* —1E **6**
Colyton Clo. *Chor* —7J **21**
Colyton Rd. *Chor* —7J **21**
Colyton Rd. E. *Chor* —7J **21**
Comet Rd. *Ley* —4E **14**
Commercial Rd. *Chor* —6G **21**
Common Bank La. *Chor* —1D **24**
Compass Rd. *Ash R* —4C **6**
Compton Grn. *Ful* —4G **3**
Conder Rd. *Ash R* —3C **6**
Congress St. *Chor* —6G **21**
Coniston Av. *Ash R* —2H **7**
Coniston Av. *Eux* —6B **20**
Coniston Dri. *Walt D* —3D **12**
Coniston Rd. *Chor* —2F **25**
Coniston Rd. *Ful* —7C **4**
Connaught Rd. *Pres* —7J **7**
Constable Av. *Los H* —6A **12**
Constable St. *Pres* —5A **8**
Convent Clo. *Bam B* —4D **12**
Convent Clo. *Ley* —4A **16**
Conway Av. *Ley* —6A **16**
Conway Av. *Pen* —4K **11**
Conway Clo. *Eux* —6C **20**
Conway Dri. *Ful* —4G **3**
Conway Ho. *Pres* —4D **8**
Conway Rd. *Ecc* —1E **22**
Coombes, The. *Ful* —6K **3**
Co-operative St. *Bam B* —5E **12**
Cooper Hill Clo. *Walt D* —7D **8**
Cooper Hill Dri. *Walt D* —7D **8**
Cooper Rd. *Pres* —4H **7**
Cooper's La. *Hesk* —7D **22**
Coote La. *W Sta* —6J **11**
Cop La. *Pen* —7F **7**
Copperwood Way. *Chor* —1D **24**
Coppice Clo. *Chor* —6J **21**
Coppice, The. *Ing* —7F **3**
Coppull Enterprise Cen. *Cop*
—6C **24**
Coppull Hall La. *Cop* —7E **24**
Coppull Rd. *Chor* —5D **24**
Copse, The. *Chor* —4F **25**
Copthurst La. *Chor* —1J **21**

Corate St. *Chor* —6J **21**
Corncroft. *Pen* —2G **11**
Cornfield. *Cot* —5C **2**
Cornflower Clo. *Chor* —5H **21**
Cornthwaite Rd. *Ful* —1J **7**
Coronation Cres. *Pres* —5B **8**
Corporation St. *Chor* —6H **21**
Corporation St. *Pres* —4K **7**
Cotswold Av. *Eux* —6B **20**
Cotswold Clo. *Ecc* —2F **23**
Cotswold Ho. *Chor* —2G **25**
Cotswold Rd. *Chor* —2G **25**
Cottage Fields. *Chor* —3F **25**
Cottage La. *Bam B* —3F **13**
Cottage St. *Pres* —4A **8**
Cottam Av. *Ing* —7D **2**
Cottam Grn. *Cot* —5C **2**
Cottam Hall La. *Ing* —6C **2**
Cottam La. *Ing & Ash R* —1E **6**
Cottam La. *Longt* —7A **10**
Cottam St. *Chor* —2G **25**
Cottam Way. *Cot* —7B **2**
Cotton Ct. *Pres* —4A **8**
Countess Way. *Bam B* —4E **12**
Countess Way. *Eux* —5B **20**
Coupe Grn. *Hogh* —1K **13**
Court, The. *Ful* —4G **3**
Court, The. *Pen* —1G **11**
Coventry St. *Chor* —2G **25**
Cow La. *Ley* —6H **15**
Cowley Rd. *Rib* —1E **8**
Cowling Brow. *Chor* —1J **25**
Cowling Cotts. *Char R* —5B **24**
Cowling La. *Ley* —5F **15**
Cowling Rd. *Chor* —2K **25**
Cowslip Way. *Chor* —5H **21**
Cow Well La. *Whit W* —6F **17**
Crabtree Av. *Pen* —2E **10**
Cragg's Row. *Pres* —3K **7**
Craigflower Ct. *Bam B* —6J **13**
Cranborne St. *Pres* —4C **8**
Cranbourne Dri. *Chor* —1J **25**
Cranbourne St. *Bam B* —5E **12**
Cranbourne St. *Chor* —1H **25**
Craven Clo. *Ful* —4K **3**
Crawford Av. *Chor* —1F **25**
Crawford Av. *Ley* —6J **15**
Crawford Av. *Pres* —3F **9**
Crescent St. *Pres* —3C **8**
Crescent, The. *Ash R* —2E **6**
Crescent, The. *Bam B* —3F **13**
Crescent, The. *Chor* —5G **21**
Crescent, The. *Lea* —3B **6**
Crescent, The. *Los H* —5C **12**
Creswell Av. *Ing* —1D **6**
Croasdale Av. *Ful* —7E **4**
Crocus Field. *Ley* —7J **15**
Croft Bank. *Pen* —3G **11**
Crofters Grn. *Ful* —4A **20**
Crofters Grn. *Pres* —2J **7**
Crofters Wlk. *Pen* —3H **11**
Croftgate. *Ful* —6K **3**
Croft Meadow. *Bam B* —7J **13**
Croft Pk. *Ley* —6A **16**
Croft Rd. *Chor* —1J **25**
Croft St. *Pres* —4H **7**
(in two parts)
Croft, The. *Ecc* —1E **22**
Croft, The. *Eux* —4K **19**
Crombleholme Rd. *Pres* —3E **8**
Cromer Pl. *Ing* —7E **2**
Cromford Wlk. *Pres* —4C **8**
Crompton St. *Pres* —3C **8**
Cromwell Av. *Pen* —2G **11**
Cromwell Rd. *Pen* —2F **11**
Cromwell Rd. *Rib* —7D **4**
Cromwell St. *Pres* —3A **8**
Crooked La. *Pres* —4A **8**
Crookings La. *Pen* —6E **6**
Crook St. *Chor* —3F **25**
Crook St. *Pres* —4B **8**

Crosby Pl. *Ing* —7E **2**
Crosier Wlk. *Cot* —6C **2**
Crosse Hall La. *Chor* —1J **25**
Crosse Hall St. *Chor* —1K **25**
Cross Field. *Hut* —4A **10**
Cross Grn. Rd. *Ful* —5J **3**
Cross Halls. *Pen* —2F **11**
Cross St. *Chor* —6G **21**
Cross St. *Ley* —4K **15**
Cross St. *Pres* —5K **7**
Cross Swords Clo. *Chor* —3E **24**
Croston La. *Char R* —6K **23**
Croston Rd. *Far M & Los H*
—3G **15**
Crowell Way. *Walt D* —2E **12**
Crow Hills Rd. *Pen* —7E **6**
Crowle St. *Pres* —4D **8**
Crownlee. *Pen* —2E **10**
Crown St. *Chor* —7G **21**
Crown St. *Far* —3K **15**
Crown St. *Pres* —4A **8**
Crummock Rd. *Pres* —3G **9**
Cuerdale La. *Walt D* —7F **9**
Cuerden Av. *Ley* —7F **15**
Cuerden Clo. *Bam B* —2C **16**
Cuerden Rise. *Los H* —6C **12**
Cuerden St. *Chor* —1J **25**
Cuerden Way. *Bam B* —5D **12**
Culbeck La. *Eux* —5H **19**
Cumberland Av. *Ley* —7G **15**
Cumberland Ho. *Pres* —4K **7**
(off Moor La.)
Cunliffe St. *Chor* —1G **25**
Cunliffe St. *Pres* —4A **8**
Cunnery Meadow. *Ley* —5C **16**
Cunningham Av. *Chor* —2F **25**
Curate St. *Chor* —6J **21**
Curwen St. *Pres* —3C **8**
(in two parts)
Customs Way. *Ash R* —4G **7**
Cutt Clo. *Ley* —1B **18**
Cuttle St. *Pres* —4D **8**
Cyon Clo. *Pen* —7J **7**
Cypress Clo. *Rib* —7G **5**
Cypress Gro. *Los H* —5B **12**

Dacca St. *Chor* —6H **21**
Daisy Bank Clo. *Ley* —5F **15**
Daisy Croft. *Lea* —4B **6**
Daisyfields. *High B* —4D **2**
Daisy Fold. *Chor* —5J **21**
Daisy La. *Pres* —1C **8**
Daisy Meadow. *Bam B* —7G **13**
Dakin St. *Chor* —1H **25**
Dalby Clo. *Pres* —1D **8**
Dale Av. *Eux* —6B **20**
Dalehead Rd. *Ley* —7J **15**
Dale St. *Pres* —4B **8**
Daleview. *Chor* —4G **25**
Dallas St. *Pres* —1J **7**
Dalmore Rd. *Ing* —1E **6**
Dane Hall La. *Eux* —5F **19**
Danes Dri. *Walt D* —4D **12**
Danesway. *Hth C* —7K **25**
Danesway. *Pen* —1E **10**
Danesway. *Walt D* —4D **12**
Danewerk St. *Pres* —4A **8**
Darkinson La. *Lea T* —7A **2**
Dark La. *Maw* —5A **22**
Dark La. *Whit W* —1J **21**
Darlington St. *Cop* —7B **24**
Dart St. *Ash R* —4G **7**
Darwen St. *High W* —1H **13**
Darwen St. *Pres* —5C **8**
Darwen View. *Walt D* —7E **8**
Daub Hall La. *Hogh* —4K **13**
Dawber's La. *Eux* —5F **19**
Dawlish Pl. *Ing* —1E **6**
Dawnay Rd. *Rib* —1E **8**
Dawson La. *Ley & Whit W* —7B **16**

Dawson Pl. *Bam B* —6G **13**
Dawson Wlk. *Pres* —3K **7**
Dean St. *Bam B* —4E **12**
Deborah Av. *Ful* —4A **4**
Deepdale Mill St. *Pres* —3B **8**
Deepdale Retail Pk. *Pres* —1C **8**
Deepdale Rd. *Pres & Ful* —4B **8**
Deepdale St. *Pres* —4B **8**
Deerfold. *Chor* —5F **21**
Deighton Av. *Ley* —6J **15**
Deighton Rd. *Chor* —2F **25**
De Lacy St. *Ash R* —2H **7**
Delamere Pl. *Chor* —7H **21**
Delaware St. *Pres* —3C **8**
Dell, The. *Ful* —4H **3**
Dellway, The. *Hut* —2B **10**
Delph La. *Char R* —2A **24**
(in two parts)
Demming Clo. *Lea* —4A **6**
Denbigh Clo. *Ley* —5K **15**
Denbigh Way. *Pres* —5A **8**
Denby Clo. *Los H* —2C **12**
Denford Av. *Ley* —6K **15**
Denham La. *Brind* —5H **17**
Dennison Dri. *Chor* —5H **21**
Denville Rd. *Pres* —3C **8**
Derby Rd. *Ful* —7J **3**
Derby Sq. *Pres* —4D **8**
Derby St. *Ley* —4K **15**
Derby St. *Pres* —4A **8**
Derek Rd. *Whit W* —5G **17**
Derry Rd. *Rib* —1E **8**
Derwent Ho. *Pres* —4D **8**
Derwent Rd. *Chor* —3F **25**
Derwentwater Pl. *Pres* —2K **7**
Dever Av. *Ful* —5F **15**
Devon Clo. *Walt D* —2D **12**
Devonport Clo. *Walt D* —2E **12**
Devonport Way. *Chor* —1J **25**
Devonport Way Flats. *Chor*
—7J **21**
Devonshire Ct. *Chor* —1G **25**
Devonshire Pl. *Pres* —3E **8**
Devonshire Rd. *Chor* —1G **25**
Devonshire Rd. *Ful* —7A **4**
Dewhurst Ind. Est. *Pres* —3H **7**
Dewhurst Row. *Bam B* —6D **12**
Dewhurst St. *Ash R* —3H **7**
Dickensons Field. *Pen* —3J **11**
Dickens Rd. *Cop* —7C **24**
Dickson Av. *Pres* —2D **8**
Dickson Hey. *New L* —5D **10**
Dickson St. *Pres* —5B **8**
Dingle, The. *Ful* —4H **3**
Dob Brow. *Char R* —4C **24**
Doctor's La. *Ecc* —2D **22**
Dodgson Pl. *Pres* —3C **8**
Dodgson Rd. *Pres* —3C **8**
Dodney Dri. *Lea* —3A **6**
Dole La. *Chor* —7G **21**
Doll La. *Ley* —5C **14**
Dolphin Brow. *Whit W* —7F **17**
Doodstone Av. *Los H* —4B **12**
Doodstone Clo. *Los H* —4B **12**
Doodstone Dri. *Los H* —4B **12**
Doodstone Nook. *Los H* —4B **12**
Dood Way. *Bam B* —7G **13**
Doris St. *Chor* —6H **21**
Dorking Rd. *Chor* —3K **21**
Dorman Rd. *Rib* —1E **8**
Dorothy Av. *Ley* —5J **15**
Dorset Av. *Walt D* —2D **12**
Dorset Rd. *Pres* —3A **8**
Douglas Clo. *Bam B* —5F **13**
Douglas Ho. *Chor* —3F **25**
Douglas Pl. *Chor* —3F **25**
Douglas Rd. *Ful* —1H **7**
Douglas Rd. N. *Ful* —1H **7**
Douglas St. *Ash R* —3G **7**
Doultons, The. *Los H* —2C **12**
Dove Av. *Pen* —1J **11**

Dovecote. *Clay W* —3E **16**
Dovedale Av. *Ing* —7E **2**
Dovedale Clo. *Ing* —7E **2**
Dovedale Clo. *Ley* —1J **19**
Dovedale Ho. *Ful* —7E **2**
Dove St. *Pres* —3B **8**
Downham Pl. *Ash R* —2C **6**
Downham Rd. *Ley* —6F **15**
Downing Ct. *Brou* —1G **3**
Downing St. *Pres* —4E **8**
Drakes Hollow. *Walt D* —1D **12**
Draper Av. *Ecc* —2E **22**
Draperfield. *Chor* —4E **24**
Driscoll St. *Pres* —4B **8**
Drive, The. *Ful* —7A **4**
Drive, The. *Walt D* —7F **9**
Drumacre La. E. *Longt* —7A **10**
Drumacre La. W. *Longt* —7A **10**
Drumhead Rd. *Chor* —4H **21**
Duchy Av. *Ful* —7B **4**
Ducie Pl. *Pres* —3F **9**
Duck La. *Ful* —7H **3**
Duddle La. *Walt D* —4D **12**
Dudley Pl. *Ash R* —2D **6**
Dukes Meadow. *Ing* —6E **2**
Duke St. *Bam B* —6E **12**
Duke St. *Chor* —2G **25**
Duke St. *Pres* —5B **8**
Dunbar Dri. *Ful* —7H **3**
Dunbar Rd. *Ing* —1D **6**
Dundonald St. *Pres* —4D **8**
Dunkirk Av. *Ful* —7G **3**
Dunkirk La. *Ley* —5B **14**
Dunmore St. *Pres* —4B **8**
Dunoon Clo. *Ing* —7D **2**
Dunrobin Dri. *Eux* —6B **20**
Dunscar Dri. *Chor* —6J **21**
Dunsop Clo. *Bam B* —5F **13**
Dunsop Rd. *Rib* —7D **4**
Durham Clo. *Ley* —1G **19**
Durton La. *Brou* —2J **3**
(in two parts)
Duxbury Hall Rd. *Chor* —5J **25**
Dymock Rd. *Pres* —3D **8**

Ealing Gro. *Chor* —3K **21**
Earls Av. *Bam B* —5E **12**
Earl St. *Pres* —4K **7**
Earls Way. *Eux* —5B **20**
Earnshaw Dri. *Ley* —4F **15**
Eastbourne Clo. *Ing* —6D **2**
East Cliff. *Pres* —6K **7**
Eastgate. *Ful* —6J **3**
Eastham St. *Pres* —3J **7**
Eastlands. *Ley* —7E **14**
Easton Clo. *Ful* —5D **4**
East Rd. *Ful* —1A **8**
East St. *Bam B* —6E **12**
East St. *Chor* —7H **21**
East St. *Far* —4K **15**
East St. *Ley* —5K **15**
East St. *Pres* —4A **8**
East Ter. *Eux* —3B **20**
East View. *Ful* —6F **5**
East View. *Los H* —6A **12**
East View. *Pres* —4A **8**
East View. *Walt D* —6C **8**
Eastway. *Ful* —3A **8**
Eastway Bus. Village. *Ful* —4B **4**
Eastwood Rd. *Ley* —5H **15**
Eaves Grn. Rd. *Chor* —3F **25**
Eaves La. *Chor* —6J **21**
Eaves La. *Ful* —7J **3**
Eaveswood Clo. *Bam B* —4F **13**
Eccles St. *Pres* —3C **8**
Ecroyd Rd. *Ash R* —2G **7**
Ecroyd St. *Ley* —5J **15**
Edale Clo. *Ley* —7J **15**
Edale Ct. *Pres* —3K **7**

Eden St. *Ley* —6J **15**
Edenway. *Ful* —4H **3**
Edgefield. *Chor* —5F **21**
Edgehill Clo. *Ful* —7J **3**
Edgehill Cres. *Ley* —4G **15**
Edgehill Dri. *Ful* —7H **3**
Edinburgh Clo. *Ley* —5A **16**
Edmund St. *Pres* —4B **8**
Edward VII Quay. *Ash R* —4F **7**
Edward Sq. *Pres* —3A **8**
Edward St. *Bam B* —5E **12**
Edward St. *Chor* —1H **25**
Edward St. *Ley* —6J **15**
Edward St. *Pres* —4K **7**
Edward St. *Walt D* —7C **8**
Edward St. W. *Pres* —5J **7**
Egan St. *Pres* —4A **8**
Egbert St. *Pres* —3A **8**
Egerton Ct. *Ash R* —3F **7**
Egerton Gro. *Chor* —2F **25**
Egerton Rd. *Ash R* —3E **6**
Egerton Rd. *Ley* —4H **15**
Elbow St. *Chor* —1G **25**
Elcho St. *Pres* —2A **8**
Elder Clo. *Ful* —5D **4**
Elder Clo. *Whit W* —4G **17**
Eldon Ho. *Chor* —1H **25**
Eldon St. *Ash R & Pres* —2G **7**
Eldon St. *Chor* —1H **25**
Elgin St. *Pres* —1A **8**
Elijah St. *Pres* —4D **8**
Elizabeth Sq. *Pres* —3A **8**
Elizabeth St. *Pres* —4K **7**
Ellen Ct. *Pres* —2K **7**
Ellen St. *Bam B* —4E **12**
Ellen St. *Pres* —3H **7**
(in three parts)
Ellerbeck Clo. *Rib* —6E **4**
Ellerbrook Clo. *Hth C* —7K **25**
Ellerslie Rd. *Ash R* —3F **7**
Elliott Clo. *Pres* —2J **7**
Elliott St. *Pres* —2J **7**
(in two parts)
Elliott Wlk. *Pres* —2J **7**
Elm Av. *Ash R* —2D **6**
Elm Dri. *Bam B* —4F **13**
Elmfield Dri. *Bam B* —7J **13**
Elm Gro. *Chor* —5J **21**
Elm Gro. *Ley* —3B **16**
Elm Gro. *Rib* —2E **8**
Elmsett Rd. *Walt D* —2F **13**
Elmsley St. *Pres* —1J **7**
Elms, The. *Clay W* —5G **17**
Elmwood. *Chor* —6F **21**
Elmwood Av. *Ley* —5G **15**
Elmwood Dri. *Pen* —1F **11**
Elswick Rd. *Ash R* —3C **6**
Elswick Rd. *Ley* —6F **15**
Elton St. *Ash R* —3G **7**
Emerson Rd. *Pres* —2D **8**
Emily St. *Chor* —3F **25**
Emily St. *Los H* —5A **12**
Emmanuel St. *Pres* —2J **7**
(in two parts)
Emmett St. *Pres* —3K **7**
Emnie La. *Ley* —7E **14**
Empress Av. *Ful* —7J **3**
Empress Way. *Eux* —5C **20**
Enfield Clo. *Ecc* —3E **22**
English Martyrs Pl. *Pres* —2K **7**
Ennerdale Clo. *Ley* —7J **15**
Ennerdale Dri. *Walt D* —7E **8**
Ennerdale Rd. *Chor* —3E **24**
Ephraim St. *Pres* —5C **8**
Epping Pl. *Chor* —7H **21**
Epsom Clo. *Chor* —3K **21**
Erskine Rd. *Chor* —6J **21**
Esher Pond. *Ful* —5G **3**
Eskdale Clo. *Ful* —3K **3**
Eskdale Rd. *Ley* —7K **15**
Esplanade. *Pres* —7B **8**

Essex St. *Pres* —3A **8**
Eton Pk. *Ful* —6C **4**
Euston St. *Pres* —5J **7**
Euxton Hall Ct. *Eux* —5A **20**
Euxton Hall Gdns. *Eux* —5A **20**
Euxton Hall M. *Eux* —5A **20**
Euxton La. *Eux* —3B **20**
Evans St. *Ash R* —3H **7**
Evergreen Av. *Ley* —7J **15**
Evergreens, The. *Cot* —7C **2**
Eversleigh St. *Pres* —3J **7**
Evesham Av. *Pen* —3J **11**
Evesham Clo. *Hut* —4A **10**
Ewell Clo. *Chor* —3K **21**
Exe St. *Pres* —2B **8**
Exeter Pl. *Ash R* —2C **6**

Factory La. *Hth C* —6F **17**
Factory La. *Pen* —2J **11**
Fairfax Pl. *Walt D* —3D **12**
Fairfax Rd. *Rib* —7E **4**
Fairfield Dri. *Ash R* —2F **7**
Fairfield Rd. *Ful* —7A **4**
Fairfield Rd. *Ley* —6H **15**
Fairfield St. *Los H* —6B **12**
Fairham Av. *Pen* —3H **11**
Fairhaven Rd. *Ley* —5F **15**
Fairhaven Rd. *Pen* —7J **7**
Fair Oak Clo. *Rib* —1F **9**
Fairway. *Chor* —5G **21**
Fairway. *Pen* —6F **7**
Fairways. *Ful* —5A **4**
Fairways Av. *Brtn* —1G **3**
Falcon St. *Pres* —2B **8**
Falkland St. *Pres* —5J **7**
Faraday Dri. *Ful* —4C **4**
Far Croft. *Los H* —4A **12**
Fareham Clo. *Walt D* —2F **13**
Far Field. *Pen* —1H **11**
Farington Av. *Ley* —7F **15**
Farington Bus. Pk. *Ley* —2J **15**
Farington Rd. *Far & Los H* —7K **11**
Farm Av. *Adl* —7K **25**
Far Nook. *Whit W* —7F **17**
Farringdon Clo. *Pres* —3F **9**
Farringdon Cres. *Pres* —3F **9**
Farringdon La. *Pres* —1F **9**
Farringdon Pl. *Pres* —3F **9**
Farrington Clo. *Pres* —3F **9**
Farrington St. *Chor* —7G **21**
Farthings, The. *Chor* —6D **20**
Fazackerley St. *Ash R* —2G **7**
Fazakerley St. *Chor* —7G **21**
Fell Clo. *Bam B* —6F **13**
Fellery St. *Chor* —7G **21**
Fell View. *Chor* —2J **25**
Fell View. *Grims* —1J **5**
Fellway Clo. *Los H* —5C **12**
Felstead St. *Pres* —4D **8**
Fensway. *Hut* —3B **10**
Fenton Rd. *Ful* —7C **4**
Fermor Rd. *Pres* —3E **8**
Fernbank. *Chor* —4H **21**
Fern Clo. *Los H* —5B **12**
Ferndale Clo. *Ley* —7K **15**
Fernleigh. *Ley* —6C **14**
Fern Meadow. *Whit W* —4G **17**
Ferns, The. *Ash R* —2G **7**
Ferns, The. *Walt D* —2B **12**
Fernyhalgh Ct. *Ful* —5D **4**
Fernyhalgh Gdns. *Ful* —5D **4**
Fernyhalgh Gro. *Ful* —5D **4**
Fernyhalgh La. *Ful* —2C **4**
(in two parts)
Fernyhalgh Pl. *Ful* —5D **4**
Fiddlers La. *Clay W* —4F **17**
Fidler La. *Far M* —1H **15**
Fielden St. *Chor* —7J **21**
Fielden St. *Ley* —5F **15**
Fieldside Av. *Eux* —6A **20**

Fieldside Clo. *Los H* —2C **12**
Fields, The. *Ecc* —1D **22**
(in two parts)
Fife Clo. *Chor* —2J **25**
Filberts Clo. *Ful* —1G **7**
Filberts, The. *Ful* —1G **7**
File St. *Chor* —1G **25**
Filey Pl. *Ing* —7E **2**
Finch's Cotts. *Pen* —1J **11**
Firbank. *Eux* —5A **20**
First Av. *Ash R* —2E **6**
Fir Tree Av. *Ful* —7F **3**
Fir Tree Clo. *Chor* —5G **25**
Fir Trees Av. *Los H* —4A **12**
Fir Trees Av. *Rib* —7F **5**
Fir Trees Cres. *Los H* —5A **12**
Fir Trees Pl. *Rib* —7F **5**
Fir Trees Rd. *Los H* —4A **12**
Fishergate. *Pres* —5K **7**
Fishergate Cen. *Pres* —5K **7**
Fishergate Hill. *Pres* —6H **7**
Fishergate Wlk. *Pres* —5K **7**
Fish St. *Pres* —3K **7**
Fishwick Pde. *Pres* —4C **8**
Fishwick Rd. *Pres* —4C **8**
Fishwick View. *Pres* —4C **8**
Fitchfield. *Pen* —3K **11**
Fitzgerald St. *Pres* —3C **8**
Fitzroy St. *Pres* —4K **7**
Five Acres. *Far M* —2G **15**
Flag La. *Hth C* —3K **25**
Flag La. *Ley* —3F **19**
Flag La. *Pen* —5J **11**
Flats, The. *Chor* —2F **25**
Fleet St. *Chor* —1G **25**
Fleet St. *Pres* —5K **7**
Fleetwood St. *Ash R* —3H **7**
Fleetwood St. *Ley* —4K **15**
Flensburg Way. *Ley* —3F **15**
Fletcher Rd. *Pen* —4B **8**
Flett St. *Ash R* —3G **7**
Flowerfield. *Cot* —5C **2**
Floyd Rd. *Rib* —1E **9**
Floyer St. *Pres* —5B **8**
Foregate. *Ful* —7J **3**
Forest Brook Ho. *Ful* —1K **7**
Forest Clo. *Los H* —2C **12**
Forest Way. *Ful* —6K **3**
Forest Way. *Ley* —6H **15**
Forge St. *Ley* —5J **15**
Formby Pl. *Ash R* —2C **6**
(in two parts)
Forrester Clo. *Ley* —5G **15**
Forshaw Rd. *Pen* —3H **11**
Forton Rd. *Ash R* —4C **6**
Fossdale Moss. *Ley* —5E **14**
Foster Ct. Chor —6J **21**
(off Foster St.)
Foster Croft. *Pen* —6G **7**
Fosterfield Pl. *Chor* —6J **21**
Foster St. *Chor* —6J **21**
Foundary St. *Chor* —7G **21**
Fountains Clo. *Chor* —3J **25**
Fourfields. *Bam B* —4E **12**
Four Oaks Rd. *Bam B* —7G **13**
Fowler Av. *Far M* —7B **12**
Fowler La. *Far & Far M* —7K **11**
Foxcote. *Chor* —5F **21**
Foxdale Gro. *Pres* —1D **8**
Foxglove Dri. *Whit W* —2F **21**
Foxhole Rd. *Chor* —6D **20**
Fox La. *Ley* —6F **15**
Fox St. *Pres* —5K **7**
Francis St. *Ash R* —3G **7**
Frankel Clo. *New L* —5D **10**
Franklands Dri. *Rib* —6F **5**
Frank St. *Pres* —3K **7**
Fraser Av. *Pen* —1J **11**
Frederick St. *Chor* —1J **25**
Freeman's La. *Char R* —5C **24**

Frenchwood Av. *Pres* —6B **8**
Frenchwood Knoll. *Pres* —6B **8**
Frenchwood St. *Pres* —6A **8**
Freshfields. *Lea* —1B **6**
Friargate. *Pres* —4K **7**
Friars, The. *Ful* —7J **3**
Friday St. *Chor* —7H **21**
Frome St. *Pres* —3D **8**
Froom St. *Chor* —7J **21**
Fryer Clo. *Pen* —4H **11**
Fulford Av. *Lea* —3A **6**
Fulshaw Rd. *Ash R* —2F **7**
Fulwood Hall La. *Ful* —7B **4**
Fulwood Heights. *Ful* —6C **4**
Fulwood Row. *Ful* —4E **4**
(in two parts)
Furness Clo. *Chor* —3H **25**
Fylde Av. *Far M* —2G **15**
Fylde Rd. *Ash R & Pres* —3H **7**
Fylde Rd. Ind. Est. *Pres* —3H **7**
Fylde St. *Pres* —4J **7**

Gables, The. *Cot* —7C **2**
Gainsborough Av. *Los H* —6A **12**
Gamull La. *Rib* —6F **5**
Ganton Ct. *Pen* —6E **6**
Garden St. *Los H* —6A **12**
Garden St. *Pres* —5K **7**
Garden Ter. *Chor* —6G **21**
Garden Wlk. *Ash R* —3F **7**
Gardner St. *Pres* —4K **7**
Garfield Ter. *Chor* —5H **21**
Garrison Rd. *Ful* —1B **8**
Garsdale Clo. *Walt D* —7E **8**
Garsdale Rd. *Rib* —7E **4**
Garstang Rd. *Brou* —1G **3**
(in two parts)
Garstang Rd. *Ful & Pres* —3H **3**
Garstone Croft. *Ful* —5H **3**
Gaskell St. *Chor* —7J **21**
Gaskell St. *Chor* —7J **21**
Gas Ter. *Ley* —5J **15**
Gatesgarth Av. *Ful* —4K **3**
Gathurst Rd. *Ash R* —2G **7**
Gaythorne Av. *Pres* —3F **9**
Geneva Rd. *Ful* —7C **4**
Geoffrey St. *Chor* —6H **21**
Geoffrey St. *Pres* —3C **8**
Georges Rd. *Pres* —5K **7**
George St. *Chor* —1G **25**
(in two parts)
George St. *Ley* —4K **15**
George St. *Pres* —5B **8**
German La. *Char R* —7B **20**
German La. *Cop* —7C **24**
Gerrard St. *Pres* —5H **7**
Gilbertson Rd. *Hth C* —6J **25**
Gilbert St. *Chor* —2G **25**
Gildow St. *Pres* —4J **7**
Gilhouse Av. *Lea* —3A **6**
Gillcroft. *Ecc* —1D **22**
Giller Clo. *Pen* —3J **11**
Giller Fold. *Pen* —3K **11**
Gillett St. *Pres* —3C **8**
(in two parts)
Gillibrand St. *Chor* —1G **25**
Gillibrand St. *Walt D* —7D **8**
Gillibrand Walks. *Chor* —2F **25**
Gin Bow. *Chor* —2H **25**
Ginnel, The. *Ley* —6J **15**
Gisburn Rd. *Rib* —7E **4**
Glamis Dri. *Chor* —7F **21**
Glamis Rd. *Ley* —6A **16**
Glebe Clo. *Ful* —7K **3**
Glencourse Dri. *Ful* —6C **4**
Glencroft. *Eux* —4K **19**
Glendale Av. *Los H* —4C **12**
Glendale Clo. *Ley* —7K **15**
Glendale Cres. *Los H* —4C **12**
Glendale Gro. *Rib* —2D **8**

Gleneagles Dri. *Ful* —4F **3**
Gleneagles Dri. *Pen* —7E **6**
Glen Gro. *Rib* —6F **5**
Glenluce Dri. *Pres* —4F **9**
Glenmore. *Chor* —3E **16**
Glen, The. *Rib* —2F **9**
Glenview Clo. *Rib* —1G **9**
Glenview Ct. *Rib* —1G **9**
(in two parts)
Glenway. *Pen* —1G **11**
Gloucester Av. *Far* —3A **16**
Gloucester Rd. *Chor* —3G **25**
Glover Clo. *Ley* —1B **18**
Glovers Ct. *Pres* —5K **7**
Glover St. *Pres* —5A **8**
Golbourne St. *Pres* —3B **8**
Goldburn Clo. *Ing* —5D **2**
Golden Hill. *Ley* —4K **15**
Golden Hill La. *Ley* —4G **15**
Goldfinch St. *Pres* —2B **8**
Golf View. *Ing* —5E **2**
Good St. *Pres* —5J **7**
Goodwood Av. *Ful* —4K **3**
Goose Grn. Av. *Cop* —7D **24**
Gordon St. *Chor* —1H **25**
Gordon St. *Pres* —3J **7**
(in two parts)
Goring St. *Chor* —1H **25**
Gorse Clo. *Whit W* —2J **21**
Gorse Gro. *Rib* —1E **8**
Gorsewood Rd. *Ley* —5G **15**
Gosforth Clo. *Walt D* —2E **12**
Gough La. *Bam B* —7H **13**
(in two parts)
Goulding Av. *Ley* —5K **15**
Goulding St. *Chor* —2H **25**
Gower Ct. *Ley* —4F **15**
Gradwell St. *Pres* —4J **7**
Grafton Rd. *Rib* —7F **5**
Grafton St. *Adl* —3F **25**
Grafton St. *Pres* —6J **7**
Graham Av. *Los H* —5C **12**
Graham St. *Pres* —3B **8**
Grange Av. *Rib* —7F **5**
(in two parts)
Grange Dri. *Eux* —3A **20**
Grange Dri. *Hogh* —1K **13**
Grange Pk. Clo. *Pen* —6E **6**
Grange Pl. *Rib* —7F **5**
Grange Rd. *Ash R* —1G **7**
Grange Rd. *Ley* —5F **15**
Granton Wlk. *Ing* —7E **2**
Granville Ct. *Chor* —6J **21**
Granville Rd. *Chor* —6J **21**
Grasmere Av. *Far* —3J **15**
Grasmere Clo. *Eux* —6C **20**
Grasmere Clo. *Ful* —7C **4**
Grasmere Clo. *Walt D* —3E **12**
Grasmere Gro. *Whit W* —7F **17**
Grasmere Ter. *Chor* —3F **25**
Gt. Avenham St. *Pres* —6A **8**
Gt. George St. *Pres* —3A **8**
Gt. Greens La. *Bam B* —1F **17**
Gt. Hanover St. *Pres* —3A **8**
Gt. Meadow. *Chor* —5E **20**
Gt. Meadow. *Los H* —5A **12**
Gt. Shaw St. *Pres* —4K **7**
Gt. Townley St. *Pres* —4D **8**
Greaves Meadow. *Pen* —3K **11**
Greaves St. *Pres* —5A **8**
Greaves Town La. *Lea* —3C **6**
Greenacres. *Ful* —4F **3**
Greenacres, The. *Hut* —3B **10**
Greenbank Av. *Pres* —2H **7**
Greenbank Pl. *Pres* —3J **7**
Greenbank Rd. *Pen* —1J **11**
Greenbank St. *Pres* —2H **7**
(in three parts)
Greencroft. *Pen* —2H **11**
Greendale M. *Ash R* —2C **6**
Green Dri. *Ful* —4J **3**

Green Dri. *Los H* —4C **12**
Green Dri. *Pen* —7F **7**
Greenfield Dri. *Los H* —5A **12**
Greenfield Rd. *Chor* —7J **21**
Greenfield Way. *Ing* —6E **2**
Green Ga. *Ful* —1G **7**
Green Ga. *Hut* —4A **10**
Greenlands Cres. *Rib* —1E **8**
Greenlands Gro. *Rib* —1E **8**
Green La. *W Sta* —4N **1**
Greenmead Clo. *Cot* —6C **2**
Green Pl. *Bam B* —7G **13**
Greenside. *Eux* —4A **20**
Greenside Av. *Lea* —3A **6**
Greenside Gdns. *Ley* —7D **14**
Green St. *Chor* —3E **24**
Greensway. *Brtn* —1G **3**
Green, The. *Ecc* —2E **22**
Green, The. *Hth C* —6K **25**
Green, The. *Rib* —2F **9**
Greenthorn Cres. *Rib* —2G **9**
Greenway. *Ecc* —1D **22**
Greenway. *Ful* —4H **3**
Greenway. *Pen* —1F **11**
Greenwood. *Bam B* —1F **17**
Greenwood Ct. *Ley* —5J **15**
Greenwood St. *Bam B* —4E **12**
Greenwood St. *Pres* —5B **8**
Gregson Cres. *High W* —2J **13**
Gregson Way. *Ful* —6B **4**
Grenville Av. *Walt D* —3D **12**
Greyfriars Av. *Ful* —6H **3**
Greyfriars Cres. *Ful* —6H **3**
Greyfriars Dri. *Pen* —7G **7**
Grey Heights View. *Chor* —7J **21**
Greystock Av. *Ful* —5J **3**
Greystock Clo. *Bam B* —5H **13**
Greystock Pl. *Ful* —5J **3**
Greystones. *Ley* —5D **14**
Grime St. *Chor* —2H **25**
Grimsargh St. *Pres* —3D **8**
Grimshaw St. *Pres* —5A **8**
Grisedale Pl. *Chor* —3F **25**
Grizedale Clo. *Rib* —2F **9**
Grizedale Cres. *Rib* —2F **9**
Grizedale Pl. *Rib* —2F **9**
Grosvenor Pl. *Ash R* —2F **7**
Grosvenor Rd. *Chor* —2F **25**
Grosvenor St. *Pres* —5B **8**
Grove Rd. *Walt D* —6C **8**
Grove St. *Bam B* —5F **13**
Grove St. *Ley* —6F **15**
Grove, The. *Ash R* —3F **7**
Grove, The. *Chor* —5G **21**
Grove, The. *Pen* —1F **11**
Grundy's La. *Chor* —7G **25**
Grundy St. *Ley* —4J **15**
Guardian Clo. *Ful* —7A **4**
Guildford Av. *Chor* —3J **21**
Guildford Rd. *Pres* —6A **8**
Guild Hall Arc. *Pres* —5A **8**
 (off Lancaster Rd.)
Guildhall St. *Pres* —5K **7**
Guild Row. *Pres* —5A **8**
Guild Way. *Pres* —5H **7**

Hacklands Av. *Lea* —3A **6**
Haddon Pl. *Ful* —1H **7**
Haig Av. *Ash R* —2H **7**
Haig Av. *Ley* —5G **15**
Haigh Clo. *Chor* —1E **24**
Haigh Cres. *Chor* —1E **24**
Haighton Ct. *Ful* —4A **4**
Haighton Dri. *Ful* —5E **4**
Haighton Grn. La. *Haig* —2C **4**
Half Acre. *Los H* —5A **12**
Halfpenny La. *Hesk* —5C **22**
Hall Croft. *Hut* —3B **10**
Hall Croft Head. *Hut* —3B **10**
Hall Ga. *Chor* —6E **20**

Hall Grn. La. *Maw* —5B **22**
Halliwell Ct. *Chor* —1G **25**
 (off Halliwell St.)
Halliwell La. *Chor* —3G **21**
Halliwell Pl. *Chor* —1G **25**
Halliwell St. *Chor* —1G **25**
Hall La. *Ley* —3H **15**
Hall La. *Maw* —5A **22**
Hall Rd. *Ful* —6J **3**
Hall Rd. *Pen* —2J **11**
Hall St. *Ash R* —3G **7**
Hallwood Rd. *Chor* —3E **24**
Halsbury St. *Pres* —6A **8**
Halstead Rd. *Rib* —6D **4**
Halton Av. *Ley* —4B **16**
Halton Pl. *Rib* —7F **5**
Hambledon Dri. *Pen* —3J **11**
Hamer Rd. *Ash R* —1H **7**
Hamilton Gro. *Rib* —1E **8**
Hamilton Rd. *Chor* —1F **25**
Hamilton Rd. *Rib* —7D **4**
Hamlet, The. *Hth C* —7K **25**
Hammond Ct. *Pres* —3J **7**
Hammond's Row. *Pres* —5A **8**
Hammond St. *Pres* —3J **7**
 (in three parts)
Hampden Rd. *Ley* —4J **15**
Hampshire Rd. *Walt D* —2D **12**
Hampson Av. *Ley* —5B **16**
Hampstead Rd. *Rib* —2D **8**
Hampton Clo. *Chor* —7F **21**
Hampton St. *Ash R* —2G **7**
Hanbury St. *Ash R* —3G **7**
Handbridge, The. *Ful* —6J **3**
Hand La. *Maw* —3B **22**
Hanover Ct. *Ing* —5D **2**
Hanover St. *Pres* —3K **7**
Harcourt St. *Pres* —3J **7**
Hardacre La. *Whit W* —2F **21**
Hardcastle Rd. *Ful* —1J **7**
Hardman's Yd. *Pres* —5K **7**
Hardwen Av. *Lea* —3A **6**
Hardwick St. *Pres* —4A **8**
Hardy Dri. *Chor* —1E **24**
Hareden Rd. *Rib* —2F **9**
Haredon Clo. *Bam B* —5F **13**
Harestone Av. *Chor* —3E **24**
Harewood. *Chor* —5F **21**
Hare Wood Rd. *Pres* —2B **8**
Hargreaves Av. *Ley* —6K **15**
Hargreaves Ct. *Ing* —7D **2**
Harland St. *Ful* —1H **7**
Harlech Dri. *Ley* —5K **15**
Harling Rd. *Pres* —3D **8**
Harold Ter. *Los H* —5A **12**
Harperley. *Chor* —5F **21**
Harpers La. *Chor* —6H **21**
Harpers St. *Chor* —5H **21**
Harrington Rd. *Chor* —7F **21**
Harrington St. *Pres* —4J **7**
Harris Cen. *Ful* —6J **3**
Harrison La. *Hut* —3F **11**
Harrison Rd. *Chor* —2G **25**
Harrison Rd. *Ful* —6J **3**
Harrison Trading Est. *Pres* —3C **8**
Harris St. *Pres* —5A **8**
Harrock Rd. *Ley* —5B **16**
Harrop Pl. *Rib* —7E **4**
Hartington Rd. *Pres* —5H **7**
Hartwood Grn. *Chor* —4G **21**
Haslemere Ind. Est. *Ley* —3H **15**
Hassett Clo. *Pres* —6J **7**
Hastings Rd. *Ash R* —3F **7**
Hastings Rd. *Ley* —4K **15**
Hatfield Rd. *Rib* —1E **8**
Havelock Rd. *Bam B* —6E **12**
Havelock Rd. *Pen* —7J **7**
Havelock St. *Pres* —2H **7**
 (in four parts)
Hawarden Rd. *Pres* —3E **8**
Haweswater Av. *Chor* —2F **25**

Hawkhurst Av. *Ful* —5H **3**
Hawkhurst Cres. *Ful* —5H **3**
Hawkhurst Rd. *Pen* —1J **11**
Hawkhurst Rd. *Pres* —3B **8**
Hawkins Clo. *Pres* —3J **7**
Hawkins St. *Pres* —3J **7**
 (in two parts)
Hawksbury Dri. *Pen* —3H **11**
Hawkshead. *Pen* —2J **11**
Hawkshead Av. *Eux* —6B **20**
Hawkshead Rd. *Rib* —6E **4**
Hawkswood. *Ecc* —2D **22**
Hawthorn Clo. *Ley* —4F **15**
Hawthorn Clo. *New L* —6E **10**
Hawthorn Cres. *Lea* —4A **6**
Hawthorne Av. *High W* —2J **13**
Hawthorne Clo. *Clay W* —4F **17**
Hawthorn Rd. *Rib* —2E **8**
 (in two parts)
Hawthorns, The. *Ecc* —1D **22**
Hawthorns, The. *Ful* —5K **3**
Hawthorns, The. *Wood* —1C **2**
Haydock Av. *Ley* —6J **15**
Haydock St. *Bam B* —3E **12**
Haydon Av. *Los H* —6A **12**
Hayfield Av. *Hogh* —4K **13**
Hayling Pl. *Ing* —7E **2**
Haysworth St. *Pres* —2K **7**
Hazel Av. *Bam B* —4G **13**
Hazel Clo. *Bam B* —4F **13**
Hazel Clo. *Pen* —2F **11**
Hazel Coppice. *Lea* —1C **6**
Hazel Gro. *Bam B* —4F **13**
Hazel Gro. *Chor* —4G **21**
Hazel Gro. *Rib* —7G **5**
Hazelhurst Rd. *Rib* —2G **9**
Hazelmere Rd. *Ash R* —3E **6**
Hazelmere Rd. *Ful* —3H **3**
Hazels, The. *Cop* —7C **24**
Hazelwood Clo. *Ley* —5G **15**
Headley Rd. *Ley* —5G **15**
Heald Ho. Rd. *Ley* —7A **16**
Heald St. *Chor* —7J **21**
Healey View. *Chor* —5J **21**
Heapey Rd. *Chor* —5K **21**
Heather Gro. *Rib* —1E **8**
Heathers, The. *Bam B* —2G **17**
Heatherway. *Ful* —5E **4**
Heathfield. *Hth C* —7K **25**
Heathfield Dri. *Rib* —7E **4**
Heathrow Pl. *Chor* —1E **24**
Heathway. *Ful* —5K **3**
Heatley St. *Pres* —5J **7**
Heaton Clo. *Walt D* —1D **12**
Heaton Mt. Av. *Ful* —4K **3**
Heaton Pl. *Pres* —3E **8**
Heaton St. *Ley* —4G **15**
Hedgerows Rd. *Ley* —6C **14**
Hellifield. *Ful* —4K **3**
Helmsley Grn. *Ley* —4K **15**
Henderson St. *Pres* —1J **7**
 (in two parts)
Hendon Pl. *Ash R* —2C **6**
Hennel La. *Los H & Walt D* —3B **12**
 (in three parts)
Henrietta St. *Pres* —4B **8**
Herbert St. *Ley* —5J **15**
Herbert St. *Pres* —3B **8**
Hermon St. *Pres* —3C **8**
 (in two parts)
Hern Av. *Los H* —5A **12**
Herschell St. *Pres* —6A **8**
Hesketh Rd. *Rib* —3E **8**
Hesketh St. *Ash R* —3G **7**
Heversham Av. *Ful* —4K **3**
Hewitt St. *Ley* —4K **15**
Hewlett Av. *Cop* —7B **24**
Hewlett St. *Cop* —7C **24**
Hey End. *New L* —5D **10**
Heyes, The. *Clay W* —4F **17**
Heysham St. *Pres* —3J **7**

Heys, The. *Cop* —6D **24**
Heywood Rd. *Ash R* —2C **6**
High Cop. *Brind* —2K **17**
Highdale Gdns. *Los H* —6C **12**
Higher Bank Rd. *Ful* —1K **7**
Higher Croft. *Pen* —3G **11**
Higher Greenfield. *Ing* —6F **3**
Higher Meadow. *Ley* —5C **16**
Higher Walton Rd. *Walt D* —7D **8**
Highfield. *Pen* —4H **11**
Highfield Av. *Far* —3A **16**
Highfield Av. *Ful* —7C **4**
Highfield Dri. *Ful* —3J **3**
Highfield Dri. *Pen* —3H **11**
Highfield Gro. *Los H* —3C **12**
Highfield Ind. Est. *Chor* —5H **21**
Highfield Rd. *Cros* —5A **18**
Highfield Rd. N. *Chor* —5G **21**
Highfield Rd. S. *Chor* —6G **21**
Highgale Gdns. *Los H* —6C **12**
Highgate. *Pen* —7F **7**
Highgate Av. *Ful* —7J **3**
Highgate Clo. *Ful* —7K **3**
High Grn. *Ley* —5H **15**
Highgrove Av. *Char R* —4H **23**
Highgrove Ct. *Ley* —6B **14**
Highgrove Ho. *Chor* —5G **21**
Highland Av. *Pen* —1F **11**
Highrigg Dri. *Brou* —2K **3**
High St. Chorley, *Chor* —7G **21**
High St. Preston, *Pres* —4A **8**
Highways Av. *Eux* —6B **20**
Hillbrook Grn. *Ley* —4H **15**
Hillbrook Rd. *Ley* —4G **15**
Hillcrest Av. *Ful* —3J **3**
Hillcrest Av. *Ing* —7E **2**
Hillcroft. *Ful* —4G **3**
Hillpark Av. *Ful* —7H **3**
Hillpark Av. *Hogh* —4K **13**
Hill Rd. *Ley* —5A **16**
Hill Rd. *Pen* —7G **7**
Hill Rd. S. *Pen* —2G **11**
Hillside. *Whit W* —6G **17**
Hillside Av. *Far M* —6K **11**
Hillside Av. *Ful* —7H **3**
Hillside Clo. *Eux* —6A **20**
Hillside Cres. *Whit W* —5G **17**
Hillside Rd. *Pres* —6C **8**
Hill St. *Pres* —5K **7**
Hill Top. *New L* —7E **10**
Hill Top La. *Whit W* —6G **17**
Hill View Dri. *Cop* —7B **24**
Hill Wlk. *Ley* —5J **15**
Hindley St. *Chor* —2G **25**
Hind St. *Pres* —6J **7**
Hodder Av. *Chor* —3F **25**
Hodder Brook. *Rib* —1G **9**
Hodder Clo. *Bam B* —5F **13**
Hodson St. *Bam B* —4E **12**
Hogg's La. *Chor* —3J **25**
Hoghton La. *High W* —2J **13**
Hoghton Rd. *Ley* —5F **15**
Hoghton St. *Los H* —5A **12**
Hoghton View. *Pres* —6C **8**
Holcombe Gro. *Chor* —6J **21**
Holker Clo. *Hogh* —2K **13**
Holker La. *Ley* —3C **18**
Holland Av. *Walt D* —3E **12**
Holland Ho. Rd. *Walt D* —2D **12**
Holland Rd. *Ash R* —3G **7**
Hollings. *New L* —6D **10**
Hollinhead Cres. *Ing* —7F **3**
Hollinhurst Av. *Pen* —6G **7**
Hollins Gro. *Ful* —1F **7**
Hollinshead St. *Chor* —7G **21**
Hollins La. *Chor* —3E **18**
Hollins Rd. *Pres* —2B **8**
Hollybank Clo. *Ing* —6D **2**
Holly Clo. *Clay W* —4F **17**
Holly Cres. *Cop* —6C **24**
Holly Pl. *Bam B* —7H **13**

Hollywood Av. *Pen* —2G **11**
Holman St. *Pres* —3C **8**
Holme Rd. *Bam B* —5D **12**
Holme Rd. *Pen* —5G **7**
Holmes Ct. *Pres* —1J **7**
Holme Slack La. *Pres* —1B **8**
Holmes Meadow. *Ley* —5D **14**
Holmfield Cres. *Lea* —3B **6**
Holmfield Rd. *Ful* —7A **4**
Holmrook Rd. *Pres* —3B **8**
Holsands Clo. *Ful* —5E **4**
Holstein St. *Pres* —4A **8**
Holt Av. *Cop* —6D **24**
Holt Brow. *Ley* —1J **19**
Holt La. *Brind* —3H **17**
Homestead. *Bam B* —2F **17**
Homestead Clo. *Ley* —5F **15**
Honeysuckle Clo. *Whit W* —2F **21**
Honeysuckle Clo. *Ecc* —2E **8**
Hope St. *Chor* —6G **21**
Hope St. *Pres* —4K **7**
Hope Ter. *Los H* —5A **12**
Hopwood St. *Bam B* —5E **12**
Hopwood St. *Pres* —4A **8**
Horby St. *Pres* —4B **8**
Hornbeam Clo. *Pen* —2F **11**
Hornby Av. *Rib* —7E **4**
Hornby Croft. *Ley* —6D **14**
Hornby Rd. *Chor* —2J **25**
Hornchurch Dri. *Chor* —7E **20**
Horn Gro. *Chor* —1E **24**
Hornsea Clo. *Ing* —7E **2**
Hough La. *Ley* —5J **15**
Houghton Clo. *Pen* —2H **11**
Houghton Rd. *Pen* —2G **11**
Houghton St. *Chor* —7H **21**
Houghton St. *Los H* —5A **12**
Houldsworth Rd. *Ful* —1J **7**
Howard Rd. *Chor* —3F **25**
Howarth Rd. *Ash R* —1H **7**
Howe Gro. *Chor* —1E **24**
Howgills, The. *Ful* —4A **4**
Howick Cross La. *Pen* —7B **6**
Howick Moor La. *Pen* —2D **10**
Howick Pk. Av. *Pen* —1D **10**
Howick Pk. Clo. *Pen* —1D **10**
Howick Pk. Dri. *Pen* —1D **10**
Howick Row. *Pen* —7B **6**
Hoylake Clo. *Ful* —5F **3**
Hoyles La. *Cot* —6A **2**
Hudson Ct. *Bam B* —6J **13**
Hudson St. *Pres* —6A **8**
Hugh Barn La. *New L* —6C **10**
Hugh La. *Ley* —3E **14**
Hull St. *Ash R* —4G **7**
Hunniball Ct. *Ash R* —2G **7**
Hunters Rd. *Ley* —5B **16**
Hunts Field. *Clay W* —4G **17**
Hunt St. *Pres* —4H **7**
Hurn Gro. *Chor* —1E **24**
Hurst Brook. *Cop* —7D **24**
Hurst Pk. *Pen* —1G **11**
Hurstway. *Ful* —4H **3**
Hurstway Clo. *Ful* —4H **3**
Hutton Hall Av. *Hut* —4C **10**
(in two parts)

Iddesleigh Rd. *Pres* —3E **8**
Illingworth Rd. *Pres* —3E **8**
Ilway. *Walt D* —2D **12**
Ince La. *Ecc* —3E **22**
Ingleborough Way. *Ley* —5A **16**
Ingle Clo. *Chor* —6H **21**
Ingle Head. *Ful* —5H **3**
Ingleton Rd. *Rib* —7E **4**
Ingot St. *Pres* —4H **7**
Inkerman St. *Ash R* —1G **7**
Inskip Clo. *Ash R* —3C **6**
Inskip Rd. *Ley* —4F **15**
Intack Rd. *Longt* —5A **10**

Ipswich Rd. *Rib* —2D **8**
Irongate. *Bam B* —5C **12**
Ironside Clo. *Ful* —7B **4**
Irvin St. *Pres* —3B **8**
Isherwood St. *Pres* —3C **8**
Isleworth Dri. *Chor* —1F **25**
Ivy Bank. *Ful* —5D **4**

Jackson Rd. *Chor* —3E **24**
Jackson Rd. *Ley* —5F **15**
Jackson St. *Bam B* —5F **13**
Jackson St. *Chor* —2H **25**
Jacson St. *Pres* —5A **8**
James Pl. *Cop* —7C **24**
James St. *Bam B* —4E **12**
James St. *Pres* —5B **8**
Jane La. *Midg H* —3C **14**
Janice Dri. *Ful* —4H **3**
Jemmett St. *Pres* —1J **7**
Johnspool. *Ful* —5G **3**
John St. *Bam B* —4E **12**
John St. *Chor* —2G **25**
John St. *Cop* —7C **24**
John St. *Ley* —5J **15**
John William St. *Pres* —4C **8**
Jordan St. *Pres* —5J **7**
Jubilee Av. *Lea* —3B **6**
Jubilee Ct. *Ley* —6G **15**
Jubilee Rd. *Los H* —5A **12**
Judd Ho. *Pres* —6J **7**
Judeland. *Chor* —5E **20**
Junction Rd. *Ash R* —5H **7**
Junction Ter. *Eux* —2A **20**
Juniper Croft. *Clay W* —5E **16**
Jutland St. *Pres* —4A **8**

Kane St. *Ash R* —3G **7**
Kaymar Ind. Est. *Pres* —5C **8**
Kay St. *Pres* —5J **7**
Keats Clo. *Ecc* —3F **23**
Kellet Acre. *New L* —6A **12**
Kellet Av. *Ley* —5B **16**
Kellet La. *Bam B* —7H **13**
Kellett St. *Chor* —7G **21**
Kem Mill La. *Whit W* —6F **17**
Kendal Ho. *Pres* —5A **8**
Kendal St. *Pres* —4J **7**
(in two parts)
Kenmure Pl. *Pres* —2K **7**
Kennet Dri. *Ful* —3K **3**
Kennington Rd. *Ful* —7A **4**
Kensington Av. *Pen* —6F **7**
Kensington Rd. *Chor* —1F **25**
Kent Av. *Walt D* —2D **12**
Kent Dri. *Ley* —4B **16**
Kentmere Av. *Bam B* —4D **12**
Kentmere Av. *Far* —3J **15**
Kent St. *Pres* —2K **7**
Kenyon La. *Heap* —7K **17**
Kerr Ct. *Pres* —4H **7**
Kershaw St. *Chor* —6J **21**
Kew Gdns. *Far* —3K **15**
Kew Gdns. *Pen* —7F **7**
Kidlington Clo. *Los H* —5C **12**
Kidsgrove. *Ing* —5D **2**
Kilmuir Clo. *Ful* —6C **4**
Kilncroft. *Clay W* —3F **17**
Kilngate. *Los H* —2C **12**
Kilruddery Rd. *Pres* —6J **7**
Kilsby Clo. *Walt D* —2E **12**
Kilshaw St. *Pres* —4K **7**
Kilworth Height. *Ful* —6G **3**
Kimberley Rd. *Ash R* —2G **7**
Kimberley St. *Cop* —7C **24**
Kingfisher St. *Pres* —2B **8**
Kingsbridge Clo. *Pen* —4J **11**
Kings Ct. *Ley* —5J **15**
Kings Cres. *Ley* —5J **15**
Kingscroft. *Walt D* —7D **8**

Kingsdale Av. *Rib* —7D **4**
Kingsdale Clo. *Ley* —1K **19**
Kingsdale Clo. *Walt D* —7F **9**
Kings Dri. *Ful* —6H **3**
Kingsfold Dri. *Pen* —3G **11**
Kingshaven Dri. *Pen* —3J **11**
Kings Lea. *Adl* —7K **25**
Kingsley Dri. *Chor* —3E **24**
Kingsmead. *Chor* —3G **25**
Kingsmuir Av. *Ful* —7D **4**
King St. *Chor* —2H **25**
King St. *Ley* —5J **15**
King St. *Los H* —6B **12**
Kingsway. *Ash R* —2D **6**
Kingsway. *Bam B* —5E **12**
Kingsway. *Eux* —5C **20**
Kingsway. *Ley* —7G **15**
Kingsway. *Pen* —6F **7**
Kingsway Av. *Brtn* —1G **3**
Kingsway W. *Pen* —6E **6**
Kingswood Rd. *Ley* —5J **15**
Kingswood St. *Pres* —5J **7**
Kirkby Av. *Ley* —5C **16**
Kirkham Clo. *Ley* —5F **15**
Kirkham St. *Pres* —4J **7**
Kirkland Pl. *Ash R* —4C **6**
Kirkstall Clo. *Chor* —3H **25**
Kirkstall Dri. *Chor* —3H **25**
Kirkstall Rd. *Chor* —3H **25**
Kittlingbourne Brow. *High W*
—2G **13**
Knot Acre. *New L* —5E **10**
Knot La. *Walt D* —7E **8**
Knowles St. *Chor* —2G **25**
Knowles St. *Pres* —4D **8**
Knowley Brow. *Chor* —5J **21**
Knowsley Av. *Far* —2A **16**
Knowsley Av. *Ley* —6A **16**
Knowsley St. *Pres* —5A **8**
(in two parts)
Korea Rd. *Ful* —6B **4**

Laburnum Av. *Los H* —5B **12**
Laburnum Clo. *Pres* —1C **8**
Laburnum Dri. *Ful* —3H **3**
Laburnum Rd. *Chor* —4G **21**
Lacy Av. *Pen* —3J **11**
Lady Crosse Dri. *Whit W* —7G **17**
Lady Hey Cres. *Lea* —3A **6**
Ladyman St. *Pres* —5J **7**
Lady Pl. *Walt D* —1E **12**
Ladysmith Rd. *Ash R* —2G **7**
Lady St. *Pres* —4K **7**
Ladywell St. *Pres* —4J **7**
Lakeland Gdns. *Chor* —3E **24**
Lambert Clo. *Rib* —1E **8**
Lambert Rd. *Rib* —1D **8**
Lancashire Enterprise Bus. Pk. *Ley*
—2J **15**
Lancaster Av. *Ley* —5C **16**
Lancaster Ct. *Chor* —5G **21**
Lancastergate. *Ley* —6H **15**
Lancaster Ho. *Ley* —3J **15**
Lancaster Ho. *Pres* —5A **8**
Lancaster La. *Ley* —5B **16**
Lancaster Rd. N. *Pres* —3K **7**
Lancaster St. *Cop* —7D **24**
Lancaster Way. Pres —4A **8**
(off St John's Shopping Cen.)
Land La. *Longt* —7B **10**
Landseer St. *Pres* —5J **7**
Lane Ends Trading Est. *Ash R*
—2G **7**
Langcliffe Rd. *Rib* —7E **4**
Langdale Clo. *Walt D* —4D **12**
Langdale Ct. *Pen* —1G **11**
Langdale Cres. *Rib* —1E **8**
Langdale Gro. *Whit W* —7F **17**
Langdale Rd. *Ley* —1J **19**
Langdale Rd. *Rib* —1E **8**

Langden Cres. *Bam B* —6F **13**
Langden Dri. *Rib* —1G **9**
Langden Fold. *Grims* —1K **5**
Langfield Clo. *Ful* —3K **3**
Langholme Clo. *Ley* —6F **15**
Langholme Rd. *Pen* —1E **10**
Langport Clo. *Ful* —3K **3**
Langton Brow. *Ecc* —3E **22**
Langton Clo. *Ley* —6E **14**
Langton St. *Pres* —5H **7**
Lansborough Clo. *Ley* —6D **14**
Lansdown Hill. *Ful* —3G **3**
Lappet Gro. *Cot* —6C **2**
Larch Av. *Chor* —5J **21**
Larches Av. *Ash R* —3D **6**
Larches La. *Ash R* —3C **6**
Larch Ga. *Ful* —4C **4**
Larch Ga. *Hogh* —3K **13**
Larch Gro. *Bam B* —4F **13**
Larchwood. *Ash R* —3C **6**
Larchwood. *Pen* —1F **11**
Larchwood Cres. *Ley* —5G **15**
Lark Av. *Pen* —1J **11**
Larkfield. *Ecc* —2D **22**
Lark Hill. *High W* —2H **13**
Larkhill Rd. *Pres* —5B **8**
Larkhill St. *Pres* —5B **8**
Latham St. *Pres* —6A **8**
Latimer Dri. *New L* —5D **10**
Lauderdale Cres. *Rib* —7F **5**
Lauderdale Rd. *Rib* —7F **5**
Lauderdale St. *Pres* —6J **7**
Laund, The. *Ley* —5C **14**
Laurel Av. *Eux* —4K **19**
Laurel Bank Av. *Ful* —1G **7**
Laurel St. *Pres* —5A **8**
Lavender Clo. *Ful* —5C **4**
Lavender Gro. *Chor* —3G **25**
Lawnwood Av. *Chor* —3E **24**
Lawrence Av. *Pres* —7B **8**
Lawrence Av. *Walt D* —3D **12**
Lawrence La. *Ecc* —1E **22**
Lawrence Rd. *Chor* —1F **25**
Lawrence Rd. *Pen* —7F **7**
Lawrence St. *Chor* —1H **7**
Lawson St. *Chor* —1J **25**
Lawson St. *Pres* —4K **7**
Laxey Gro. *Pen* —1D **8**
Layton Rd. *Ash R* —3C **6**
Leach Pl. *Bam B* —5H **13**
Leadale. *Lea* —2B **6**
Leadale Grn. *Ley* —5F **15**
Leadale Rd. *Ley* —5F **15**
Leafy Clo. *Ley* —7K **15**
Leagram Cres. *Rib* —1F **9**
Lea Rd. *Lea* —7A **2**
Lea Rd. *Whit W* —2G **21**
Leek St. *Pres* —4E **8**
Leesands Clo. *Ful* —6D **4**
Leeson Av. *Char R* —4B **24**
(in two parts)
Leeward Rd. *Ash R* —4D **6**
Leicester Rd. *Pres* —3A **8**
Leigh Brow. *Bam B* —3B **12**
Leigh Row. *Chor* —1G **25**
Leigh St. *Chor* —1G **25**
Leighton St. *Pres* —4J **7**
Lennon St. *Chor* —1G **25**
Lennox St. *Pres* —5A **8**
Letchworth Dri. *Chor* —2F **25**
Letchworth Pl. *Chor* —2F **25**
Levens Dri. *Ley* —4B **16**
Levensgarth Av. *Ful* —3K **3**
Levens St. *Pres* —3D **8**
Lever Ho. La. *Ley* —4A **16**
Lex St. *Pres* —4C **8**
Leyburn Clo. *Rib* —6E **4**
Leyfield. *Pen* —3H **11**
Leyfield Rd. *Ley* —6H **15**
Leyland La. *Ley* —5E **18**
Leyland Rd. *Pen & Los H* —7H **7**

Leyland Way. Ley —5A 16
Leyton Av. Ley —7F 15
Leyton Grn. Ley —7G 15
Library Rd. Clay W —2F 17
Library St. Chor —1G 25
Library St. Pres —5A 8
Lichen Clo. Char R —4B 24
Lichfield Rd. Ash R —2D 6
Lichfield Rd. Chor —2F 25
Lidget Av. Lea —3A 6
Liege Rd. Ley —6J 15
Lightfoot Clo. Ful —3H 3
Lightfoot Grn. La. L Grn —3F 3
Lightfoot La. High B & Ful —4D 2
(in three parts)
Lighthurst Av. Chor —2G 25
Lighthurst La. Chor —3H 25
Lilac Av. Pen —3K 11
Lilac Gro. Pres —1C 8
Lily Gro. Pres —1C 8
Limbrick Rd. Chor —1J 25
Lime Chase. Ful —3G 3
Lime Clo. Pen —1E 10
Lime Gro. Ash R —2D 6
Lime Gro. Chor —3G 25
Limes Av. Eux —3A 20
Limes, The. Pres —3B 8
Lincoln Chase. Lea —3A 6
Lincoln St. Pres —3B 8
Lincoln Wlk. Pres —3B 8
Lindale Av. Grims —2K 5
Lindale Rd. Ful —7A 4
Linden Clo. Los H —4B 12
Linden Dri. Los H —5B 12
Linden Gro. Chor —4H 21
Linden Gro. Rib —1E 8
Lindle Av. Hut —3C 10
Lindle Clo. Hut —3C 10
Lindle Cres. Hut —3C 10
Lindle La. Hut —3C 10
Lindley St. Los H —5A 12
Lindsay Av. Ley —5K 15
Lindsay Dri. Chor —1E 24
Lingwell Av. Whit W —2G 21
Linksfield. Ful —1G 7
Links Ga. Ful —1G 7
Links Rd. Pen —6F 7
Linnet St. Pres —2B 8
Linton Gro. Pen —7E 6
Linton St. Ful —1H 7
Liptrott Rd. Chor —3E 24
Lit. Banks Clo. Bam B —7H 13
Little Clo. Pen —2G 11
Liverpool Rd. Hut & Pen —4A 10
Livesey St. Pres —5B 8
Lockhart Rd. Pres —2K 7
Lockside Rd. Ash R —4D 6
Lodge Clo. Bam B —4F 13
Lodge La. Far M —6H 11
Lodge St. Pres —4H 7
(in two parts)
Lodgings, The. Ful —6C 4
London Rd. Pres —5B 8
London Way. Walt D —1C 12
Longbrook Av. Bam B —3E 12
Long Butts. Pen —3H 11
Long Clo. Ley —6C 14
Long Copse. Chor —6D 20
Long Croft Meadow. Chor —4F 21
Longfield. Ful —3J 3
Longfield. Pen —1F 11
Longfield Av. Cop —6C 24
Long La. Hth C —3K 25
Longley Clo. Ful —3K 3
Long Meadow. Chor —3E 24
Longmeanygate. Midg H & Ley —4C 14
Long Moss. Ley —6C 14
Long Moss La. New L —7C 10
Longridge Rd. Rib —7F 5

Longsands La. Ful —6C 4
Longton By-Pass. Longt —7A 10
Longton St. Chor —7J 21
Longworth Av. Cop —6D 24
Longworth St. Bam B —3E 12
Longworth St. Chor —2F 25
Longworth St. Pres —3C 8
Lonsdale Clo. Ley —1J 19
Lonsdale Rd. Pres —3C 8
Lord's Av. Los H —6B 12
Lords Croft. Clay W —4E 16
Lord's La. Pen —4J 11
Lord St. Chor —1H 25
Lord St. Clay W —5G 17
Lord St. Ecc —3E 22
Lord St. Pres —5A 8
Lord's Wlk. Pres —4A 8
Lorne St. Chor —1G 25
Lorraine Av. Ful —1J 7
Lorton Clo. Ful —5K 3
Lostock Ct. Los H —6B 12
Lostock La. Los H —6C 12
Lostock Meadow. Clay W —5E 16
Lostock Sq. Los H —6B 12
Lostock View. Los H —6A 12
Lourdes Av. Los H —4A 12
Lovat Rd. Pres —2K 7
Low Croft. Wood —1F 3
Lwr. Bank Rd. Ful —1K 7
Lwr. Burgh Way. Chor —4E 24
Lwr. Copthurst La. Whit W —7J 17
Lwr. Croft. Pen —4H 11
Lwr. Field. Far M —7K 11
Lwr. Greenfield. Ing —7F 3
Lwr. Hill Dri. Hth C —7K 25
Lwr. House Rd. Ley —6G 15
Lowesby Clo. Walt D —2E 12
Low Grn. Ley —5H 15
Lowick Clo. Hogh —1K 13
Lowndes St. Pres —2J 7
(in two parts)
Lowood Gro. Lea —3B 6
Lowry Clo. Los H —6A 12
Lowther Cres. Ley —3F 15
Lowther Dri. Ley —4F 15
Lowther St. Ash R —3G 7
Lowthian St. Pres —4K 7
Lowthorpe Cres. Pres —2B 8
Lowthorpe Pl. Pres —2B 8
Lowthorpe Rd. Pres —2B 8
Lucas Av. Char R —1B 24
Lucas La. Whit W —2G 21
Lucerne Clo. Ful —7C 4
Lucerne Rd. Ful —7C 4
Lulworth Av. Ash R —2H 7
Lulworth Pl. Walt D —3D 12
Lulworth Rd. Ful —7A 4
Lund St. Pres —4K 7
Lune Dri. Ley —4C 16
Lune St. Pres —5K 7
Lupin Clo. Whit W —2F 21
Lupton St. Chor —2G 25
Luton Rd. Ash R —2C 6
Lutwidge Av. Pres —3C 8
Lutwidge St. Pres —4B 8
Lychfield. Bam B —6E 12
Lychgate. Pres —4A 8
Lydd Gro. Chor —1E 24
Lydgate. Chor —3E 24
Lydiate La. Ecc —7D 18
Lydiate La. Ley —2A 16
Lydric Av. Hogh —3K 13
Lyndale Clo. Los H —3C 12
Lyndale Clo. Ley —1K 19
Lyndale Gro. Los H —3C 12
Lyndeth Clo. Ful —5E 4
Lyndhurst Dri. Ash R —2C 6
Lynn Pl. Rib —2D 8
Lynton Av. Ley —6A 16
Lynwood Av. Grims —1J 5

Lyod Gro. Chor —1E 24
Lyons La. Chor —1H 25
Lytham Clo. Ful —1H 7
Lytham Rd. Ash R —1G 7
Lytham St. Chor —1J 25
Lythcoe Av. Ful —7G 3

McKenzie St. Bam B —5F 13
Maddy St. Pres —4H 7
Mafeking Rd. Ash R —2G 7
Magnolia Clo. Ful —5C 4
Magnolia Rd. Pen —2F 11
Main Sprit Weind. Pres —5A 8
Mainway St. Bam B —5E 12
Maitland Clo. Pres —4C 8
Maitland St. Pres —4C 8
(in two parts)
Malcolm St. Pres —3D 8
Malden St. Ley —5J 15
Maldon Pl. Rib —2D 8
Malham Rd. Pen —7E 4
Mallom Av. Eux —6C 20
Mall, The. Rib —2E 8
Malthouse Ct. Ash R —3H 7
Malthouse Way. Pen —2H 11
Maltings, The. Pen —2H 11
Malton Dri. Los H —6A 12
Malvern Av. Pres —7B 8
Malvern Clo. Los H —5C 12
Malvern Ho. Pres —3J 11
Malvern Rd. Pres —6B 8
Manchester Mill Ind. Est. Pres —4C 8
Manchester Rd. Pres —5A 8
Manning Rd. Pres —3E 8
(in two parts)
Manor Av. Ful —7B 4
Manor Av. Pen —1F 11
Manor Ct. Ful —4F 3
Manor Gro. Pen —1E 10
Manor Ho. Cres. Pres —1B 8
Manor Ho. Clo. Ley —6D 14
Manor Ho. La. Pres —1B 8
Manor La. Pen —1E 10
Manor Pk. Pen —1C 8
Manor Rd. Clay W —3F 17
Manston Gro. Chor —1E 24
Maplebank. Lea —3A 6
Maple Dri. Bam B —4F 13
Maple Gro. Chor —4H 21
Maple Gro. Grims —2K 5
Maple Gro. Pen —1F 11
Maple Gro. Rib —7G 5
Maples, The. Ley —1B 18
Maplewood Clo. Ley —6G 15
Marathon Pl. Ley —3E 14
Mardale Cres. Ley —7K 15
Mardale Rd. Pres —3G 9
Maresfield Rd. Pres —7H 7
Margaret Rd. Pen —1J 11
Margate Pl. Ing —7E 2
Margate St. Pres —4A 8
Marilyn Av. Los H —5B 12
Marina Clo. Los H —4A 12
Marina Dri. Ful —4J 3
Marina Dri. Los H —4A 12
Marina Gro. Los H —4A 12
Mariners Way. Ash R —4E 6
Mark Clo. Pen —4K 11
Market Pl. Chor —7G 21
Market Pl. Pres —5K 7
Market St. Chor —7G 21
Market St. Pres —4K 7
Market St. W. Pres —4K 7
Market Wlk. Chor —7G 21
Markham St. Ash R —3G 7
Markland St. Pres —5J 7
Mark's Av. Far M —5J 15
Marl Av. Pen —1F 11
Marlborough Dri. Ful —4H 3

Marlborough Dri. Walt D —1D 12
Marlborough St. Chor —6J 21
Marl Croft. Pen —3H 11
Marlfield Clo. Ing —6D 2
Marl Hill Cres. Rib —2G 9
Marrow Clo. Ley —6G 15
Marsden Clo. Ecc —1D 22
Marsett Pl. Rib —6E 4
Marshall Gro. Ing —7E 2
Marshall's Brow. Pen —2J 11
Marshall's Clo. Pen —1J 11
Marsh La. Pres —5H 7
Marsh Way. Pen —3G 11
Marston Clo. Ful —4G 3
Marston Moor. Ful —4G 3
Martindales, The. Clay W —3E 16
Martinfield. Ful —3K 3
Martin Field Rd. Pen —3H 11
Martins Av. Hth C —6J 25
Marton Rd. Ash R —4D 6
Marybank Clo. Ful —5C 4
Masefield Pl. Walt D —3D 12
Masonfield. Bam B —1F 17
Mason Hill View. Ful —7A 4
Mason Ho. Cres. Ing —6E 2
Mason St. Chor —5J 21
Masonwood. Ful —5A 4
Matlock Pl. Ing —6E 2
Matterdale Rd. Ley —7K 15
Maudland Bank. Pres —4J 7
Maudland Rd. Pres —4J 7
Maud St. Chor —2F 25
Maureen Av. Los H —5B 12
Mavis Dri. Cop —7C 24
Mayfield Av. Ing —7F 3
(in two parts)
Mayfield Av. Los H —5B 12
Mayfield Rd. Ash R —3F 7
Mayfield Rd. Chor —6H 21
Mayfield Rd. Ley —7J 15
Mayflower Av. Pen —2E 10
Maynard St. Ash R —2H 7
Maypark. Bam B —1E 16
Mead Av. Ley —6J 15
Meadow Bank. Bam B —2F 17
Meadow Bank. Pen —2G 11
Meadowbarn Clo. Cot —6C 2
Meadow Ct. Pres —6J 7
Meadowcroft. Eux —4K 19
Meadowcroft Rd. Ley —7F 15
Meadowfield. Ful —3K 3
Meadowfield. Pen —3J 11
Meadowlands. Char R —4B 24
Meadow La. Bam B —2F 17
Meadowside Dri. Hogh —4K 13
Meadows, The. Hesk —6G 23
Meadow St. Ley —5J 15
Meadow St. Pres —4A 8
Meadow St. Wheel —7K 17
Meadow, The. Ley —6D 14
Meadow Vale. Ley —6C 14
Meadow Way. Cop —7B 24
Meads Rd. Ash R —3F 7
Meadway. Clay W —3F 17
Meadway. Pen —7E 6
Mealhouse La. Chor —7G 21
Meanygate. Bam B —5E 12
Mearley Rd. Rib —7E 4
Meath Rd. Pres —6H 7
Medway. Ful —5K 3
Medway Clo. Los H —4B 12
Melba Rd. Rib —1E 8
Melbert Av. Ful —1G 7
Melbourne St. Pres —4K 7
Mellings Fold. Pres —6C 8
Melling St. Pres —4K 7
Melling's Yd. Pres —5K 7
Mellor Pl. Pres —5K 8
Mellor Rd. Ley —4F 15
Melrose Av. Ful —6B 4
Melrose Way. Chor —2H 25

Melton Pl. *Ley* —5K **15**
Menai Dri. *Ful* —4H **3**
Mendip Rd. *Ley* —5B **16**
Mercer Ct. *Hth C* —7K **25**
Mercer Rd. *Los H* —4A **12**
Mercer St. *Pres* —4C **8**
Mere Clo. *Brtn* —1G **3**
Merefield. *Chor* —6E **20**
Mere Fold. *Char R* —5B **24**
Merrick Av. *Pres* —4F **9**
Merryburn Clo. *Ful* —7A **4**
Merry Trees La. *Cot* —6B **2**
Mersey St. *Ash R* —4G **7**
Merton Av. *Ful* —5K **3**
Merton Gro. *Chor* —4J **21**
Mete St. *Pres* —4D **8**
Methuen Av. *Ful* —5J **3**
Mickleden Av. *Ful* —4K **3**
Middlefield. *Ley* —6C **14**
Middleforth Grn. *Pen* —1J **11**
Middlewood Clo. *Ecc* —2E **22**
Midge Hall La. *Midg H* —1A **14**
Midgery La. *Brou & Ful* —2A **4**
(in two parts)
Miles St. *Pres* —2K **7**
Miles Wlk. *Pres* —2J **7**
Millbank. *Ful* —1G **7**
Millbrook Way. *Pen* —3F **11**
Millcombe Way. *Walt D* —2E **12**
Millcroft. *Chor* —5E **20**
Mill Croft. *Ful* —7G **3**
Miller Arc. *Pres* —5A **8**
Miller Field. *Lea* —1C **6**
Millergate. *Cot* —7C **2**
Miller La. *Cot* —5C **2**
Miller Rd. *Pres & Rib* —3D **8**
Miller's La. *Ley* —3D **14**
Miller St. *Pres* —4C **8**
Millfield Rd. *Chor* —6F **21**
Mill Fold. *Pres* —3K **7**
Millgate. *Eux* —7B **20**
Mill Ga. *Ful* —1H **7**
Millhaven. *Ful* —7H **3**
Mill Hill. *Pres* —4J **7**
Mill La. *Char R* —6J **23**
Mill La. *Clay W* —5F **17**
Mill La. *Cop* —6C **24**
Mill La. *Ecc* —3E **22**
Mill La. *Eux* —6J **19**
(in two parts)
Mill La. *Far M* —3G **15**
Mill La. *Ful* —7G **3**
Mill La. *Ley* —6F **15**
Mill La. *Walt D* —7D **8**
Mill Row. *Pen* —2K **11**
Millstone Clo. *Cop* —7D **24**
Mill St. *Cop* —7C **24**
Mill St. *Far* —3K **15**
Mill St. *Ley* —6D **15**
Mill St. *Pres* —4H **7**
Mill St. *Wheel* —7K **17**
Millwood Glade. *Chor* —6F **21**
Millwood Rd. *Los H* —2B **12**
Milner St. *Pres* —2K **7**
Milton Clo. *Walt D* —3D **12**
Milton Ct. *Cop* —7C **24**
Milton Rd. *Cop* —7C **24**
Milton Ter. *Chor* —5H **21**
Mimosa Rd. *Rib* —2E **8**
Minster Pk. *Cot* —6C **2**
Mitton Dri. *Rib* —1G **9**
Moira Cres. *Rib* —7E **4**
Molyneux Ct. *Pres* —4A **8**
Mona Pl. *Pres* —4J **7**
Monks Wlk. *Pen* —6G **7**
Montcliffe Rd. *Chor* —6J **21**
Montgomery St. *Bam B* —5F **13**
Montjoly St. *Pres* —5C **8**
Montrose Clo. *Chor* —2J **25**
Moody La. *Maw* —7A **22**
Moon St. *Bam B* —5E **12**

Moor Av. *Pen* —2D **10**
Moorbrook St. *Pres* —3J **7**
Moorcroft. *Brou* —1F **3**
Moorcroft Cres. *Rib* —1D **8**
Moore St. *Pres* —5C **8**
Moor Field. *New L* —6E **10**
Moorfield Clo. *Ful* —3J **3**
Moorfield Dri. *Rib* —1E **8**
Moorfield Rd. *Ley* —6E **14**
Moorfields. *Chor* —6J **21**
Moorfields Av. *Ful* —3J **3**
Moorgate. *Ful* —6K **3**
Moor Hall St. *Pres* —2J **7**
Moorhey Cres. *Bam B* —5G **13**
Moorhey Cres. *Pen* —7F **7**
Moorhey Dri. *Pen* —7F **7**
Moorland Av. *Rib* —6D **4**
Moorland Cres. *Rib* —6D **4**
Moorland Ga. *Chor* —2K **25**
Moorlands. *Pres* —1J **7**
Moor La. *Hut* —4B **10**
Moor Pk. Av. *Pres* —2K **7**
Moor Rd. *Chor* —3E **24**
Moor Rd. *Cros* —4A **18**
Moorside Av. *Rib* —1F **9**
Morland Av. *Los H* —6A **12**
Mornington Rd. *Pen* —7F **7**
Mornington Rd. *Pres* —3F **9**
Morris Clo. *Ley* —6J **15**
Morris Ct. *Rib* —2D **8**
Morris Cres. *Rib* —2D **8**
Morrison St. *Chor* —5H **21**
Morris Rd. *Chor* —6J **21**
Morris Rd. *Rib* —2D **8**
Mosley St. *Ley* —5J **15**
Mosley St. *Pres* —4C **8**
Moss Acre Rd. *Pen* —2J **11**
Moss Av. *Ash R* —2E **6**
(in two parts)
Moss Bank. *Cop* —7C **24**
Moss Bri. Pk. *Los H* —5C **12**
Mossbrook Dri. *Cot* —6D **2**
Moss Clo. *Chor* —7J **21**
Mossdale Av. *Rib* —7D **4**
Mossfield Clo. *Los H* —5B **12**
Mossfield Rd. *Chor* —7J **21**
Moss Ho. Rd. *Wood* —1F **3**
Mosslands. *Ley* —5F **15**
Moss La. *Breth* —6A **14**
Moss La. *Cop* —7C **24**
Moss La. *Far M* —1E **14**
(in two parts)
Moss La. *Ley* —4K **15**
Moss La. *Los H* —5B **12**
Moss La. *Mos S* —5B **18**
Moss La. *New L* —5B **10**
Moss La. *Pen* —5J **11**
Moss La. *Whit W* —2G **21**
(in three parts)
Moss Side Way. *Ley* —7D **14**
Moss St. *Los H* —5B **12**
Moss St. *Pres* —4J **7**
Moss Ter. *Whit W* —2J **21**
Mossway. *New L* —7D **10**
Mottram Clo. *Whit W* —2G **21**
Mounsey Rd. *Bam B* —5F **13**
Mountain Rd. *Cop* —7C **24**
Mountbatten Rd. *Chor* —2F **25**
Mt. Pleasant. *Pres* —5K **7**
Mt. Pleasant. *Whit W* —6G **17**
Mount St. *Pres* —5K **7**
Muirfield. *Pen* —6E **6**
Muirfield Clo. *Ful* —5F **3**
Mulberry Av. *Pen* —2E **10**
Mulgrave Av. *Ash R* —3E **6**
Muncaster Rd. *Pres* —2K **7**
Munro Clo. *Ley* —6B **14**
Murdock Av. *Ash R* —2H **7**
Murray Av. *Far M* —1G **15**
Murray St. *Ley* —5K **15**

Murray St. *Pres* —3J **7**
Mythop Pl. *Ash R* —3D **6**

Nab Rd. *Chor* —6J **21**
Naptha La. *W Sta* —1E **14**
Nares St. *Ash R* —3G **7**
Narrow La. *Midg H* —4B **14**
Nateby Pl. *Ash R* —3D **6**
Navigation Bus. Village. *Ash R*
—4D **6**
Navigation Way. *Ash R* —4D **6**
Neapsands Clo. *Ful* —6D **4**
Neargates. *Char R* —5B **24**
Neath Clo. *Walt D* —2E **12**
Nell La. *Ley* —2B **16**
Nelson Av. *Ley* —5K **15**
Nelson Cres. *Lea* —2B **6**
Nelson Dri. *Lea* —2B **6**
Nelson Rd. *Chor* —1G **25**
Nelson St. *Bam B* —5E **12**
Nelson Ter. *Pres* —4H **7**
Nelson Way. *Ash R* —5C **6**
Nene Clo. *Ley* —7K **15**
Neston St. *Pres* —4E **8**
Netherley Rd. *Cop* —7C **24**
Nevett St. *Pres* —4D **8**
Newark Pl. *Ash R* —2C **6**
Newark Pl. *Ful* —3H **3**
New Brook Ho. *Pres* —4C **8**
Newbury Clo. *Ful* —3G **3**
Newbury Grn. *Ful* —3G **3**
Newby Dri. *Ley* —4B **16**
Newby Pl. *Rib* —7D **4**
(in two parts)
Newcock Yd. *Pres* —5K **7**
Newfield Rd. *Bam B* —6G **13**
Newgate. *Ful* —7J **3**
Newgate La. *W Sta* —5G **11**
New Hall La. *Pres* —4B **8**
Newlands. *Ecc* —2E **22**
Newlands Av. *Pen* —1F **11**
New La. *Ecc* —5C **18**
New La. *Pen* —2J **11**
New Links Av. *Ing* —5E **2**
Newlyn Pl. *Ing* —6D **2**
New Mkt. St. *Chor* —7G **21**
New Mill St. *Ecc* —2E **22**
New Moss La. *Whit W* —2G **21**
New Pastures. *Los H* —5C **12**
New Rd. *Cop* —5D **24**
New Rd. *Los H* —4B **12**
New Rough Hey. *Ing* —5D **2**
Newsham Hall La. *Wood* —1C **2**
Newsham La. *Wood* —1F **3**
Newsham St. *Ash R* —3H **7**
Newsome St. *Ley* —5J **15**
New St. *Ecc* —2E **22**
Newton Av. *Pres* —4G **9**
Newton Clo. *Ley* —6D **14**
Newton Ct. *Ash R* —3F **7**
Newton Rd. *Ash R* —2F **7**
Newton St. *Pres* —4A **8**
(in two parts)
New Ward St. *Los H* —6B **12**
Nichol St. *Chor* —6G **21**
Nimes St. *Pres* —4D **8**
Nine Elms. *Ful* —5G **3**
Nixon Ct. *Ley* —6B **14**
Nixon La. *Ley* —6B **14**
Noel Sq. *Rib* —3E **8**
Nook Cres. *Grims* —2J **5**
Nookfield. *Ley* —5C **14**
Nook Glade. *Grims* —2J **5**
Nooklands. *Ful* —7J **3**
Nook La. *Bam B* —6D **12**
Nook La. *Maw* —3A **22**
Noor St. *Pres* —4H **7**
Norbreck Dri. *Ash R* —3C **6**
Norcross Pl. *Ash R* —3D **6**
Norfolk Clo. *Ley* —7G **15**

Norfolk Rd. *Pres* —3A **8**
Norfolk Rd. *Walt D* —1D **12**
Normandy Rd. *Wood* —1F **3**
Norris St. *Chor* —2G **25**
Norris St. *Ful & Pres* —1H **7**
(in two parts)
Northbrook Rd. *Ley* —5G **15**
(in two parts)
N. Cliff St. *Pres* —6J **7**
Northcote Rd. *Pres* —5H **7**
Northcote St. *Ley* —5J **15**
Northenden Rd. *Cop* —7C **24**
Northgate. *Ley* —4J **15**
Northgate Dri. *Chor* —5J **21**
North Gro. *Los H* —4C **12**
N. Highfield. *Ful* —5E **4**
Northlands. *Ful* —5J **3**
Northlands. *Ley* —7E **14**
Northleach Av. *Pen* —3K **11**
N. Ribble St. *Walt D* —6C **8**
North Rd. *Pres* —3K **7**
Northside. *Eux* —4A **20**
North St. *Chor* —5H **21**
North St. *Pres* —4K **7**
N. Syke Av. *Lea* —3A **6**
North Ter. *Eux* —3B **20**
Northumberland Ho. *Pres* —4K **7**
Northumberland St. *Chor* —1H **25**
North Vale. *Hth C* —7K **25**
North View. *Ley* —5K **15**
Northway. *Brtn* —1G **3**
Northway. *Ful* —4H **3**
Norwich Pl. *Pres* —5A **8**
Nottingham Rd. *Pres* —3A **8**
Nursery Clo. *Char R* —4C **24**
Nursery Clo. *Ley* —6H **15**
Nursery La. *New L* —5C **10**
Nutter Rd. *Pres* —4J **7**

Oak Av. *Eux* —4B **20**
Oak Av. *Pen* —2F **11**
Oak Croft. *Clay W* —4F **17**
Oak Dri. *Chor* —4G **21**
Oakengate. *Ful* —4C **4**
Oakenhead St. *Pres* —3E **8**
Oakfield. *Ash R* —3F **7**
Oakfield. *Ful* —4K **3**
Oakfield Dri. *Ley* —6D **14**
Oak Gro. *New L* —7E **10**
Oakham Ct. *Pres* —5A **8**
Oakland Glen. *Pen* —2A **12**
Oakland Glen Caravan Pk. *Pen*
—2A **12**
Oaklands Dri. *Pen* —1E **10**
Oaklands Gro. *Ash R* —3D **6**
Oakland St. *Bam B* —4E **12**
Oakmere. *Brind* —3G **17**
Oakridge Clo. *Ful* —4K **3**
Oakshott Pl. *Bam B* —6H **13**
Oaks, The. *Chor* —4F **25**
Oaks, The. *Walt D* —2B **12**
Oak St. *Pres* —5A **8**
Oaktree Av. *Ley* —3B **16**
Oak Tree Av. *Ley* —3B **16**
Oaktree Clo. *Ing* —7E **2**
Oak View. *Ley* —5J **15**
Oakwood Av. *Walt D* —1C **12**
Oakwood Dri. *Ful* —3H **3**
Oakwood Rd. *Chor* —2G **25**
Oakwood Rd. *Cop* —6D **24**
Oakwood View. *Chor* —4F **25**
Oakworth Av. *Rib* —6F **5**
Oban Ct. *Grims* —2K **5**
Oban Cres. *Pres* —1D **8**
Odell Way. *Walt D* —2E **12**
Old Bri. Way. *Chor* —6H **21**
Old Brown La. *Bam B* —6A **13**
Oldcock Yd. *Pres* —5A **8**
Old Croft. *Ful* —3H **3**
Old Dawber's La. *Eux* —6K **19**

Oldfield. *Pen* —3H **11**
Oldfield Rd. *Bam B* —6G **13**
Old Hall Clo. *Bam B* —5E **12**
Old Hall Dri. *Bam B* —5E **12**
Old Hall La. *Char R* —2K **23**
Old Hey Croft. *Pen* —3H **11**
Old Lancaster La. *Pres* —3H **7**
Old Millstones. *Pres* —5H **7**
Old Mill Ter. *Chor* —6J **21**
Old Oak Gdns. *Walt D* —2B **12**
Old Pope La. *W Sta* —5F **11**
Old School Clo. *Ley* —6C **14**
Old School La. *Eux* —4B **20**
(in two parts)
Old School La. *Los H* —7C **12**
Old Sta. Clo. *Grims* —2K **5**
Old Tram Rd. *Bam B* —5E **12**
(in two parts)
Old Tram Rd. *Pen & Walt D*
(in three parts) —1A **12**
Old Vicarage. *Pres* —4A **8**
Olive Clo. *Whit W* —2G **21**
Olivers Pl. *Ful* —3B **4**
Olivers Way. *Ful* —3A **4**
Orchard Av. *New L* —6E **10**
Orchard Clo. *Eux* —4B **20**
Orchard Clo. *Ing* —6E **2**
Orchard Croft. *Los H* —5A **12**
Orchard Dri. *Whit W* —2G **21**
Orchard St. *Ley* —5K **15**
Orchard St. *Pres* —4K **7**
Orchard, The. *Wood* —2C **2**
Ord Rd. *Ash R* —2G **7**
Ormskirk Rd. *Pres* —4A **8**
Orrell Clo. *Ley* —5F **15**
Orrest Rd. *Pres* —3G **9**
Osborne Rd. *Walt D* —2D **12**
Osborne St. *Pres* —5J **7**
Oswald Rd. *Ash R* —3G **7**
Otters Clo. *Rib* —2F **9**
Otway St. *Pres* —2J **7**
Outram Way. *Bam B* —5E **12**
Overton Rd. *Ash R* —4C **6**
Owens St. *Chor* —1J **25**
Owen St. *Pres* —4B **8**
Owtram St. *Pres* —4C **8**
Oxford Rd. *Bam B* —5F **13**
Oxford Rd. *Ful* —7H **3**
Oxford St. *Chor* —1G **25**
Oxford St. *Pres* —5A **8**
Ox Hey Av. *Lea* —2A **6**
Oxheys Ind. Est. *Pres* —2H **7**
Oxheys St. *Pres* —2H **7**
Oxley Rd. *Pres* —3D **8**
(in two parts)

Paddock Av. *Ley* —6C **14**
Paddock, The. *Ful* —5A **4**
Paddock, The. *Pen* —3J **11**
Padway. *Pen* —3H **11**
Pages Clo. *Los H* —6B **12**
Paley Rd. *Pres* —5H **7**
Pall Mall. *Chor* —2G **25**
Paradise La. *Ley* —5D **14**
Paradise St. *Chor* —4K **21**
Park Av. *Eux* —5B **20**
Park Av. *New L* —5C **10**
Park Av. *Pres* —2B **8**
Park Clo. *Pen* —1H **11**
Park Dri. *Lea* —3B **6**
Parker La. *W Sta* —7G **11**
Parker St. *Ash R* —2H **7**
Parker St. *Chor* —6G **21**
Parkfield Av. *Ash R* —2F **7**
Parkfield Clo. *Lea* —3A **6**
Parkfield Clo. *Ley* —6E **14**
Parkfield Cres. *Lea* —4A **6**
Parkfield Dri. *Lea* —4A **6**
Parkfield View. *Lea* —4A **6**
Parkgate Dri. *Ley* —7G **15**

Park Hall Rd. *Hesk* —4G **23**
Parklands Av. *Pen* —1E **10**
Parklands Clo. *Pen* —1E **10**
Parklands Dri. *Ful* —3J **3**
Parklands Gro. *Ful* —3J **3**
Park La. *Pen* —2J **11**
Park Mill Pl. *Pres* —3A **8**
Park Pl. *Walt D* —1E **12**
Park Rd. *Chor* —7G **21**
Park Rd. *Cop* —7C **24**
Park Rd. *Ful* —7A **4**
Park Rd. *Ley* —7J **15**
Park Rd. *Pen* —1H **11**
Parkside. *Lea* —2B **6**
Parkside. *Pres* —1B **8**
Parkside Av. *Chor* —7G **21**
Parkside Dri. N. *Whit W* —1F **21**
Parkside Dri. S. *Whit W* —1F **21**
Park Stone Rd. *Brtn* —1G **3**
Park St. *Chor* —6G **21**
Park St. *Ecc* —2E **22**
Parkthorn Rd. *Lea* —4A **6**
Park View. *Pen* —1H **11**
Park View Av. *Ash R* —2F **7**
Park Wlk. *Ful* —1A **8**
Park Way. *Pen* —1H **11**
Park Way Caravan Site. *Pen*
 —1H **11**

Parlick Rd. *Rib* —2G **9**
Parr Cottage Clo. *Ecc* —1E **22**
Parr La. *Ecc* —1E **22**
Parrock Clo. *Pen* —2J **11**
Parsons Brow. *Chor* —1G **25**
Pasture Field Clo. *Ley* —6E **14**
Patten St. *Pres* —4K **7**
Pavilions, The. *Ash R* —5G **7**
Peachtree Clo. *Ful* —5D **4**
Peacock Hall Rd. *Ley* —7F **15**
Pearfield. *Ley* —4J **15**
Pear Tree Av. *Cop* —5C **24**
Pear Tree Clo. *Walt D* —3E **12**
Pear Tree Cres. *Walt D* —3E **12**
Pear Tree La. *Eux* —4C **20**
Pear Tree Rd. *Clay W* —3F **17**
Pear Tree St. *Bam B* —3E **12**
Pechell St. *Ash R* —3G **7**
Pedder's Gro. *Ash R* —4E **6**
Pedder's La. *Ash R* —4E **6**
Pedder St. *Ash R* —4H **7**
Pedder's Way. *Ash R* —4E **6**
Peel Hall La. *Pres* —3B **8**
Peel St. *Ash R* —4J **7**
Peel St. *Chor* —1G **25**
Pembroke Pl. *Chor* —2F **25**
Pembroke Pl. *Ley* —6J **15**
Pembroke Pl. *Pres* —5A **8**
Pembury Av. *Pen* —2K **11**
Pendle Rd. *Ley* —5B **16**
Penguin St. *Pres* —3B **8**
Pennine Av. *Eux* —6B **20**
Pennine Rd. *Chor* —7J **21**
Pennines, The. *Ful* —4A **4**
Penny St. *Pres* —4A **8**
Penwortham Ct. *Pen* —1H **11**
Penwortham Hall Gdns. *Pen*
 —2J **11**
Penwortham Way. *Pres* —3F **11**
Pen-y-Ghent Way. *Ley* —5A **16**
Percy St. *Chor* —1H **25**
Percy St. *Pres* —4A **8**
Peregrine Pl. *Ley* —4E **14**
Peterfield Rd. *Pen* —3H **11**
Peter St. *Chor* —7G **21**
Pickerings, The. *Los H* —5C **12**
Pikestone Ct. *Chor* —7J **21**
Pilling Clo. *Chor* —2H **25**
Pilling La. *Chor* —3G **25**
Pincock Brow. *Eux* —7A **20**
Pincock St. *Eux* —7A **20**
Pine Clo. *Rib* —7F **5**
Pine Gro. *Chor* —4H **21**

Pines Clo. *Bam B* —2G **17**
Pines, The. *Ley* —6B **14**
Pine Walks. *Lea* —3A **6**
Pineway. *Ful* —7G **3**
Pinewood Av. *Brtn* —1H **3**
Pinewood Cres. *Ley* —6G **15**
Pinfold St. *Pres* —4D **8**
Pingle Croft. *Clay W* —4E **16**
Pippin St. *Brind* —2J **17**
Pitman Ct. *Ful* —3B **4**
Pitman Way. *Ful* —3B **4**
(in two parts)
Pitt St. *Pres* —5J **7**
Plant St. *Ash R* —3G **7**
Pleasant View. *Cop* —6D **24**
Plevna Rd. *Pres* —4C **8**
Plock Grn. *Chor* —3G **25**
Plover St. *Pres* —2B **8**
Plumpton Field. *Wood* —1C **2**
Plumpton Rd. *Ash R* —2G **7**
Plumtree Clo. *Ful* —5C **4**
Plungington Rd. *Ful & Pres*
 —1H **7**
Plymouth Gro. *Chor* —7J **21**
Polefield. *Ful* —4J **3**
Pole St. *Pres* —4A **8**
Pollard St. *Pres* —4J **7**
Poole Rd. *Ful* —7A **4**
Pool Ho. La. *Ing* —6D **2**
Pope La. *Rib* —2F **9**
Pope La. *W Sta & Pen* —5F **11**
Pope Wlk. *Pen* —2H **11**
Poplar Av. *Bam B* —4F **13**
Poplar Av. *Eux* —3A **20**
Poplar Clo. *Bam B* —4F **13**
Poplar Dri. *Pen* —1G **11**
Poplar Gro. *Bam B* —4F **13**
Poplar Gro. *Rib* —7G **5**
Poplar St. *Chor* —2H **25**
Poppy Av. *Chor* —5H **21**
Poppyfield. *Cot* —5D **2**
Porter Pl. *Pres* —6A **8**
Porter St. *Pres* —3B **8**
Portland St. *Chor* —7H **21**
Portland St. *Pres* —5H **7**
Portman St. *Pres* —4A **8**
Portree Clo. *Ful* —6C **4**
Portsmouth Dri. *Chor* —7J **21**
Port Way. *Ash R* —4G **7**
Potter La. *High W* —6J **9**
Potter La. *Sam* —3K **9**
Poulton Cres. *Hogh* —2K **13**
Poulton St. *Ash R* —3G **7**
Powis Rd. *Ash R* —4E **6**
Poynter St. *Pres* —3C **8**
Preesall Clo. *Ash R* —3C **6**
Preesall Rd. *Ash R* —3C **6**
Preston Guild Trading Est. *Pres*
 —3B **8**
Preston New Rd. *Sam* —3H **9**
(in two parts)
Preston Nook. *Ecc* —3E **22**
Preston Rd. *Bam B & Clay W*
 —7G **13**
Preston Rd. *Char* —5K **23**
Preston Rd. *Grims* —3J **5**
Preston Rd. *Ley* —4K **15**
Preston Rd. *Whit W & Chor*
 —2G **21**
Preston St. *Chor* —5G **21**
Pretoria St. *Bam B* —5E **12**
Primrose Gro. *Pres* —1C **8**
Primrose Hill. *Pres* —5B **8**
Primrose Hill Rd. *Eux* —4K **19**
Primrose La. *Pres* —1C **8**
Primrose Rd. *Pres* —1C **8**
Primrose St. *Chor* —7H **21**
Princes Ct. *Pen* —6F **7**
Princes Dri. *Ful* —5J **3**
Princes Reach. *Ash R* —5E **6**
Princes Rd. *Pen* —6F **7**

Prince's Rd. *Walt D* —1E **12**
Princess St. *Bam B* —5F **13**
Princess St. *Chor* —2H **25**
Princess St. *Ley* —5K **15**
Princess St. *Los H* —6B **12**
Princess St. *Pres* —5B **8**
Princess Way. *Eux* —5B **20**
Prince's Way. *Eux* —5C **20**
Prior's Oak Cotts. *Pen* —7G **7**
Priory Clo. *Ley* —4A **16**
Priory Clo. *Pen* —6G **7**
Priory Cres. *Pen* —6G **7**
Priory La. *Pen* —7F **7**
Priory St. *Ash R* —4H **7**
Progress St. *Chor* —7J **21**
Prospect Av. *Los H* —5B **12**
Prospect Pl. *Ash R* —3F **7**
Prospect Pl. *Pen* —1J **11**
Prospect View. *Los H* —6B **12**
Pump Ho. La. *Ley* —1B **18**
Pump St. *Pres* —4A **8**

Quarry Rd. *Chor* —2J **25**
Queens Ct. Ful —1J **7**
(off Queens Rd.)
Queenscourt Av. *Pen* —3J **11**
Queensdale Clo. *Walt D* —1E **12**
Queensgate. *Chor* —1F **25**
Queen's Gro. *Chor* —7G **21**
Queen's Retail Pk. *Pres* —5B **8**
Queen's Rd. *Chor* —7F **21**
Queens Rd. *Ful* —1H **7**
Queen's Rd. *Walt D* —7E **8**
Queen St. *Los H* —6B **12**
Queen St. *Pres* —5B **8**
Queen St. E. *Chor* —2H **25**
Queensway. *Ash R* —2D **6**
Queensway. *Bam B* —4E **12**
Queensway. *Eux* —5C **20**
Queensway. *Ley* —6G **15**
Queensway. *Pen* —6F **7**
Queensway Clo. *Pen* —6F **7**
Quin St. *Ley* —5J **15**

Radburn Brow. *Clay W*
 —3F **17**
Radburn Clo. *Clay W* —3F **17**
Radnor St. *Pres* —4J **7**
Raglan St. *Ash R* —2H **7**
Raikes Rd. *Pres* —3C **8**
Railway Rd. *Chor* —6H **21**
Railway St. *Chor* —7H **21**
Railway St. *Ley* —4K **15**
Raleigh Rd. *Ful* —5J **3**
Ramsey Av. *Pres* —1D **8**
Ranaldsway. *Ley* —6F **15**
Ranglet Rd. *Bam B* —6H **13**
Rangletts Av. *Chor* —2G **25**
Ranglit Av. *Lea* —3A **6**
Ratten La. *Hut* —2A **10**
Ravenhill Dri. *Chor* —6G **21**
Ravensthorpe. *Chor* —6E **20**
Raven St. *Pres* —2C **8**
Ravenswood. *Rib* —2E **8**
Rawcliffe Dri. *Ash R* —4C **6**
Rawcliffe Rd. *Chor* —1G **25**
Rawlinson La. *Hth C* —6A **23**
Rawstorne Rd. *Pen* —7F **7**
Rectory Clo. *Chor* —7G **21**
Red Bank. *Chor* —3H **25**
Redcar Av. *Ing* —7D **2**
Red Cross St. *Pres* —5J **7**
Redhill. *Hut* —4A **10**
Redhill Gro. *Chor* —4J **21**
Red Ho. La. *Ecc* —2D **22**
Red La. *Ecc* —1F **23**
Redmayne St. *Pres* —4D **8**
Redsands Dri. *Ful* —6D **4**

Red Scar Ind. Est. *Rib* —6H **5**
(in two parts)
Redwood Av. *Ley* —5G **15**
Reedfield. *Bam B* —2G **17**
Reedfield Pl. *Bam B* —7G **13**
Reeveswood. *Ecc* —2D **22**
Regency Av. *Los H* —6D **12**
Regent Ct. *Ful* —6J **3**
Regent Dri. *Ful* —7H **3**
Regent Gro. *Ful* —6J **3**
Regent Pk. *Ful* —6J **3**
Regent Rd. *Chor* —1F **25**
Regent Rd. *Ley* —5J **15**
Regent Rd. *Walt D* —1D **12**
Regent St. *Cop* —7C **24**
Regent St. *Pres* —6K **7**
Regentsway. *Bam B* —4E **12**
Regents Way. *Eux* —5B **20**
Reigate. *Chor* —4K **21**
Reiver Rd. *Ley* —3E **14**
Renshaw Dri. *Walt D* —3E **12**
Rhoden Rd. *Ley* —5E **14**
Rhodesway. *Hogh* —3K **13**
Ribble Bank. *Pen* —6F **7**
Ribble Bank St. *Pres* —5J **7**
Ribble Brook Ho. *Pres* —3K **7**
Ribble Clo. *Pen* —1J **11**
Ribble Clo. *Pres* —6J **7**
Ribble Ct. *Ash R* —3G **7**
Ribble Cres. *Walt D* —6C **8**
Ribble Rd. *Ley* —6F **15**
Ribble St. *Pres* —5J **7**
Ribblesdale Dri. *Grims* —3J **5**
Ribblesdale Pl. *Chor* —1F **25**
Ribblesdale Pl. *Pres* —6K **7**
Ribble St. *Pres* —5J **7**
Ribbleton Av. *Pres & Rib* —3D **8**
Ribbleton Hall Cres. *Rib* —1F **9**
Ribbleton Hall Rd. *Rib* —1F **9**
Ribbleton La. *Pres* —4B **8**
Ribbleton Pl. *Pres* —4B **8**
Ribbleton St. *Pres* —4B **8**
Ribby Pl. *Ash R* —3D **6**
Richmond Ct. *Ley* —5D **14**
Richmond Ho. *Pres* —5A **8**
Richmond Rd. *Chor* —2J **25**
Richmond Rd. *Ecc* —1E **22**
Richmond St. *Pres* —5B **8**
Ridgeford Gdns. *Ful* —6H **3**
Ridgemont. *Ful* —5G **3**
Ridge Rd. *Chor* —1J **25**
Ridgeway. *Pen* —1H **11**
Ridings, The. *Whit W* —1G **21**
Riding St. *Pres* —3K **7**
Ridley La. *Maw & Bis* —6A **22**
Ridley Rd. *Ash R* —2G **7**
Rigby St. *Pres* —3C **8**
Riley Clo. *Ley* —6J **15**
Ringway. *Chor* —1E **24**
Ring Way. *Pres* —5J **7**
Ringwood Rd. *Pres* —2C **8**
Ripon St. *Pres* —2H **7**
Ripon Ter. *Pres* —3F **9**
River Heights. *Los H* —5C **12**
River Pde. *Pres* —6H **7**
Riversedge Rd. *Ley* —6E **14**
Riverside. *Bam B* —6E **12**
Riverside. *Pen* —7J **7**
Riverside. *Pres* —7J **7**
Riverside Av. *Far M* —2G **15**
Riverside Clo. *Far M* —2G **15**
Riverside Ter. *Far* —2G **15**
River St. *Pres* —5J **7**
Riversway. *Ash R* —4A **6**
Riversway Bus. Village. *Ash R*
—4E **6**
River Way Clo. *Los H* —5C **12**
Rivington Rd. *Chor* —6J **21**
Roberts St. *Chor* —1G **25**
Robin Clo. *Char R* —5B **24**
Robin Hey. *Ley* —5D **14**
Robinson St. *Ful* —1H **7**

Robin St. *Pres* —3D **8**
Rock Villa Rd. *Whit W* —6F **17**
Rodney St. *Pres* —4J **7**
Roebuck St. *Ash R* —2G **7**
Roe Hey Dri. *Cop* —6D **24**
Roman Rd. *Pres* —5B **8**
Roman Way. *Rib* —5J **5**
Roman Way Ind. Est. *Rib* —5J **5**
Romford Rd. *Pres* —2C **8**
Ronaldsway. *Ley* —6F **15**
Ronaldsway. *Pres* —1D **8**
Rookery Clo. *Chor* —2E **24**
Rookery Clo. *Pen* —3K **11**
Rookery Dri. *Pen* —3K **11**
Rook St. *Pres* —3B **8**
Rookwood. *Ecc* —2D **22**
Rookwood Av. *Chor* —5G **21**
Roseacre Pl. *Ash R* —3C **6**
Rose Av. *Ash R* —1G **7**
Rosebank. *Lea* —3A **6**
Roseberry Av. *Cot* —6C **2**
Rose Cotts. *Whit W* —2H **21**
Rose Fold. *Pen* —1H **11**
Rose Hill. *Eux* —3A **20**
Rose La. *Pres* —1C **8**
Rose Lea. *Ful* —5D **4**
Rosemary Ct. *Pen* —3G **11**
Rosemeade Av. *Los H* —5B **12**
Rose St. *Far* —3K **15**
Rose St. *Pres* —5A **8**
Rose Ter. *Ash R* —3F **7**
Roseway. *Ash R* —3E **6**
Rosewood Av. *High W* —2J **13**
Rosewood Dri. *High W* —2H **13**
Roshaw. *Grims* —2K **5**
Rosklyn Rd. *Chor* —1J **25**
Rossall Clo. *Hogh* —1K **13**
Rossall Dri. *Ful* —7G **3**
Rossall Rd. *Chor* —6J **21**
Rossall Rd. *Ful* —7G **3**
Rossall St. *Ash R* —3G **7**
Rostrevor Clo. *Ley* —5D **14**
Rotherwick Av. *Chor* —1F **25**
Rothwell Ct. *Ley* —4J **15**
Rothwell Cres. *Rib* —7F **5**
Rough Hey Pl. *Ful* —4H **5**
Rough Hey Rd. *Grims* —4H **5**
Round Acre. *Pen* —4A **12**
Round Meadow. *Ley* —5E **14**
Round Wood. *Pen* —5F **7**
Roundway Down. *Ful* —4G **3**
Rowan Av. *Rib* —7G **5**
Rowan Clo. *Pen* —2F **11**
Rowan Croft. *Clay W* —5E **16**
Rowangate. *Ful* —4C **4**
Rowan Gro. *Chor* —4G **25**
Rowarth Clo. *Walt D* —2E **12**
Rowberrow Clo. *Ful* —5D **4**
Rowton Heath. *Ful* —4H **3**
Royal Av. *Ful* —5J **3**
Royal Av. *Ley* —7G **15**
Royalty Av. *New L* —5E **10**
Royalty Gdns. *New L* —5D **10**
Royalty La. *New L* —5E **10**
Royle Rd. *Chor* —7F **21**
Royton Dri. *Whit W* —2G **21**
Rufus St. *Pres* —2C **8**
Rundle Rd. *Ful* —1H **7**
Runshaw Hall La. *Eux* —2J **19**
Runshaw La. *Eux* —5F **19**
Rushy Hey. *Los H* —5A **12**
Ruskin Av. *Ley* —5J **15**
Ruskin St. *Pres* —6B **8**
Rusland Dri. *Hogh* —1K **13**
Russell Av. *Ley* —6A **16**
Russell Av. *Pres* —3G **9**
Russell Sq. *Chor* —6H **21**
Russell Sq. W. *Chor* —6H **21**
Rutland Av. *Walt D* —2D **12**
Rutland St. *Pres* —4C **8**
Rydal Av. *Pen* —2G **11**

Rydal Av. *Walt D* —4D **12**
Rydal Clo. *Ful* —7C **4**
Rydal Pl. *Chor* —2F **25**
Rydal Rd. *Pres* —2D **8**
Ryddingwood. *Pen* —6F **7**
Ryden Av. *Ley* —5A **16**
Ryefield. *Heap* —7K **17**
Ryefield Av. *Pen* —3H **11**
Ryelands Cres. *Ash R* —4C **6**
Rye St. *Pres* —3A **8**
Rylands Rd. *Chor* —1F **25**

Sackville St. *Chor* —1J **25**
Sagar St. *Ecc* —2E **22**
Sage Ct. *Pen* —3G **11**
Sage La. *Pres* —1B **8**
St Aiden's Rd. *Bam B* —3E **12**
St Albans Pl. *Chor* —4A **8**
St Ambrose Ter. *Ley* —4K **15**
St Andrew's Av. *Ash R* —2E **6**
St Andrew's Clo. *Ley* —7J **15**
St Andrew's Rd. *Pres* —2A **8**
St Andrews Way. *Ley* —6J **15**
St Anne's Rd. *Chor* —1J **25**
St Anne's Rd. *Ley* —3A **16**
St Anne's St. *Pres* —2A **8**
St Anthony's Clo. *Ful* —7G **3**
St Anthony's Cres. *Ful* —7G **3**
St Anthony's Dri. *Ful* —7G **3**
St Anthony's Rd. *Pres* —2A **8**
St Austin's Pl. *Pres* —5A **8**
St Austin's Rd. *Pres* —5A **8**
St Barnabas Pl. *Pres* —3A **8**
St Catherines Clo. *Ley* —4A **16**
St Catherine's Dri. *Ful* —7G **3**
St Chad's Rd. *Pres* —3C **8**
St Christine's Av. *Far* —2A **16**
St Christopher's Rd. *Pres* —2A **8**
St Clares Av. *Ful* —5A **4**
St Clements Av. *Far* —3A **16**
St Cuthbert's Clo. *Ful* —1H **7**
St Cuthberts Rd. *Los H* —4A **12**
St Cuthbert's Rd. *Pres* —2A **8**
St David's Rd. *Ley* —4A **16**
St David's Rd. *Pres* —2A **8**
St Francis Clo. *Ful* —4A **4**
St George's Rd. *Pres* —2K **7**
St George's Shopping Cen. *Pres*
—5K **7**
St Georges St. *Chor* —1G **25**
St Gerrard's Rd. *Los H* —4A **12**
St Gregory Rd. *Pres* —2B **8**
St Gregory's Pl. *Chor* —3G **25**
St Helen's Rd. *Whit W* —5G **17**
St Hilda's Clo. *Chor* —4G **25**
St Ignatius Pl. *Pres* —4A **8**
St Ignatius Sq. *Pres* —4A **8**
St Ives Cres. *Pres* —7E **2**
St James Clo. *Los H* —5B **12**
St James Ct. *Los H* —5B **12**
St James Gdns. *Ley* —6C **14**
St James Lodge. *Ley* —6D **14**
St James' Rd. *Pres* —2K **7**
St James's Pl. *Chor* —1J **25**
St James's St. *Chor* —1J **25**
St John's Clo. *Whit W* —7F **17**
St John's Grn. *Ley* —5G **15**
St John's Pl. *Pres* —5A **8**
St John's Rd. *Walt D* —7D **8**
St John's Shopping Cen. Pres
(off Lancaster Rd.) —4A **8**
St Joseph's Ter. *Pres* —3C **8**
St Jude's Av. *Bam B* —4D **12**
St Jude's Av. *Far* —2A **16**
St Leonard's Clo. *Ing* —1E **6**
St Luke's Pl. *Pres* —3C **8**
St Margarets Rd. *Ley* —4A **16**
St Mark's Pl. E. *Pres* —4H **7**
St Mark's Pl. W. *Pres* —4H **7**
St Mark's Rd. *Pres* —4H **7**

St Marlowes Av. *Ley* —3A **16**
St Martin's Rd. *Pres* —2A **8**
St Mary's Av. *Walt D* —4D **12**
St Mary's Clo. *Pres* —4C **8**
St Mary's Clo. *Walt D* —4D **12**
St Mary's Ct. *Pres* —4B **8**
St Mary's Ga. *Eux* —4A **20**
St Mary's Rd. *Bam B* —4E **12**
St Mary's St. *Pres* —4B **8**
St Mary's St. N. *Pres* —4B **8**
St Mary's Wlk. *Chor* —7G **21**
St Michael's Clo. *Chor* —6F **21**
St Michael's Rd. *Ley* —4A **16**
St Michael's Rd. *Pres* —2A **8**
St Oswald's Clo. *Pres* —2C **8**
St Patrick's Pl. *Walt D* —1E **12**
St Paul's Av. *Pres* —3A **8**
St Paul's Clo. *Far M* —6K **11**
St Paul's Ct. *Pres* —4A **8**
St Paul's Rd. *Pres* —2A **8**
St Pauls Sq. *Pres* —4A **8**
St Peter's Clo. Pres —4K **7**
(off St Peter's St.)
St Peter's Sq. *Pres* —4J **7**
St Peter's St. *Chor* —6J **21**
St Peter's St. *Pres* —4K **7**
St Philip's Rd. *Pres* —2A **8**
St Saviour's Clo. *Bam B* —6F **13**
St Stephen's Rd. *Pres* —2A **8**
St Theresa's Dri. *Ful* —7G **3**
St Thomas' Pl. *Pres* —3K **7**
St Thomas Rd. *Pres* —2K **7**
St Thomas's Rd. *Chor* —7G **21**
St Thomas St. *Pres* —3K **7**
St Vincents Rd. *Ful* —6J **3**
St Walburge Av. *Ash R* —4J **7**
St Walburge's Gdns. *Ash R* —4H **7**
St Wilfrid St. *Pres* —5K **7**
Salisbury Rd. *Pres* —5H **7**
Salisbury St. *Chor* —1H **25**
Salisbury Pl. *Pres* —3D **8**
Salmon St. *Pres* —5C **8**
Salter St. *Pres* —4J **7**
Salt Pit La. *Maw* —4B **22**
Salwick Pl. *Ash R* —3C **6**
Samuel St. *Pres* —4D **8**
Sanderson La. *Hesk* —7C **22**
Sanderson M. *Hesk* —7C **22**
Sandfield St. *Ley* —5K **15**
Sandgate. *Chor* —3H **25**
Sandham St. *Chor* —7H **21**
Sandown Ct. *Pres* —5A **8**
Sandridge Av. *Chor* —1F **25**
Sandringham Av. *Ley* —6A **16**
Sandringham Pk. Dri. *New L*
—5E **10**
Sandringham Rd. *Chor* —7F **21**
Sandringham Rd. *Ecc* —1E **22**
Sandringham Rd. *Walt D* —2D **12**
Sandsdale Av. *Ful* —6C **4**
Sandwick Clo. *Ful* —4K **3**
Sandybrook Clo. *Ful* —6E **4**
Sandycroft. *Rib* —2F **9**
Sandyforth La. *L Grn* —4E **2**
Sandygate La. *Brou* —1F **3**
Sandy La. *Clay W* —3G **17**
Sandy La. *Ley* —6J **15**
Sandy La. *Lwr B & Cot* —3B **2**
Sandy Pl. *Ley* —6J **15**
Sarscow La. *Ley* —6A **18**
Saul St. *Pres* —4K **7**
Saunders Clo. *Hut* —3B **10**
Saunder's La. *Hut* —4C **10**
Saunders M. *Chor* —5G **25**
Savick Av. *Lea* —3B **6**
Savick Clo. *Bam B* —5F **13**
Savick Rd. *Ful* —7H **3**
Savick Way. *Ash R & Lea* —1C **6**
Saville St. *Chor* —3G **25**
Savoy St. *Pres* —5J **7**
Sawley Cres. *Rib* —2F **9**

Saxon Hey. *Ful* —1G **7**
Scarlet St. *Chor* —1J **25**
Scawfell Rd. *Chor* —3F **25**
Schleswig St. *Pres* —4A **8**
Schleswig Way. *Ley* —5E **14**
Scholars Grn. *Lea* —3A **6**
School Field. *Bam B* —1F **17**
School La. *Bam B* —3E **12**
School La. *Brins* —7F **17**
School La. *Eux* —4B **20**
School La. *Ley* —4H **15**
School La. *Los H* —5K **11**
School La. *Mos S* —5C **14**
School St. *Bam B* —3F **13**
School St. *Far* —4K **15**
School St. *Pres* —5J **7**
Scotforth Rd. *Pres* —4C **8**
Scott's Wood. *Ful* —4H **3**
Sedburgh St. *Ful* —1H **7**
Sedgwick St. *Pres* —3A **8**
Seedlee Rd. *Bam B* —7G **13**
Seed St. *Pres* —5K **7**
Sefton Rd. *Walt D* —2D **12**
Selborne St. *Pres* —6A **8**
Selby St. *Pres* —3H **7**
Selkirk Dri. *Walt D* —3D **12**
Sellers St. *Pres* —3C **8**
Sephton St. *Los H* —5A **12**
Sergeant St. *Bam B* —5F **13**
Seven Acres. *Bam B* —1G **17**
Sevenoaks. *Chor* —4G **25**
Seven Stars Rd. *Ley* —7F **15**
Severn Dri. *Walt D* —3D **12**
Severn Hill. *Ful* —3G **3**
Seymour St. *Pres* —2H **7**
Seymour Rd. *Ash R* —1G **7**
Seymour St. *Chor* —1H **25**
Shade La. *Chor* —6H **25**
Shady La. *Bam B* —2C **16**
Shaftesbury Av. *New L* —5D **10**
Shaftesbury Av. *Pen* —6F **7**
Shaftesbury Pl. *Chor* —7F **21**
Shakespeare Rd. *Pres* —3D **8**
(in two parts)
Shakespeare Ter. *Chor* —5H **21**
Shalgrove Field. *Ful* —4J **3**
Sharoe Grn. La. *Ful* —4J **3**
Sharoe Grn. La. S. *Ful* —7A **4**
Sharoe Grn. Pk. *Ful* —6A **4**
Sharoe Mt. Av. *Ful* —4K **3**
Sharratt's Path. *Char R* —4D **24**
Shawbrook Clo. *Eux* —2A **20**
Shaw Brook Rd. *Ley* —1F **19**
Shaw Brow. *Whit W* —7F **17**
Shaw Hill. *Whit W* —1F **21**
Shaw Hill Dri. *Whit W* —1F **21**
Shaw Hill St. *Chor* —1G **25**
Shaw St. *Pres* —4A **8**
Sheep Hill La. *Clay W* —4D **16**
(in two parts)
Sheep Hill La. *New L* —6D **10**
Sheffield Dri. *Lea* —2B **6**
Sheldon Ct. *Pres* —3K **7**
(off Moor La.)
Shelley Dri. *Ecc* —3F **23**
Shelley Rd. *Ash R* —2G **7**
Shepherd St. *Pres* —5A **8**
Shepherds Way. *Chor* —7H **21**
Sherbourne Cres. *Pres* —2B **8**
Sherbourne St. *Chor* —1H **25**
Sherburn Rd. *Pen* —2J **11**
Sherdley Rd. *Los H* —6B **12**
Sherwood Pl. *Chor* —7H **21**
Sherwood Way. *Ful* —5A **4**
Shire Bank Cres. *Ful* —6J **3**
Shop La. *High W* —1H **13**
Shuttle St. *Pres* —4B **8**
Shuttleworth Rd. *Pres* —2K **7**
Shuttling Fields La. *Bam B* —4G **13**
(in two parts)

Sibbering Brow. *Eux* —7A **20**
Sidgreaves La. *Lea T* —6A **2**
Silsden Av. *Rib* —6D **4**
Silverdale Clo. *Ley* —1K **19**
Silverdale Dri. *Rib* —6D **4**
Silverdale Rd. *Chor* —1J **25**
Silvester Rd. *Chor* —2G **25**
Simmons Av. *Walt D* —3B **12**
Simpson St. *Pres* —4K **7**
Singleton Clo. *Ful* —4K **3**
Singleton Row. *Pres* —3K **7**
Singleton Way. *Ful* —4K **3**
Sion Clo. *Rib* —7F **5**
Sion Hill. *Rib* —7F **5**
Six Acre La. *Longt* —7A **10**
Sizehouse St. *Pres* —4K **7**
Sizer St. *Pres* —3K **7**
Skeffington Rd. *Pres* —2B **8**
Skip La. *Hut* —2A **10**
Skipton Cres. *Rib* —6E **4**
Slade St. *Pres* —5J **7**
Slaidburn Pl. *Rib* —2G **9**
Slaidburn Rd. *Rib* —2F **9**
Slater La. *Ley* —6D **14**
(in three parts)
Sly Clo. *Pen* —2J **11**
Smalley Croft. *Pen* —2K **11**
Smith Clo. *Grims* —2J **5**
Smith Croft. *Ley* —6D **14**
Smithills Clo. *Chor* —6J **21**
Smith St. *Bam B* —5F **13**
Smith St. *Chor* —2H **25**
Smith St. *Whit W* —6G **17**
Smithy Brow. *Wrig* —7E **22**
Smithy Clo. *Brind* —1K **17**
Smithy La. *Brind* —1K **17**
Smithy St. *Bam B* —5E **12**
Snipewood. *Ecc* —2D **22**
Snow Hill. *Pres* —4K **7**
Sod Hall La. *New L & Midg H*
—1C **14**
Sod Hall Rd. *New L* —7E **10**
Sollam's Clo. *Bam B* —3F **13**
Solway Clo. *Pen* —2J **11**
Somersby Clo. *Walt D* —2E **12**
Somerset Av. *Chor* —6G **21**
Somerset Pk. *Ful* —4F **3**
Somerset Rd. *Ley* —4K **15**
Somerset Rd. *Pres* —3A **8**
Sorrel Ct. *Pen* —3G **11**
South Av. *Chor* —2H **25**
South Av. *New L* —5D **10**
Southbrook Rd. *Ley* —5G **15**
S. Cliff St. *Pres* —6J **7**
Southdowns Rd. *Chor* —2H **25**
South Dri. *Ful* —4J **3**
South End. *Pres* —7J **7**
Southern Av. *Pres* —6C **8**
Southern Pde. *Pres* —6B **8**
Southey Clo. *Ful* —4K **3**
Southfield Dri. *New L* —6D **10**
Southgate. *Ful* —6H **3**
Southgate. *Pres* —3K **7**
Southgates. *Char R* —5B **24**
South Gro. *Ful* —3J **3**
Southlands Av. *Los H* —5C **12**
Southlands Dri. *Ley* —7D **14**
S. Meadow La. *Pres* —6J **7**
S. Meadow St. *Pres* —4A **8**
Southport Rd. *Chor* —6D **20**
Southport Rd. *Ley & Ecc* —5A **18**
Southport Ter. *Chor* —1J **25**
S. Ribble Ind. Est. *Walt D* —7C **8**
S. Ribble St. *Walt D* —6C **8**
South Rd. *Cop* —7C **24**
Southside. *Eux* —4A **20**
South Ter. *Eux* —3B **20**
South View. *Los H* —6A **12**
(School La.)
South View. *Los H* —6B **12**
(Watkin La.)

S. View Ter. *Ley* —6J **15**
Spa Rd. *Pres* —4H **7**
Spa St. *Pres* —4H **7**
Spey Clo. *Ley* —6G **15**
Spinners Sq. *Bam B* —6E **12**
Spinney Brow. *Rib* —7D **4**
Spinney Clo. *New L* —5D **10**
Spinney Clo. *Whit W* —1F **21**
Spinney, The. *Chor* —4G **21**
Spinney, The. *Pen* —2D **10**
Spires Gro. *Cot* —6C **2**
Spring Bank. *Pres* —5J **7**
Springcroft. *Far* —3A **16**
Springfield Ind. Est. *Pres* —3J **7**
(off Eastham St.)
Springfield Rd. *Chor* —7G **21**
(Chorley)
Springfield Rd. *Cop* —7C **24**
(Coppull)
Springfield Rd. *Ley* —7F **15**
Springfield Rd. N. *Cop* —7C **24**
Springfield St. *Pres* —3J **7**
Spring Gdns. *Ley* —6H **15**
Spring Gdns. *Pen* —3K **11**
Spring Meadow. *Ley* —5C **16**
Springsands Clo. *Ful* —6E **4**
Springs Cres. *Whit W* —2J **21**
Springs Rd. *Chor* —5H **21**
Spring St. *Ley* —5K **15**
Springwood Clo. *Walt D* —2A **12**
Springwood Dri. *Chor* —3J **25**
Square, The. *Far* —4K **15**
Square, The. *Walt D* —7F **9**
Squires Clo. *Hogh* —3K **13**
Squires Ga. Rd. *Ash R* —1G **7**
Squires Rd. *Pen* —6G **7**
Squires Wood. *Ful* —5E **4**
Squirrel Fold. *Rib* —2F **9**
Squirrel's Chase. *Los H* —6A **12**
Stackcroft. *Clay W* —4E **16**
Stafford Rd. *Pres* —3A **8**
Staining Av. *Ash R* —3D **6**
Stamford Dri. *Whit W* —2G **21**
Standish St. *Chor* —1H **25**
Stanhope St. *Pres* —2H **7**
Stanifield Clo. *Far* —3K **15**
Stanifield La. *Far & Los H* —4K **15**
Stanley Av. *Far* —2A **16**
Stanley Av. *Hut* —3B **10**
Stanley Av. *Pen* —7J **7**
Stanley Croft. *Wood* —1F **3**
Stanleyfield Clo. *Pres* —3A **8**
Stanleyfield Rd. *Pres* —3A **8**
Stanley Gro. *Pen* —1E **10**
Stanley Pl. *Chor* —7G **21**
Stanley Pl. *Pres* —5J **7**
Stanley Rd. *Far* —2A **16**
Stanley St. *Chor* —1J **25**
Stanley St. *Ley* —5K **15**
Stanley St. *Pres* —4B **8**
Stanley Ter. *Pres* —5J **7**
Stanning St. *Ley* —6J **15**
Stansford Ct. *Pen* —1H **11**
Stansted Rd. *Chor* —1E **24**
Starkie St. *Ley* —5K **15**
Starkie St. *Pres* —5K **7**
Starrgate Dri. *Ash R* —3C **6**
Station Brow. *Ley* —4K **15**
Station Rd. *Bam B* —6E **12**
(in two parts)
Station Rd. *Cop* —7D **24**
Station Rd. *Ley* —3C **14**
Station Rd. *New L* —5D **10**
Staveley Pl. *Ash R* —2C **6**
Steeley La. *Chor* —1H **25**
Steeple View. *Ash R* —4H **7**
Stefano Rd. *Pres* —4C **8**
Stephendale Av. *Bam B* —5H **13**
Stephenson St. *Chor* —7J **21**
Stevenson Av. *Far* —3A **16**
Stewart St. *Pres* —4H **7**

Stiles Av. *Hut* —4A **10**
Stirling Clo. *Chor* —1J **25**
Stirling Clo. *Ley* —5A **16**
Stockdale Cres. *Bam B* —6F **13**
Stocks La. *Hesk* —5G **23**
Stocks Rd. *Ash R* —2G **7**
Stocks St. *Pres* —4J **7**
Stokes Hall Av. *Ley* —6J **15**
Stonebridge Clo. *Los H* —5C **12**
Stone Croft. *Pen* —3H **11**
Stonecroft Rd. *Ley* —7F **15**
Stonefield. *Pen* —1J **11**
Stonefold Av. *Hut* —4A **10**
Stonehouse Grn. *Clay W* —3F **17**
Stoney Butts. *Lea* —4B **6**
Stoneygate. *Pres* —5A **8**
Stoney Holt. *Ley* —5C **16**
Stoney La. *Los H* —7C **12**
Stony Bank. *Brind* —1K **17**
Stonyhurst. *Chor* —4G **25**
Stour Lodge. *Ful* —5G **3**
Strand Rd. *Pres* —5H **7**
Strand St. W. *Ash R* —4G **7**
Stratfield Pl. *Ley* —5K **15**
Stratford Dri. *Ful* —7H **3**
Stratford Rd. *Chor* —7H **21**
Strathmore Gro. *Chor* —1F **25**
Strathmore Rd. *Ful* —7J **3**
Stricklands La. *Pen* —1H **11**
Strutt St. *Pres* —3B **8**
Stryands. *Hut* —4A **10**
Stuart Clo. *Rib* —1E **8**
Stuart Rd. *Rib* —1E **8**
Studfold. *Chor* —5F **21**
Studholme Av. *Pen* —3J **11**
Studholme Clo. *Pen* —3J **11**
Studholme Cres. *Pen* —2J **11**
Stump La. *Chor* —7H **21**
Sturminster Clo. *Pen* —3J **11**
Suffolk Clo. *Ley* —1G **19**
Suffolk Rd. *Pres* —3A **8**
Sulby Dri. *Rib* —6F **5**
Sulby Gro. *Rib* —6G **5**
Summer Trees Av. *Lea* —1B **6**
Sumner St. *Ley* —5J **15**
Sumpter Croft. *Pen* —3J **11**
Sunbury Av. *Pen* —2H **11**
Sunningdale. *Wood* —1F **3**
Sunnybank Clo. *Pen* —1J **11**
Sunny Brow. *Cop* —6E **24**
Surgeon's Ct. *Pres* —5K **7**
Surrey St. *Pres* —4C **8**
Sussex St. *Pres* —3A **8**
Sutcliffe St. *Chor* —1H **25**
Sutton Dri. *Ash R* —4B **6**
Sutton Gro. *Chor* —3K **21**
Swallow Av. *Pen* —1J **11**
Swallow Ct. *Clay W* —5G **17**
Swansea St. *Ash R* —3G **7**
Swansey La. *Clay W* —5G **17**
Swan St. *Pres* —4C **8**
Swill Bk. La. *Pres* —6C **8**
Sycamore Av. *Eux* —4B **20**
Sycamore Clo. *Ful* —5C **4**
Sycamore Ct. *Chor* —3F **25**
Sycamore Dri. *Pen* —2J **11**
Sycamore Rd. *Chor* —5H **21**
Sycamore Rd. *Rib* —2E **8**
(in two parts)
Syd Brook La. *Cros & Maw*
—7A **18**
Syke Hill. *Pres* —5A **8**
Syke St. *Pres* —5A **8**
Sylvancroft. *Ing* —6E **2**
Sylvan Gro. *Bam B* —3G **13**
Symonds Rd. *Ful* —1J **7**

Tabley La. *High B* —2B **2**
Tag Croft. *Ing* —6D **2**
Tag Farm Ct. *Ing* —6D **2**

West Rd. *Ful* —1K **7**
W. Strand. *Pres* —4G **7**
West St. *Chor* —1G **25**
West Ter. *Eux* —3B **20**
West View. *Bam B* —6E **12**
West View. *Pres* —2C **8**
W. View Ter. *Pres* —4G **7**
West Way. *Chor* —6D **20**
Westway. *Ful* —7A **4**
Westway Ct. *Ful* —7A **4**
Westwell Rd. *Chor* —6H **21**
Westwood. *Ley* —4J **15**
Westwood Rd. *Bam B* —2G **17**
Wetherall St. *Ash R* —3H **7**
Whalley Rd. *Hesk* —4F **23**
Whalley St. *Bam B* —3F **13**
Whalley St. *Chor* —1G **25**
Wham Hey. *New L* —6E **10**
Wham La. *New L* —6E **10**
Wharfedale Av. *Rib* —6E **4**
Wharfedale Clo. *Ley* —7J **15**
Wheatfield. *Ley* —6C **14**
Wheelton La. *Far* —4J **15**
Whernside Cres. *Rib* —6D **4**
Whernside Way. *Ley* —5A **16**
Whimberry Clo. *Chor* —7J **21**
Whinfield Av. *Chor* —6H **21**
Whinfield La. *Ash R* —4D **6**
Whinfield Pl. *Ash R* —4D **6**
Whinnyfield La. *Wood* —1A **2**
Whinny La. *Eux* —3C **20**
Whinsands Clo. *Ful* —6D **4**
Whitby Av. *Ing* —6D **2**
 (in three parts)
Whitby Pl. *Ing* —6D **2**
Whitebeam Clo. *Pen* —2F **11**
Whitefield Meadow. *Bam B*
 —3F **13**
Whitefield Rd. *Pen* —1E **10**
Whitefield Rd. E. *Pen* —1E **10**
Whitefield Rd. W. *Pen* —1E **10**
Whitefriar Clo. *Ing* —6E **2**
Whitegate Fold. *Char R* —5C **24**
Whiteholme Pl. *Ash R* —3C **6**
Whitelens Av. *Lea* —3A **6**
White Meadow. *Lea* —1C **6**
Whitendale Dri. *Bam B* —6F **13**
Whitethorn Clo. *Clay W* —4E **16**
Whitethorn Sq. *Lea* —3B **6**
Whitmore Dri. *Rib* —2G **9**
Whitmore Gro. *Rib* —2G **9**
Whitmore Pl. *Rib* —2G **9**
Whittam Rd. *Chor* —2G **25**
Whittingham La. *Brou* —1H **3**
Whittingham La. *Haig & Grims*
 —1H **5**
Whittle Brow. *Cop* —7A **24**
Whittle Grn. *Wood* —1C **2**

Whittle Hill. *Wood* —1C **2**
Whitworth Dri. *Chor* —1E **24**
Wholesome La. *New L* —7C **10**
Wigan La. *Chor* —7H **25**
Wigan Rd. *Eux* —2A **20**
Wigan Rd. *Ley* —7A **16**
Wignall St. *Pres* —3C **8**
Wigton Av. *Ley* —7F **15**
Wilbraham St. *Pres* —3C **8**
Wilderswood Clo. *Whit W* —4G **17**
Wildman St. *Pres* —2J **7**
Wilkinson St. *Los H* —5B **12**
William Henry St. *Pres* —4C **8**
Williams La. *Ful* —4C **4**
William St. *Chor* —2G **25**
Willow Clo. *Hogh* —4K **13**
Willow Clo. *Los H* —5A **12**
Willow Clo. *Pres* —1E **10**
Willow Coppice. *Lea* —1C **6**
Willow Cres. *Ley* —3B **16**
Willow Cres. *Rib* —2D **8**
Willow Dri. *Char R* —5B **24**
Willowfield. *Clay W* —3G **17**
Willow Grn. *Ash R* —4E **6**
Willow Rd. *Chor* —5J **21**
Willow Rd. *Ley* —1B **18**
Willows, The. *Cop* —7C **24**
Willow Tree Av. *Brtn* —1H **3**
Willow Tree Cres. *Ley* —5F **15**
Willow Way. *New L* —6D **10**
Wilmar Rd. *Ley* —4A **16**
Wilmot Rd. *Rib* —1E **8**
Wilton Gro. *Pen* —1E **10**
Wilton Pl. *Ley* —5K **15**
Winchester Av. *Chor* —5J **25**
Winckley Ct. *Pres* —5K **7**
Winckley Rd. *Pres* —6H **7**
Winckley Sq. *Pres* —5K **7**
Winckley St. *Pres* —5K **7**
Windermere Av. *Far* —3J **15**
Windermere Rd. *Chor* —1J **25**
Windermere Rd. *Ful* —7C **4**
Windermere Rd. *Pres* —3G **9**
Windsor Av. *Ash R* —2F **7**
Windsor Av. *New L* —4E **10**
Windsor Av. *Pen* —2G **11**
Windsor Clo. *Chor* —1F **25**
Windsor Dri. *Ful* —5H **3**
Windsor Rd. *Chor* —1F **25**
Windsor Rd. *Ecc* —1E **22**
Windsor Rd. *Walt D* —2D **12**
Winery La. *Walt D* —7C **8**
Wingates. *Pen* —2G **11**
Winmarleigh Rd. *Ash R* —3F **7**
Winslow Clo. *Pen* —3J **11**
Winsor Av. *Ley* —6K **15**
Winster Clo. *Hogh* —1K **13**
Winton Av. *Ful* —5K **3**

Withington La. *Hesk* —6G **23**
Withnell Gro. *Chor* —6J **21**
Withy Ct. *Ful* —1J **7**
Withy Gro. Clo. *Bam B* —4F **13**
Withy Gro. Cres. *Bam B* —4F **13**
Withy Gro. Rd. *Bam B* —4F **13**
Withy Pde. *Ful* —7J **3**
Withy Trees Av. *Bam B* —5F **13**
Withy Trees Clo. *Bam B* —4F **13**
Witton St. *Pres* —4B **8**
Woburn Grn. *Ley* —4K **15**
Wolseley Clo. *Ley* —6J **15**
Wolseley Pl. *Pres* —5A **8**
Wolseley Rd. *Pres* —7J **7**
Woodacre Rd. *Rib* —2G **9**
Woodale Rd. *Clay W* —2F **17**
Wood Bank. *Pen* —2G **11**
Woodcock Est. *Los H* —7B **12**
Woodcock Fold. *Ecc* —1E **22**
Woodcock La. *Hesk* —4G **23**
Woodcock's Ct. *Pres* —5K **7**
Woodcroft Clo. *Pen* —3G **11**
Wood End Rd. *Clay W* —3E **16**
Woodfall. *Chor* —6F **21**
Woodfield. *Bam B* —7H **13**
Woodfield Rd. *Chor* —6G **21**
Woodford Copse. *Chor* —1D **24**
Woodgreen. *Ley* —4G **15**
Woodhart La. *Ecc* —3E **22**
Woodhouse Gro. *Pres* —5J **7**
Woodland Grange. *Pen* —2H **11**
Woodland Gro. *Pen* —7F **7**
Woodlands Av. *Bam B* —3G **13**
Woodlands Av. *Pen* —3H **11**
Woodlands Av. *Rib* —2E **8**
Woodlands Dri. *Ful* —3J **3**
Woodlands Dri. *Ley* —6H **15**
Woodlands Gro. *Grims* —2K **5**
Woodlands Meadow. *Chor* —5G **25**
Woodlands, The. *Ash R* —3C **6**
Wood La. *Hesk* —4F **23**
Wood La. *Maw* —3A **22**
Woodlea Rd. *Ley* —6H **15**
Woodman Cote. *Chor* —5F **21**
Woodplumpton La. *Brou* —1G **3**
Woodplumpton Rd. *Ful* —7F **3**
Woodplumpton Rd. *Wood* —2B **2**
Woods Grn. *Pres* —7J **7**
Woodside. *Chor* —4J **25**
Woodside. *Eux* —4A **20**
Woodside. *Far* —2A **16**
Woodside Av. *Clay W* —5F **17**
Woodside Av. *Ful* —7J **3**
Woodside Av. *New L* —6D **10**
Woodside Av. *Rib* —1E **8**
Woodstock Clo. *Los H* —5C **12**
Woodvale. *Ley* —6C **14**
Woodville Rd. *Chor* —7G **21**

Woodville Rd. *Hth C* —7K **25**
Woodville Rd. *Pen* —3H **11**
Woodville Rd. W. *Pen* —3G **11**
Woodville St. *Far* —3K **15**
Woodway. *Ful* —7G **3**
Wookey Clo. *Ful* —5D **4**
Worcester Av. *Ley* —6K **15**
Worcester Pl. *Chor* —5J **25**
Worden Clo. *Ley* —7H **15**
Worden La. *Ley* —7H **15**
Worden Rd. *Ash R* —1H **7**
Wordsworth Pl. *Walt D* —3D **12**
Wordsworth Ter. *Chor* —5H **21**
Worthing Rd. *Ing* —7E **2**
Worthy St. *Chor* —1J **25**
Wray Cres. *Ley* —1B **18**
Wren Av. *Pen* —7J **7**
Wrennalls La. *Ecc* —3D **22**
Wren St. *Pres* —3B **8**
Wrights Fold. *Ley* —6A **16**
Wright St. *Chor* —7J **21**
Wychnor. *Ing* —4F **3**
Wymundsley. *Chor* —5E **20**
Wyresdale Cres. *Rib* —7D **4**
Wyresdale Dri. *Ley* —7K **15**
Wyre St. *Ash R* —3G **7**

Yarrow Ga. *Chor* —2J **25**
Yarrow Pl. *Ley* —6F **15**
Yarrow Rd. *Chor* —2J **25**
Yarrow Rd. *Ley* —6F **15**
Yates St. *Chor* —3F **25**
Yeadon Gro. *Chor* —1E **24**
Yeovil Ct. *Pres* —3D **8**
Yewland Av. *Char R* —5H **23**
Yewlands Av. *Bam B* —4F **13**
Yewlands Av. *Ful* —5J **3**
Yewlands Av. *Ley* —5J **15**
Yewlands Cres. *Ful* —5J **3**
Yewlands Dri. *Ful* —5J **3**
Yewlands Dri. *Ley* —5H **15**
Yew Tree Av. *Eux* —3A **20**
Yew Tree Av. *Grims* —1J **5**
Yewtree Clo. *Chor* —5J **25**
Yewtree Gro. *Los H* —6A **12**
Yew Trees Av. *Rib* —7G **5**
York Av. *Ful* —7J **3**
York Clo. *Ley* —7G **15**
York Clo. *Walt D* —2D **12**
York Ho. *Pres* —5A **8**
York St. *Chor* —1H **25**
Young Av. *Ley* —5A **16**

Zetland St. *Pres* —5C **8**